THE ALPHAS

"THEY'RE STRONGER, FASTER... YOUR WORST NIGHTMARE."

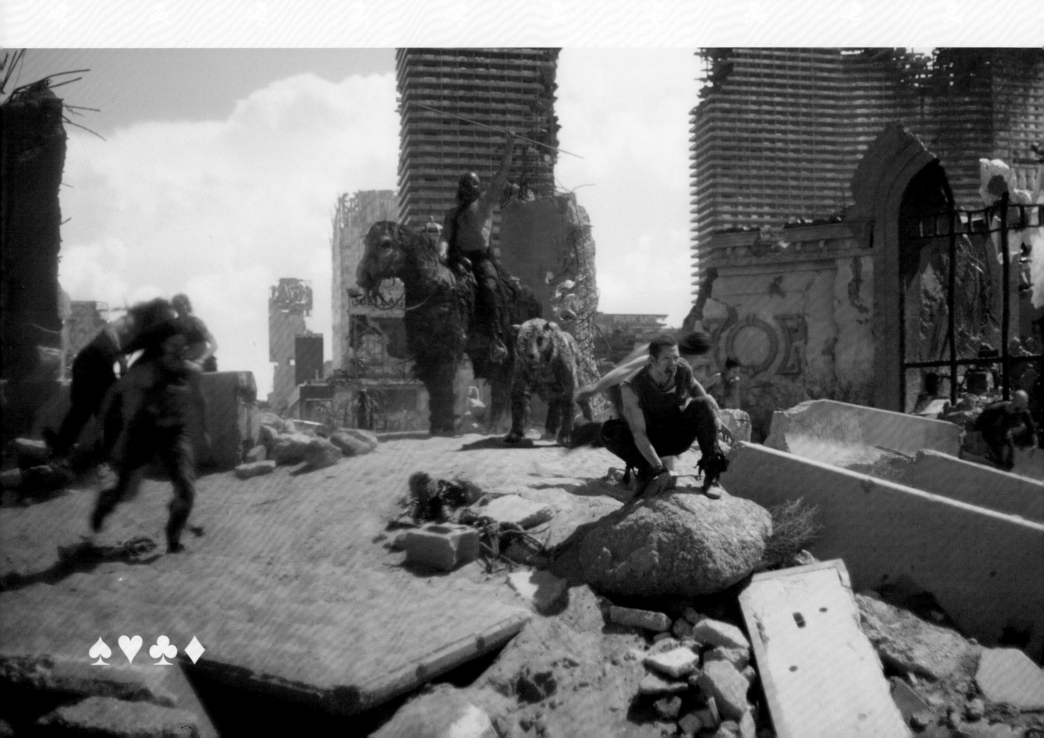

♠ ♥ ♣ ♦

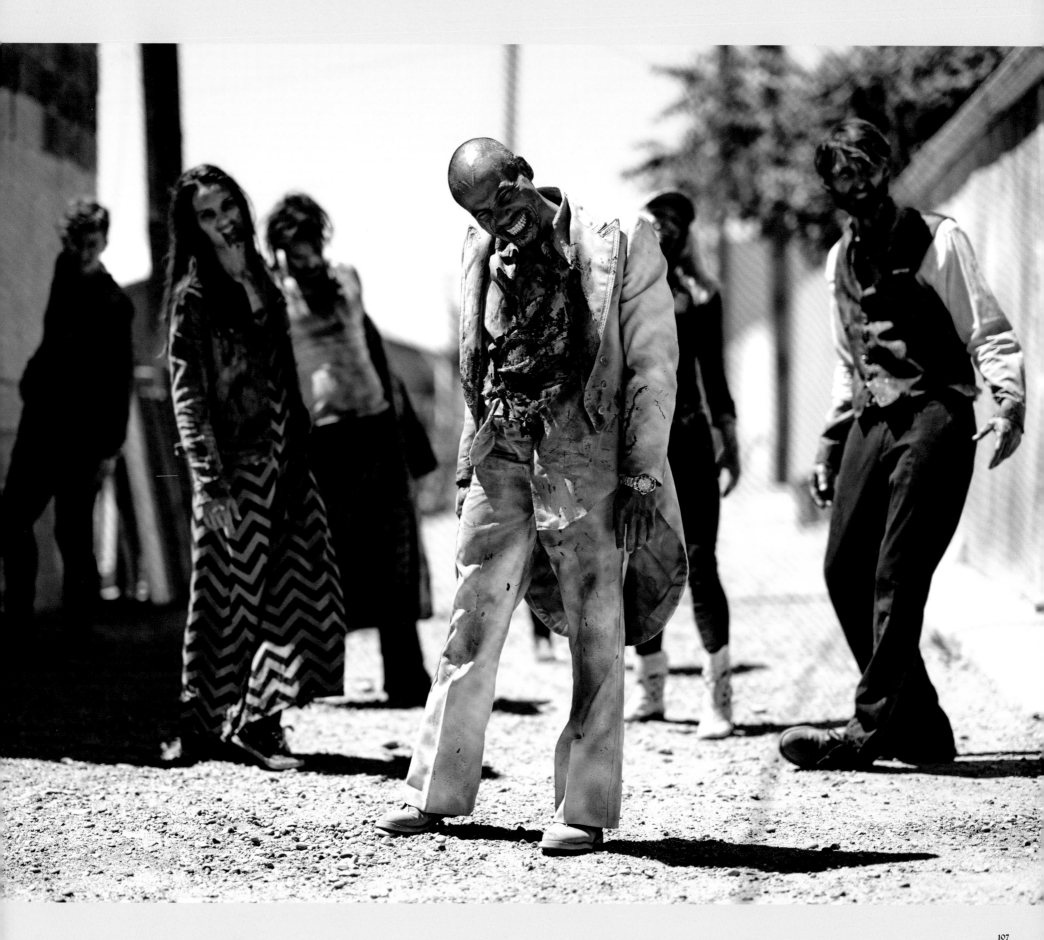

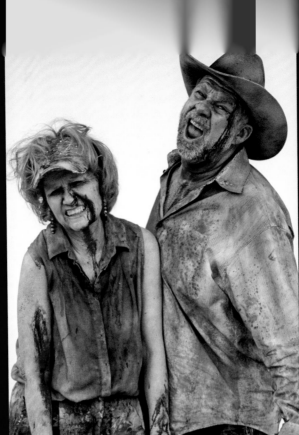

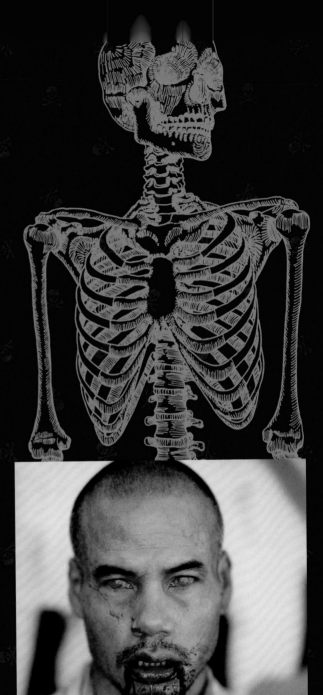

The ubiquity of this type of zombie in pop culture allowed for a certain shorthand when directing scenes. "When you cast the extras in the film, they all have the zombie walk," says Snyder. "You don't have to teach them. You have to correct them—'No, that's not how we're doing it'—but they all have one. No one asks, 'How does a zombie move…?' Everyone has an idea."

SOME SHAMBLERS HAVE ALMOST A QUICK WALK, BECAUSE THEY'RE FRESH.

Additionally, it made sense to differentiate movement patterns between the different stages. "Freshly killed or freshly reanimated Shamblers, you'll see move faster than Stage Two, Stage Three, or Stage Four," second unit director Damon Caro explains. "You'll see in the opening montage, some of the Shamblers have almost a quick walk or stumble, because they're

THIS SPREAD/ A smattering of Shamblers that call Sin City home.

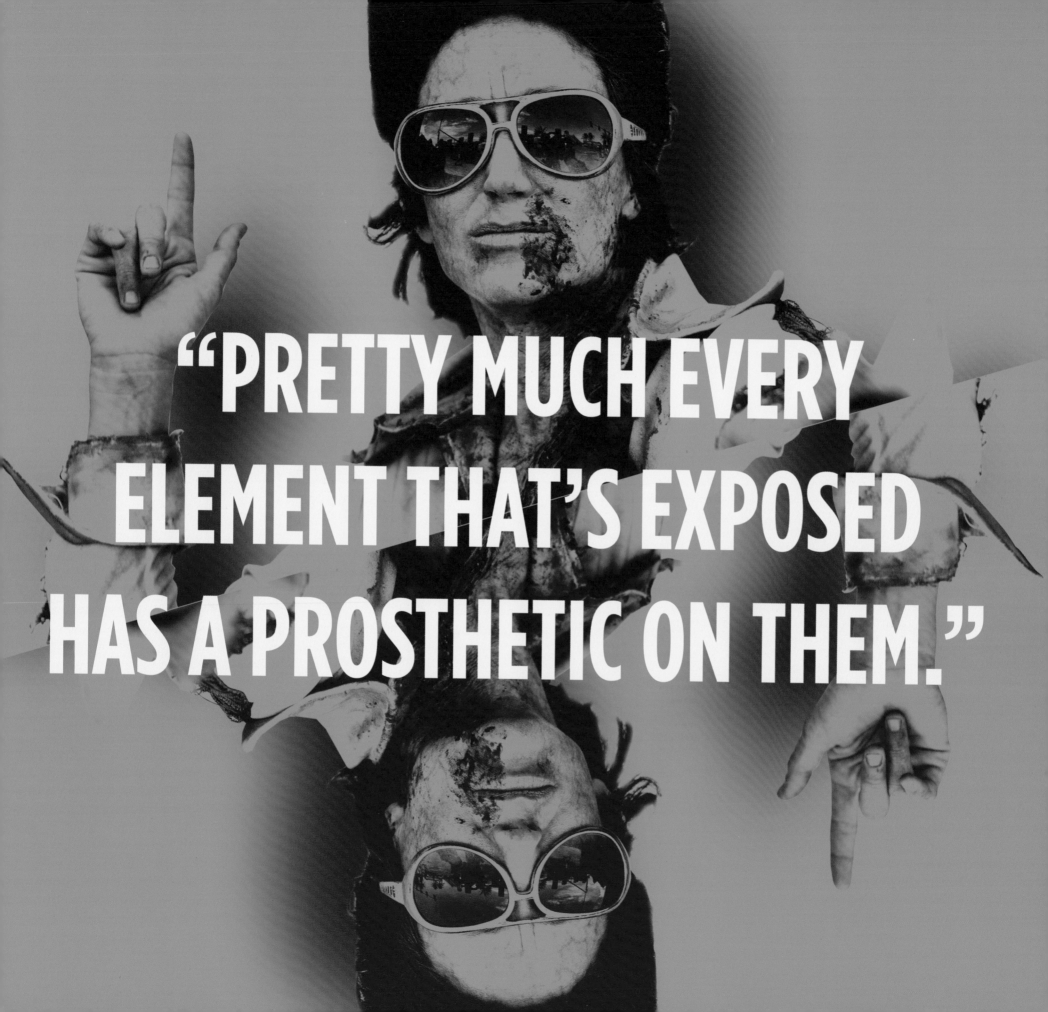

"PRETTY MUCH EVERY ELEMENT THAT'S EXPOSED HAS A PROSTHETIC ON THEM."

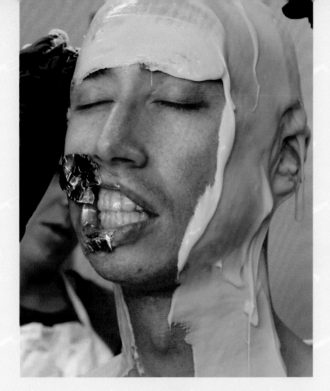

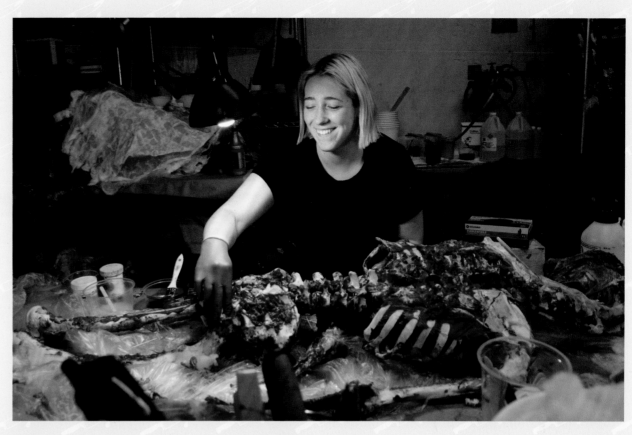

ABOVE/ Making a mold for the Vault Shambler.

RIGHT/ Artist Jessie Fine prepares some blood and guts.

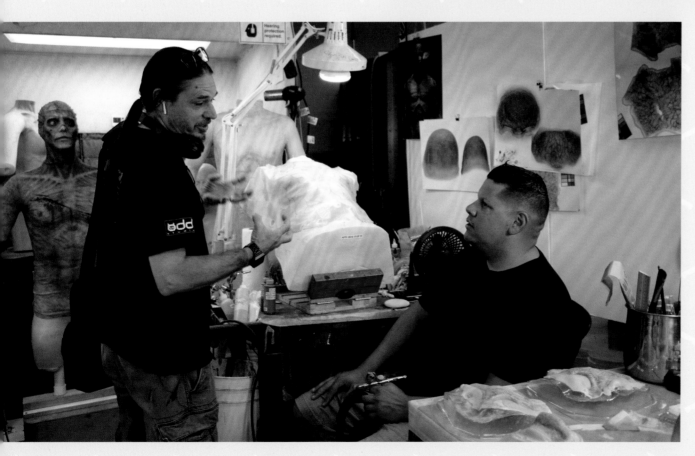

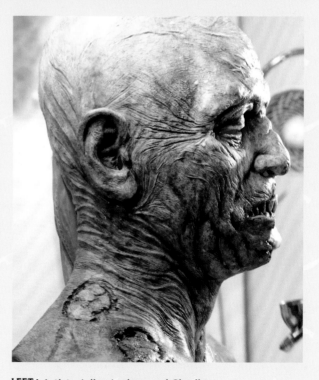

LEFT/ Artists Julian Ledger and Charlie Hernandez churn out some zombie appliances.

ABOVE/ An Alpha mask.

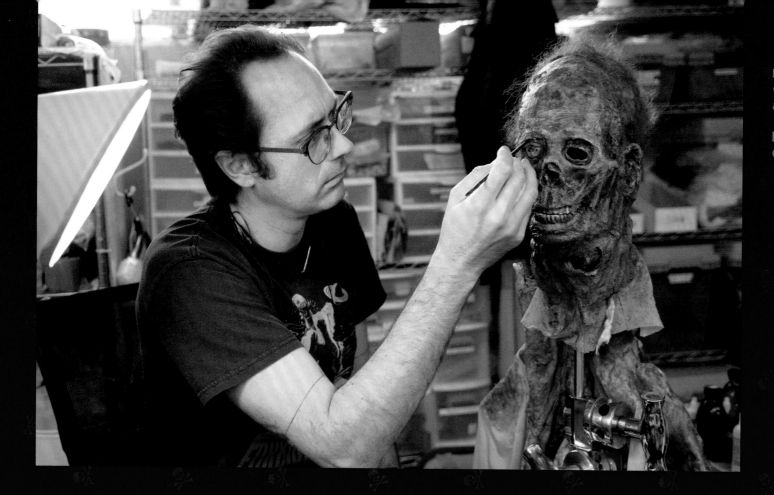

LEFT/ Make-up artist Jesse Gee
works on a Shambler mask for
a background performer.

BELOW/ (Left) Shambler Stage
One vs. (Right) Stage Four.

Stage Three: "It's another step further. Even more dehydrated looking, and eyes even more blind and glossed over, skin really gray-brown up to very blackish-brown. More paint, prosthetics, contact lenses, dental pieces."

Stage Four: "After [Las Vegas has] been locked down for years, we assume they've been exposed to the desert elements. So, these things have really dehydrated down, shriveled up, and almost mummified, with beef-jerky flesh, if you will. All of our Shamblers have become these dry, emaciated things, which you don't usually see in zombie movies that rarely get to that point in the timeline. That was a big challenge. With actors, as opposed to puppets, we had to take a specialized approach to make it feel right in the environment, and those are complete prosthetic characters. Pretty much every element that's exposed has a prosthetic on them: wigs, contact lenses, dental veneers. Some of the characters will have digital work to remove part of their face, but for the most part it's prosthetic."

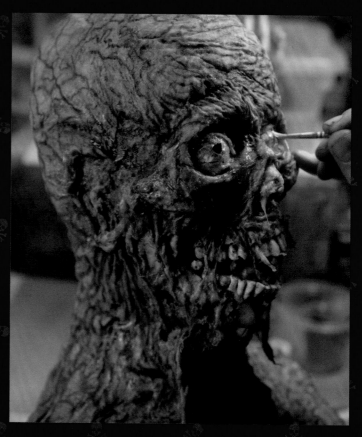

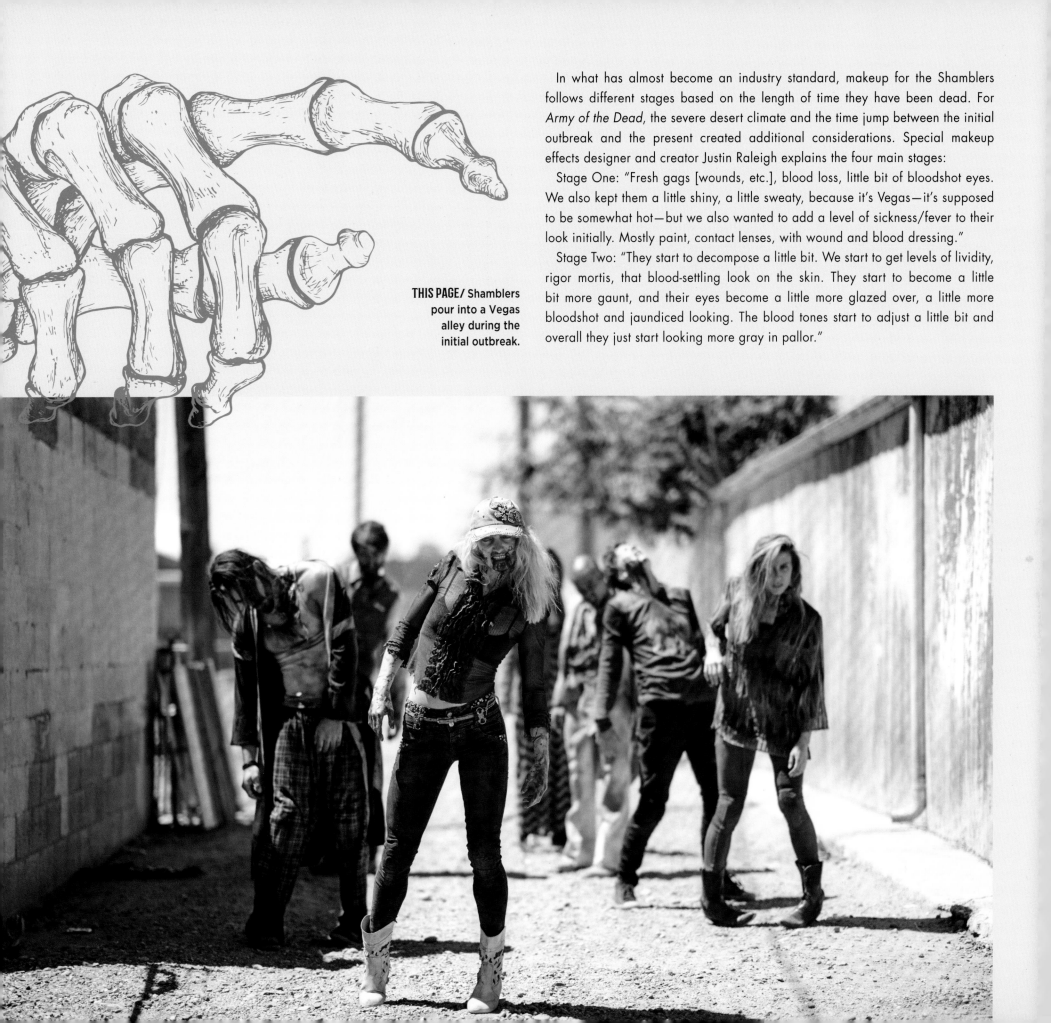

In what has almost become an industry standard, makeup for the Shamblers follows different stages based on the length of time they have been dead. For *Army of the Dead*, the severe desert climate and the time jump between the initial outbreak and the present created additional considerations. Special makeup effects designer and creator Justin Raleigh explains the four main stages:

Stage One: "Fresh gags [wounds, etc.], blood loss, little bit of bloodshot eyes. We also kept them a little shiny, a little sweaty, because it's Vegas—it's supposed to be somewhat hot—but we also wanted to add a level of sickness/fever to their look initially. Mostly paint, contact lenses, with wound and blood dressing."

Stage Two: "They start to decompose a little bit. We start to get levels of lividity, rigor mortis, that blood-settling look on the skin. They start to become a little bit more gaunt, and their eyes become a little more glazed over, a little more bloodshot and jaundiced looking. The blood tones start to adjust a little bit and overall they just start looking more gray in pallor."

THIS PAGE/ Shamblers pour into a Vegas alley during the initial outbreak.

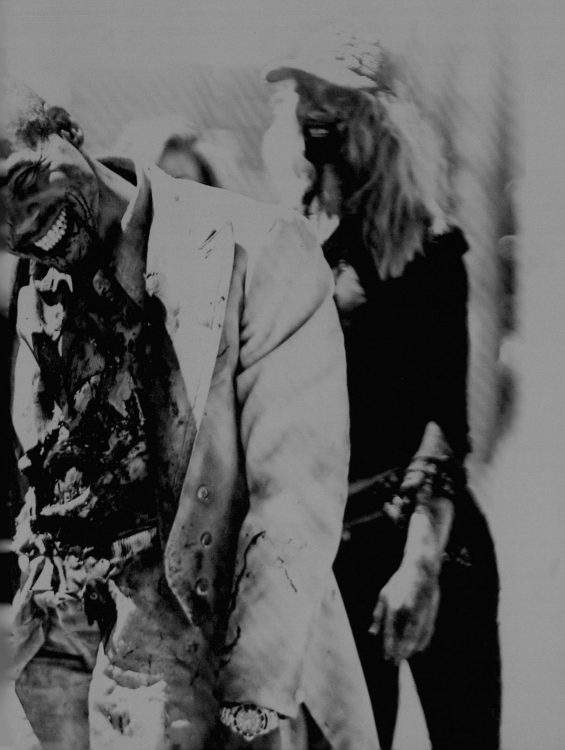
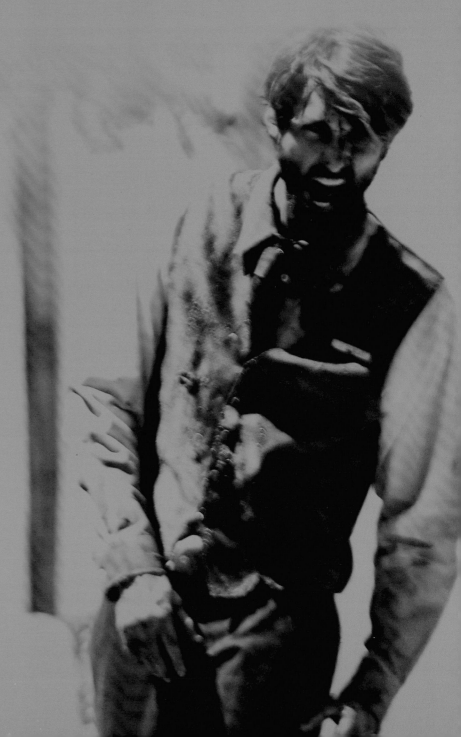

They are what most people today picture when they hear the word 'zombie,' "which is a traditional, mindless, shambling, slow zombie that is on a singular path of devouring humans," explains producer Wesley Coller. In director Zack Snyder's view, this sort of baseline undead does not make for true antagonists; they are more environmental hazards for the heroes than anything else. "They're kind of like weather—like bad weather. They're gonna come up and fuck up your deal, but they're not necessarily evil. They don't have intent," he explains.

They are the result of an infected bite from another Shambler or an Alpha (see page 108). Shamblers quickly overwhelmed Las Vegas, from the tops of the high-roller suites to the outermost suburbs. They are what the Las Vengeance crew spent months fighting during the zombie war. However, only a short time before, they were their neighbors, friends, and family. "I had a lot of compassion for the zombies, in a way. They're victims," says Nora Arnezeder.

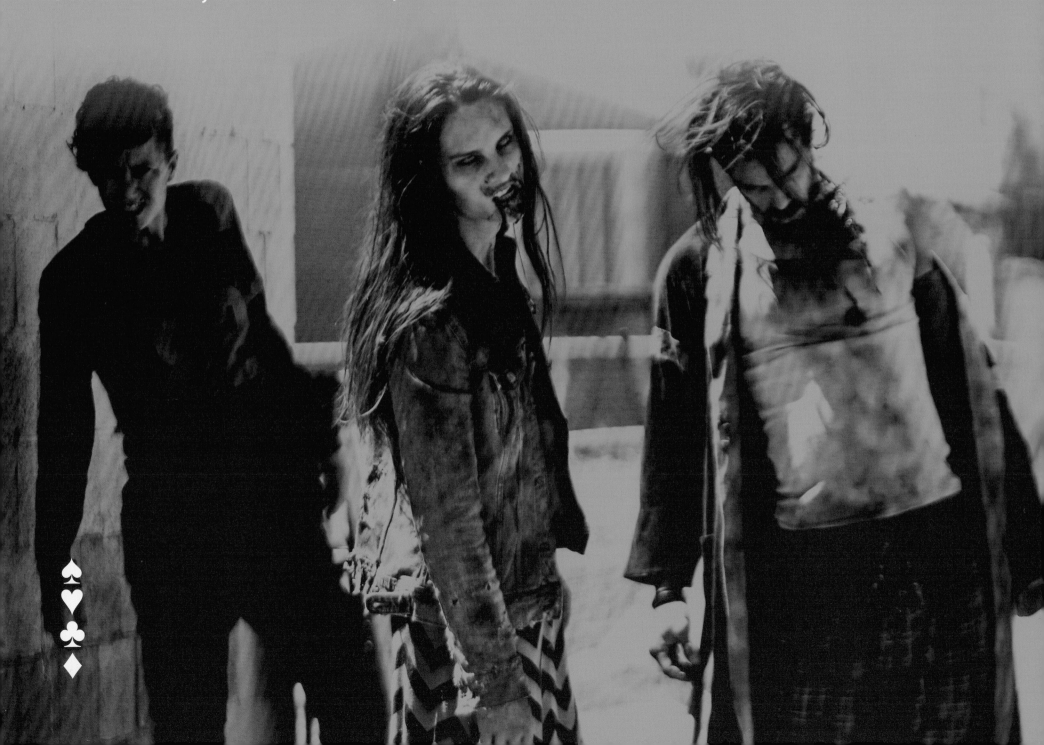

THE SHAMBLERS

MINDLESS, SHAMBLING, SLOW ZOMBIES

EDGE

THE HOUSE

One of the measures of a great zombie movie is the quality of its zombies. *Army of the Dead* naturally has that covered, but goes a bit further: Variety. These zombies come in all shapes, sizes, and temperaments. Let's take a closer look at the types currently inhabiting Las Vegas, see what different roles they have to play, and appreciate the hard work that went into bringing them to the screen.

"I always imagined at some point she had to make a decision between saving her kids and saving her husband, and maybe the husband died because of that decision. She's guilty about that. In India, married women wear something called the mangalsutra, this black and gold bead chain around their neck to say they're married. She keeps wearing that and playing with that throughout the film. I thought that was a really nice, interesting element to bring. At least everyone watching in India will love it."

What raises the stakes considerably higher for Geeta is the ticking clock of the impending nuclear bomb. As a result, the camp is due to be evacuated, and with it any chance of getting into Las Vegas to grab money to bribe her way out will be lost. Out of desperation and out of options, Geeta turns to Lilly before it's too late. Ominously, she hasn't returned from Vegas by the time Scott and his team set off, triggering Kate to join them in search of her.

"I remember watching [Snyder's] *Dawn of the Dead*," says Qureshi. "There's a scene in which the dog runs away and goes between the zombies, and this one girl, she puts herself and everybody else in danger and she goes to get the dog. I guess in this film, I'm the puppy, and Ella's character, Kate, is just like the one that goes to rescue me."

You'd be forgiven for thinking that would make Geeta a simple damsel in distress, but you'd be dead wrong. "What's so great about the film is that you get to see different sides of people, and you get to see how your perception isn't always correct," says Deborah Snyder. "This woman, who you might think is weak, actually is really, really strong."

> ## "FOR FIVE GRAND, I COULD BUY MY WAY OUT, ME AND MY KIDS."
> *GEETA*

GEETA

"WHATEVER IT TAKES TO KEEP MY KIDS SAFE."

Another inhabitant of the detention camp who gets pulled into the horror of Las Vegas is Geeta, the mother of two small children. She is portrayed by Indian actress Huma Qureshi (*D-Day, City of Revenge*), who was thrilled to be part of this zombie extravaganza. "It's just larger than life. It's really this visual delight," she says. "*Army of the Dead* offered everything. It has these beautiful, emotional stories, and the characters are really driven by so much passion, and I love that. I love the journey of my character, and the whole arc. I thought that it was really beautiful and very special."

Driving that journey is her deep-seated need to protect and provide for her children, a drama that resonates daily with parents around the world. "Geeta is this amazing mother who wants, more than anything, to keep her kids safe and to get them out of this bad condition they're in," Deborah Snyder says. "How far would she go in order to protect her kids?" For Qureshi, that need to protect was what attracted her to the character. "That's what makes her so compelling, that greed is not her primary motive. It's something else, something that's more than her," she says.

HOW FAR WOULD SHE GO TO PROTECT HER KIDS?

An invented backstory and personal cultural knowledge also informed Qureshi's interpretation of the character. "I always played it with a lot of pain, as someone who's gone through something," she says.

THIS SPREAD/ Geeta (Huma Qureshi) will go to any lengths to improve the lives of her children.

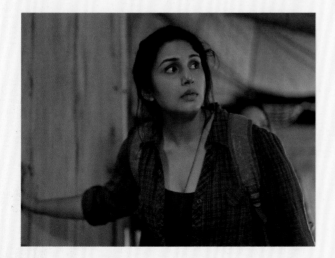

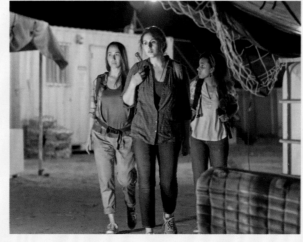

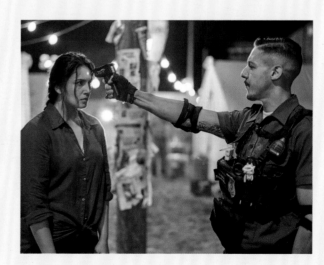

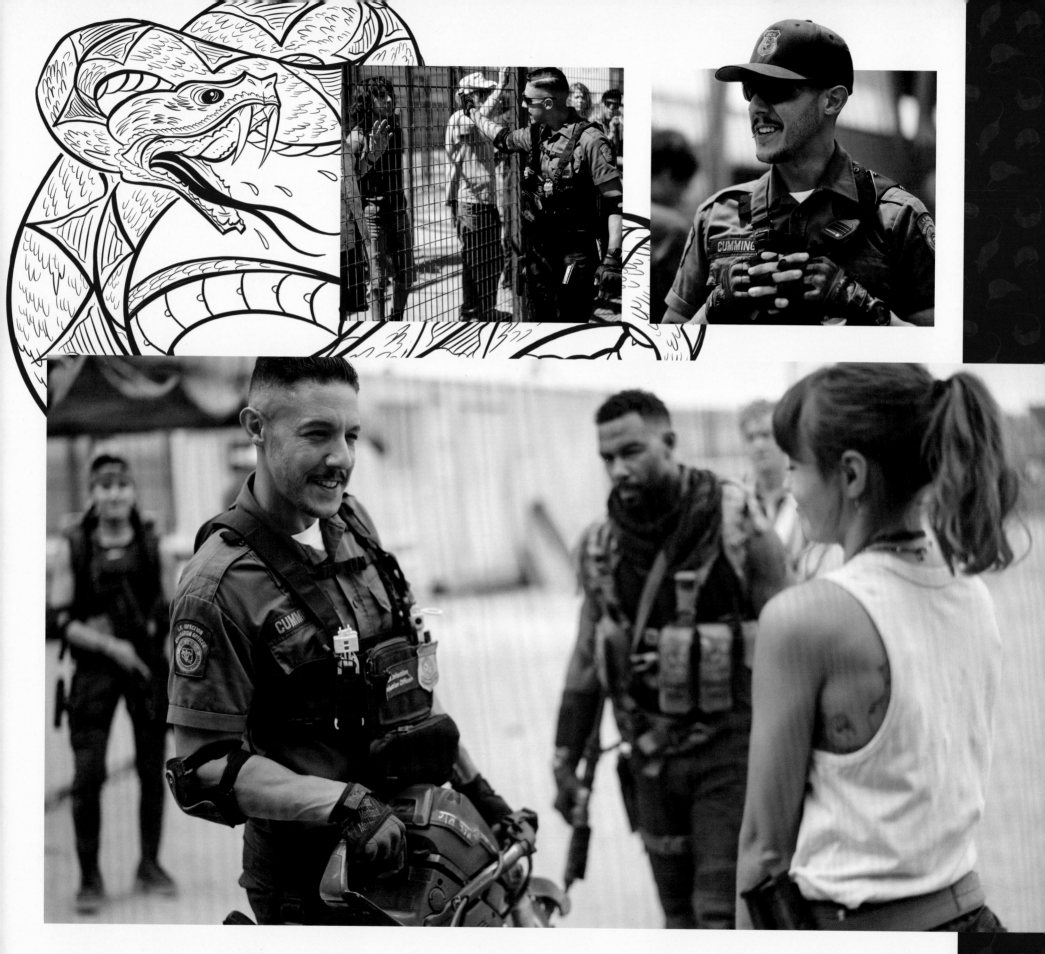

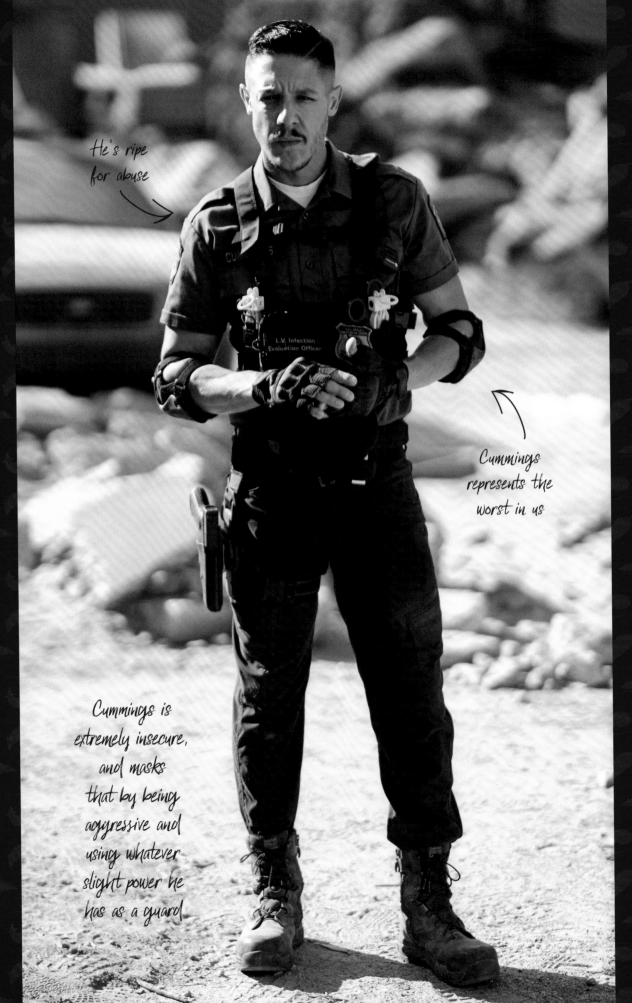

He's ripe for abuse

Cummings represents the worst in us

Cummings is extremely insecure, and masks that by being aggressive and using whatever slight power he has as a guard

In creating such a bad guy, the first impression is key. "One of the first things I worked on on this film, really even before I read close to a final script, was how he was gonna look," says Rossi. "Everything he does, from how high he rolls his sleeves to how he pops his collar—he wants to be noticed. Not too ostentatious, not too loud and screaming, 'I'm in charge!' but at the same time, he sticks out so much from the rest of this team that you see he's different, and not in a good way."

"Even when we did our first costume test with him, he put a toothpick in his mouth," says Deborah Snyder. "He really worked hard to embody this character who does horrific things and uses scare tactics. Cummings represents the worst in us. That's ironic, because Theo is such a sweet, likable guy, and he's playing this despicable guard who is taking advantage of everyone."

Then why on earth, you may ask, would Scott and company invite this creep along on the heist? Blame Lilly, who says they need him. "They need him to navigate. He kinda knows the area. That only empowers the ego in him and the bad behavior," says Rossi, "and that sets the tone for not just his descent into becoming the worst version of himself, but also to propel them to get to a different place."

In a bizarre way, the journey through Las Vegas becomes a revelatory crucible for Cummings. "That actually becomes quite humorous, because there are things that go on throughout the film in which that entire façade that he's created gets taken down. He's all talk. He becomes his real self in the face of the true bad guys," says Rossi.

BURT CUMMINGS

"THIS'LL BE FUN, YEAH?"

In the same way that U.S. Immigration and Customs Enforcement (ICE) grew out of the response to 9/11, the Las Vegas Quarantine Center became a stand-alone entity following the zombie outbreak. Afforded considerable autonomy in a region cut off from the civil rights protections of the U.S. Constitution, it can be expected that some in the organization would abuse that authority, given the opportunity.

TO BE A BAD GUY IN A ZOMBIE FILM, YOU GOTTA BE A PRETTY BAD GUY.

Enter Burt Cummings, played by Theo Rossi (*Sons of Anarchy*, *Luke Cage*), a guard at the McCarren Camp Detention Facility in Henderson, Nevada, who is barely pretending to care about his charges. "That is the guy you love to hate right up front," says Coller, "and Theo does a great job of making this guy who, you can tell, is probably up to no good."

Rossi describes life in the camp as, "Not pleasant. There's fear, and outstanding fear of what's outside the gates. A place like that is a breeding ground for nefarious activity, because it's unregulated." It's a situation his character takes full advantage of.

"This is a guy who wanted to be in the military, wanted to have a position of power, so he's ripe for abuse. He obviously is extremely insecure, and masks that by being aggressive and using whatever slight power he has as a guard," he says. "And to be a bad guy in a zombie film, you gotta be a pretty bad guy."

THIS SPREAD/ Abusing his authority comes easily to Burt Cummings (Theo Rossi).

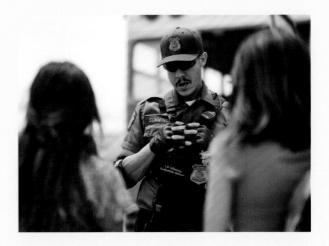

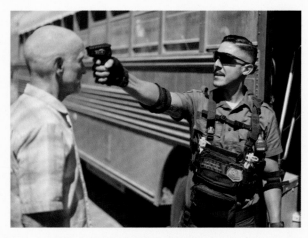

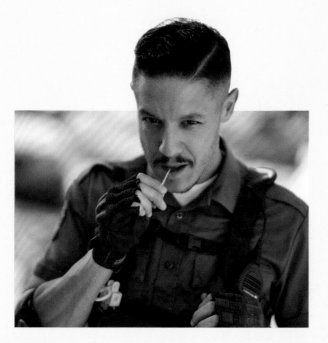

Like many of the other characters, there is a core of practicality to Lilly's wardrobe, but even small details can influence character. "She's not trying to be fashionable or anything," says Arnezeder, "but she's a little punk rock; borderline punk rock. She's wearing a T-shirt with [British punk band] The Exploited on it. I was not aware of them until they gave me that T-shirt. It's interesting, because I listened to a lot of their songs and it actually really inspired me for my character."

DON'T LET 'EM GRIND YOU DOWN

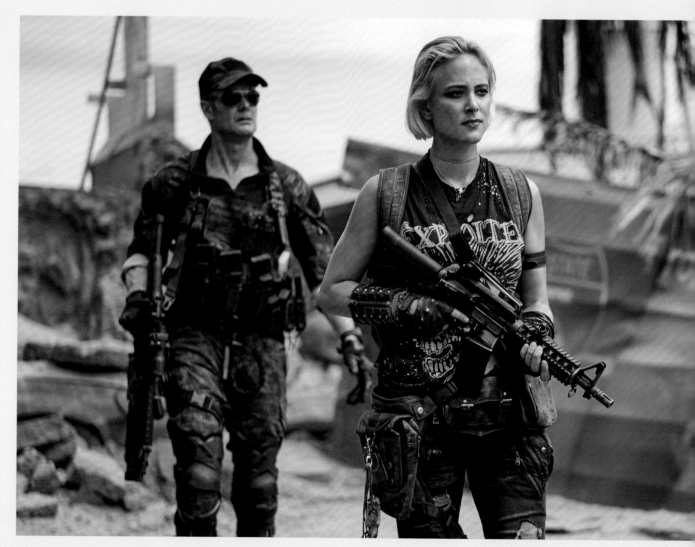

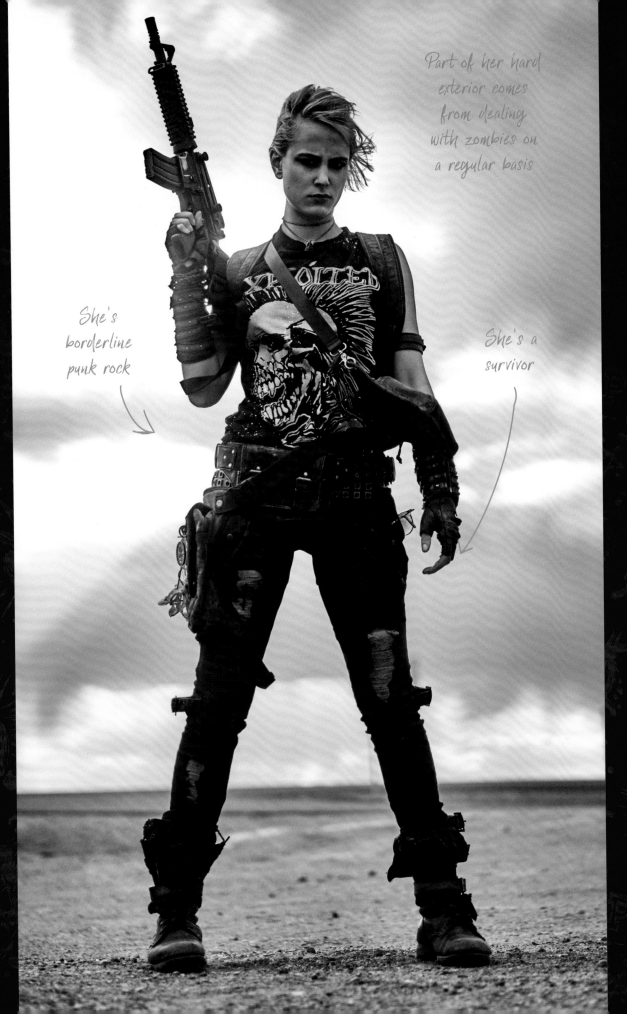

Part of her hard exterior comes from dealing with zombies on a regular basis

She's borderline punk rock

She's a survivor

Production designer Julie Berghoff points out that Lilly also uses her forays into the city and her influence to set up quite a profitable business in the camp for herself. "She is connected to all the guards," she says, "so she is selling water and blankets, games— a deck of cards is probably a pretty hot commodity— and people are trading what they have."

The audience would be mistaken, however, if they view Lilly as having purely mercenary motives. "At the beginning of the movie, you think she's out for herself, she just wants money. It's a job," says Deborah Snyder. "But what you come to realize is, she actually is trying to help people get out of the camp. It's about perceptions: What you think someone's motivation is might not really be the case. If you dig a little deeper, you'll find out that things are not always as they seem."

When Lilly accepts the job of leading Scott and his crew inside, there is no expectation that she will become an integral part of the team, but she does. "I think there's a version where she probably could've gotten in and bailed on them," Coller observes, "but there's another offer that comes across her plate during that process, which leaves her intrigued and wanting to continue on the journey deeper into the city."

Part of her hard exterior comes from dealing with zombies on a regular basis. It has obviously affected Lilly, including how she deals with regular people. "She sees danger everywhere, and her personality gets very heightened, in a way," explains Arnezeder. "Lilly is really trying to help, but sometimes doesn't know how to express herself or how to communicate her thoughts and feelings." She concedes that this makes her relationship with Kate a bit complicated, especially when Lilly escorts a mutual friend into Vegas and that friend doesn't return. "Kate and Lilly have a history. They've been friends, they've known each other through the camp, but this kind of situation puts a bit of a twist in their relationship," Arnezeder says. "They have very different personalities. Lilly is ruthless."

THIS SPREAD/ The Coyote in her element.

LILLY

"YOU THINK I ENJOY HAVING TO LEAVE PEOPLE?"

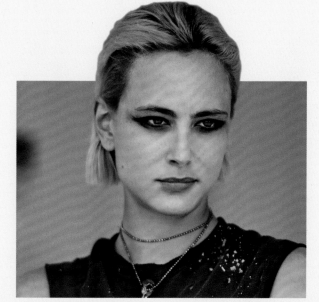

If there's a barrier you need to cross to get into someplace that's forbidden, many people turn to a 'coyote,' a professional people smuggler. If you need to get into zombie Vegas, the coyote you want is Lilly. But why would any sane person want to go into that hellhole? Two reasons: money and desperation.

NOT ONLY A TOUGH COOKIE, SHE'S ALSO GOING THROUGH A LOT IN HER LIFE.

This is especially true of the people stuck in the McCarren Camp Detention Facility, where she's based. They are literally feet from tens of thousands of abandoned slot machines and cash registers.

Having money means a possibility that they can buy passage out of the camp from corrupt guards. "Lilly knows her way into the city," explains Coller, "and knows how to get in and out of there unscathed, and she's become the go-to person when it's time to try and get some cash to get out of the camp."

French-born actress Nora Arnezeder (*Angélique, Mozart in the Jungle*) portrays the enigmatic Lilly, and was drawn in by the moral ambiguity of this woman doing what needs to be done. "When I first read the script, what really jumped at me was this character, Lilly. Lilly was very inspiring for me," says Arnezeder. "She had a lot of interesting nuances that I could explore. She's not only a tough cookie, she's going through a lot of things in her life. I think Lilly made peace with death, and that's the reason she can do what she's doing. She's a survivor."

THIS SPREAD/ Lilly the Coyote (Nora Arnezeder) thrives where others despair.

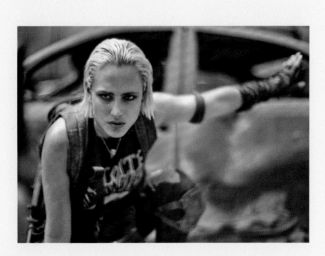

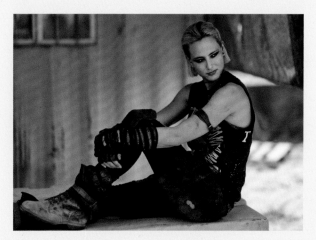

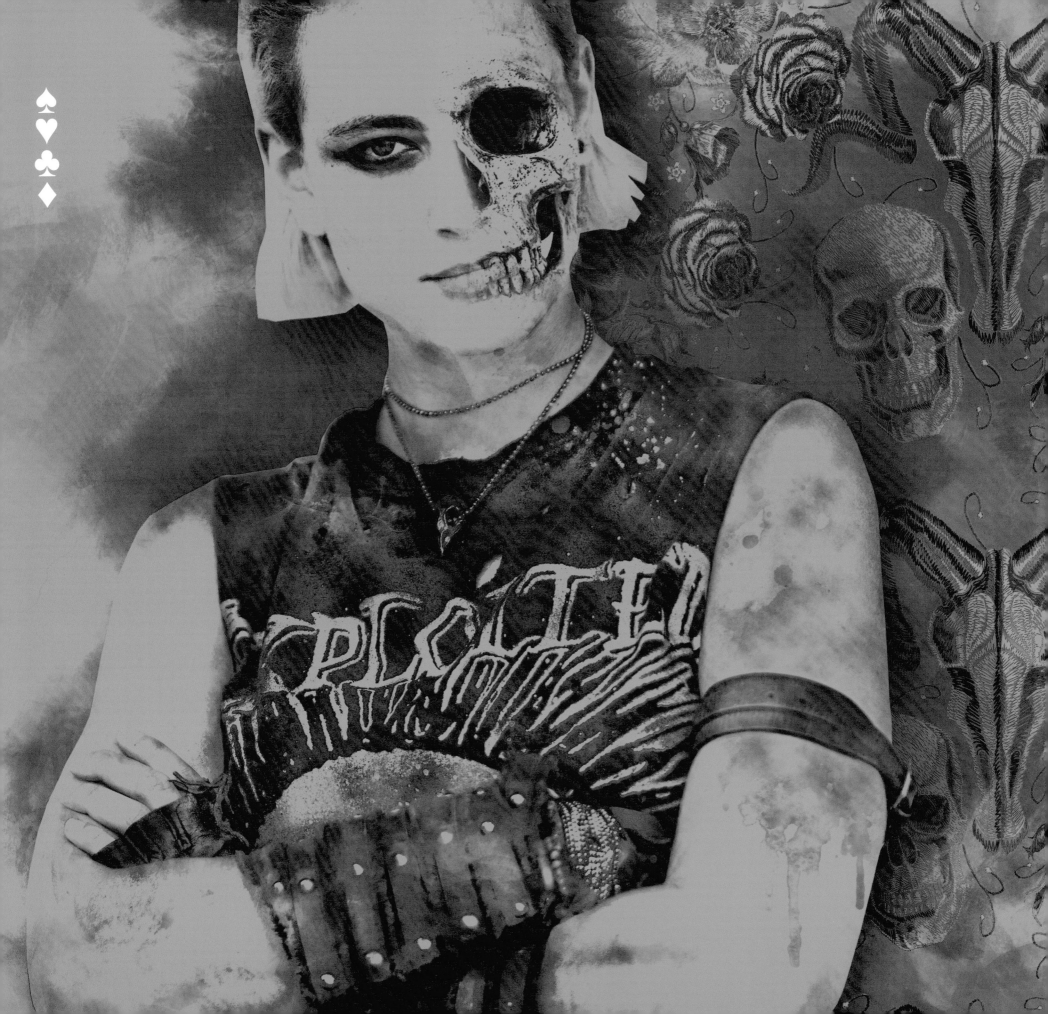

The very location of that training eased them into the correct mind space. "In Albuquerque, outside, they had built this apocalyptic set, where there were flipped-over cars, things were burnt, there were skeletons hanging out of windows," she says. "We got to do part of our gun training there, and it really helped set the tone of the film in our heads, but also made us feel more part of the environment." Chambers brought her own inimitable flair to that environment with her signature P90 submachine gun, with the word 'Babygirl' inlaid in gold.

Strangely enough, the style she and the wardrobe department developed for Chambers ended up having a real-life influence on Win. "I'm not one to wear jewelry. I was so used to training, especially growing up as a martial artist and then as a stuntwoman, it was a nuisance before," she explains. "Now I'm wearing hoop earrings and a bracelet, which for me is a big deal. I really liked that spunk that Stephanie envisioned for Chambers, the not shying away from your femininity, even though you're fighting and falling and slaying. Chambers taught me that lesson. Maybe I'm a little late in life for that, but better late than never!"

THIS SPREAD/ Nothing escapes Chambers' cold, hard stare.

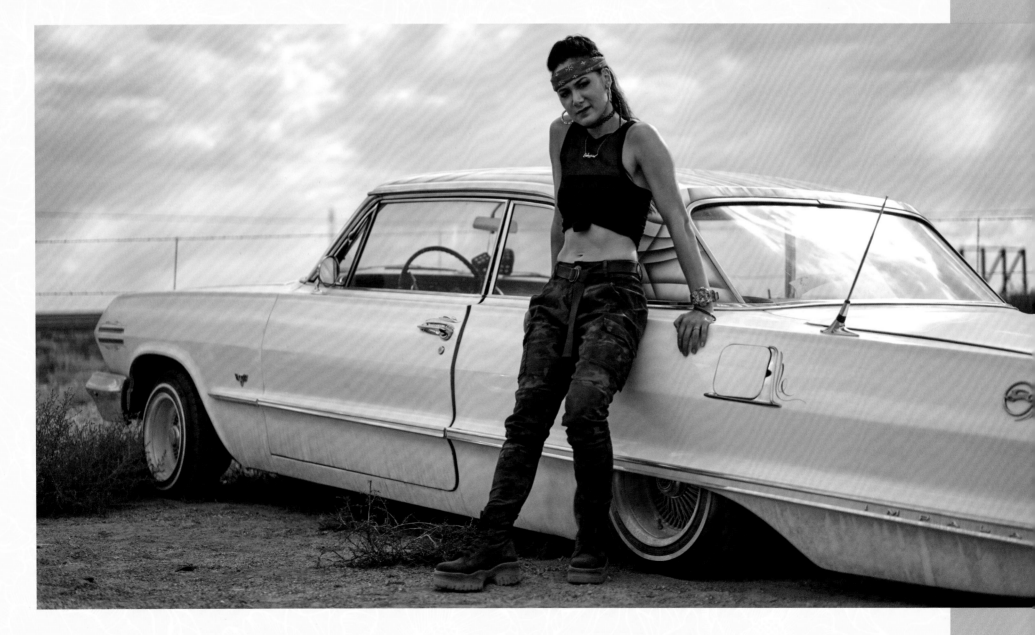

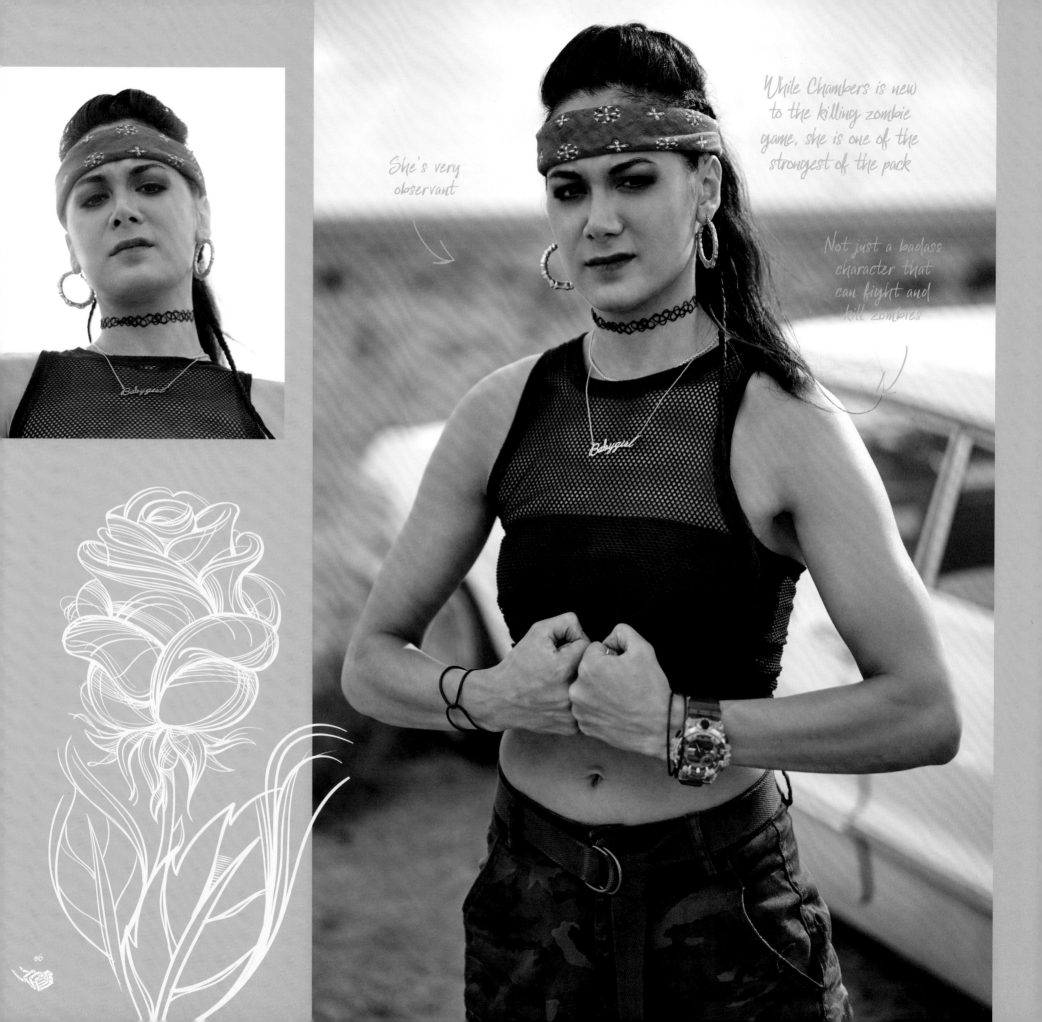

While Chambers is new to the killing zombie game, she is one of the strongest of the pack

She's very observant

Not just a badass character that can fight and kill zombies

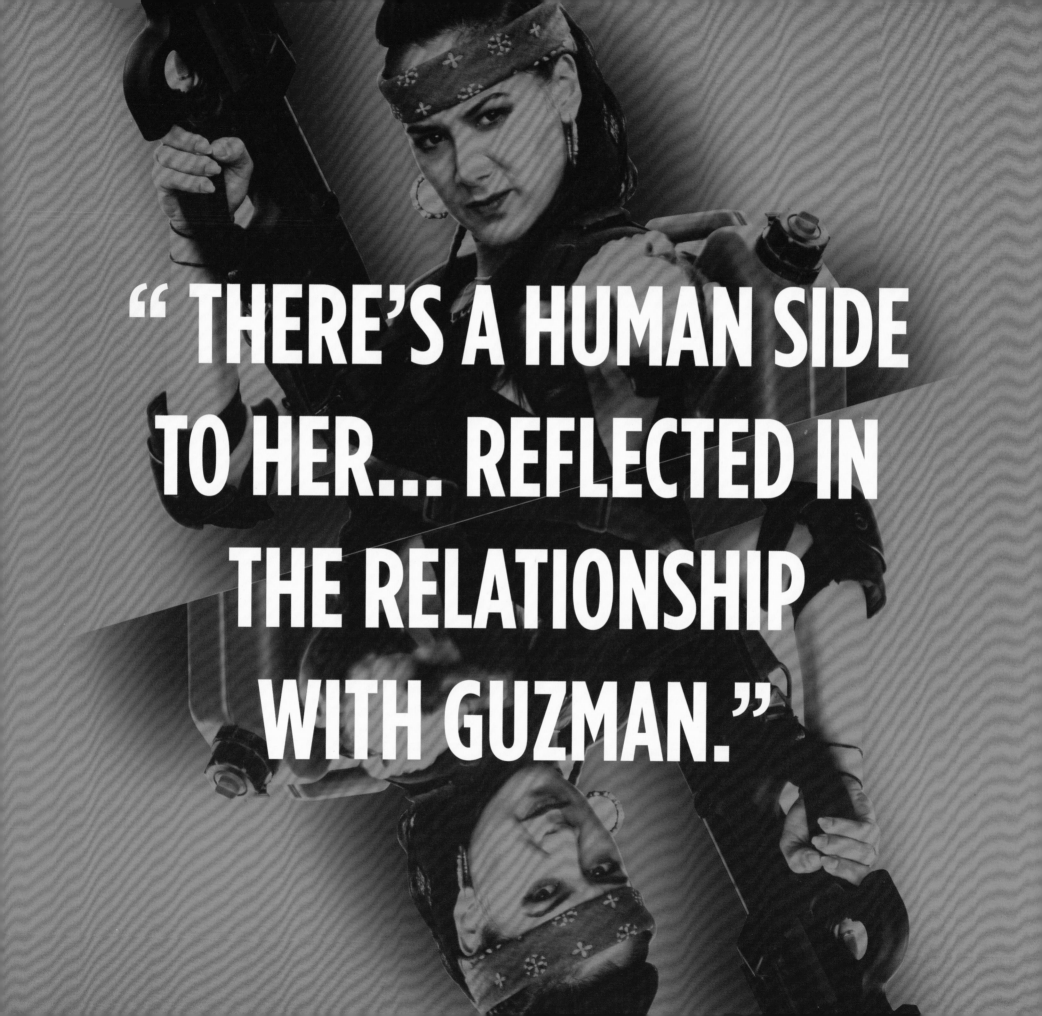

" THERE'S A HUMAN SIDE TO HER... REFLECTED IN THE RELATIONSHIP WITH GUZMAN. "

olds, and she doesn't care. If you've seen young kids gaming nowadays, everything moves so fast on the screen. She's able to catch things a little bit faster. She's very observant, and she plays an important role that way."

Naturally, Win had a leg up on the other actors with her extensive stunt background, as well as her long working relationship with stunt coordinator Wayne Dalglish and second unit director Damon Caro— two other long-time Snyder collaborators. "They're like a well-oiled machine at this point. It's cool. It's fighting with friends," Win says. She really enjoys the mental as well as the physical challenge of fight choreography. "It's so technical and dynamic. It's like a brain puzzle when you're trying to memorize half beats, and you have your knife in a zombie while you're still shooting other zombies. I like the chaotic nature of it. To be able to jump and break through a glass window and then continue fighting on the other side of it. When else would you be allowed to do that?" she says.

Curiously enough, despite her years of martial arts and stunt work on countless films and television series, Win initially found the rigorous firearms training a bit daunting. However, it became an unexpected vehicle for bonding the cast together. "It can be an intimidating thing to pick up a gun or play a character using so many guns. I have three on my person at any given point," she explains. "None of us have served, and none of us have that extensive gun training, so it was nice to learn together, see that no one's perfect. We started flowing with each other and walking beside each other."

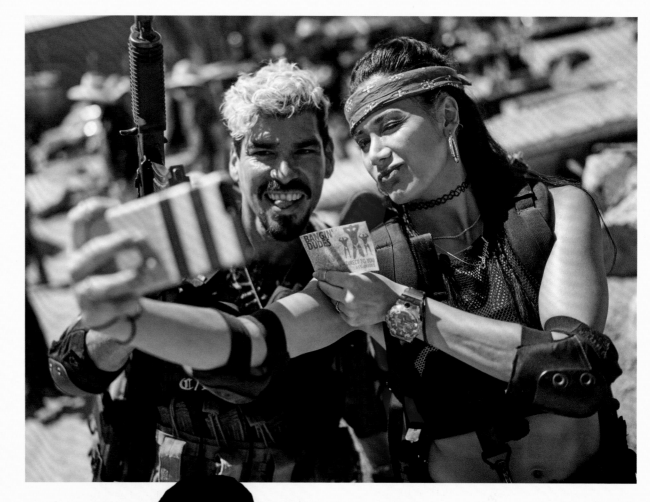

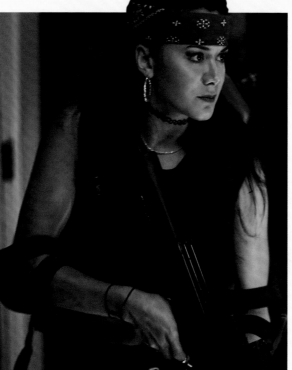

THIS SPREAD/ Chambers takes selfies, but she doesn't take any guff.

CHAMBERS

"I DON'T TRUST ANY OF THESE PEOPLE..."

Although her character is new to Scott's team in the film, Samantha Win (*Agents of S.H.I.E.L.D.*, *Wonder Woman*) is a veteran of the Snyder crew. "Zack and I have actually worked with her since she was seventeen years old," says Deborah Snyder. "In *Sucker Punch* [2011] she was a stunt double for one of our actors. We've seen her grow. She's an amazing wushu athlete, and she also is an amazing actor. She uses both those skills in this film, because she does all her own stunts."

A BADASS... [BUT] THERE'S A HUMAN SIDE TO HER.

The only reason Chambers joins the heist is because she and Guzman are a matched pair. "He brings along his friend, who is sort of his little sister," Castillo explains. "He trained her and she's really great at zombie killing, so they work as a unit." They always have each other's back in a pinch, but even during the quieter moments they can say a lot with very little. "As much as I like to feel part of the team, for Chambers, she's there for Guzman," says Win. "It's nice it's not just a badass character that can fight and kill zombies and wears this cool bandana and has muscles. There's a human side to her, and that is reflected in the relationship with Guzman."

Win concludes at least some of Chambers' reflexes, perceptive abilities, and thick skin came from a background in playing video games. "She's probably one of those girls who can game and hang with the guys," she says. "She's probably on the headsets with the guys and getting shit-talked by eleven-year-

THIS SPREAD/ Chambers (Samantha Win) has a thick skin and quick trigger finger.

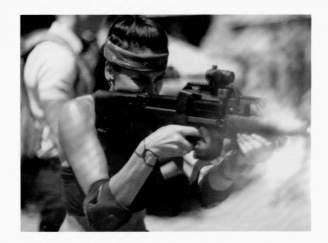

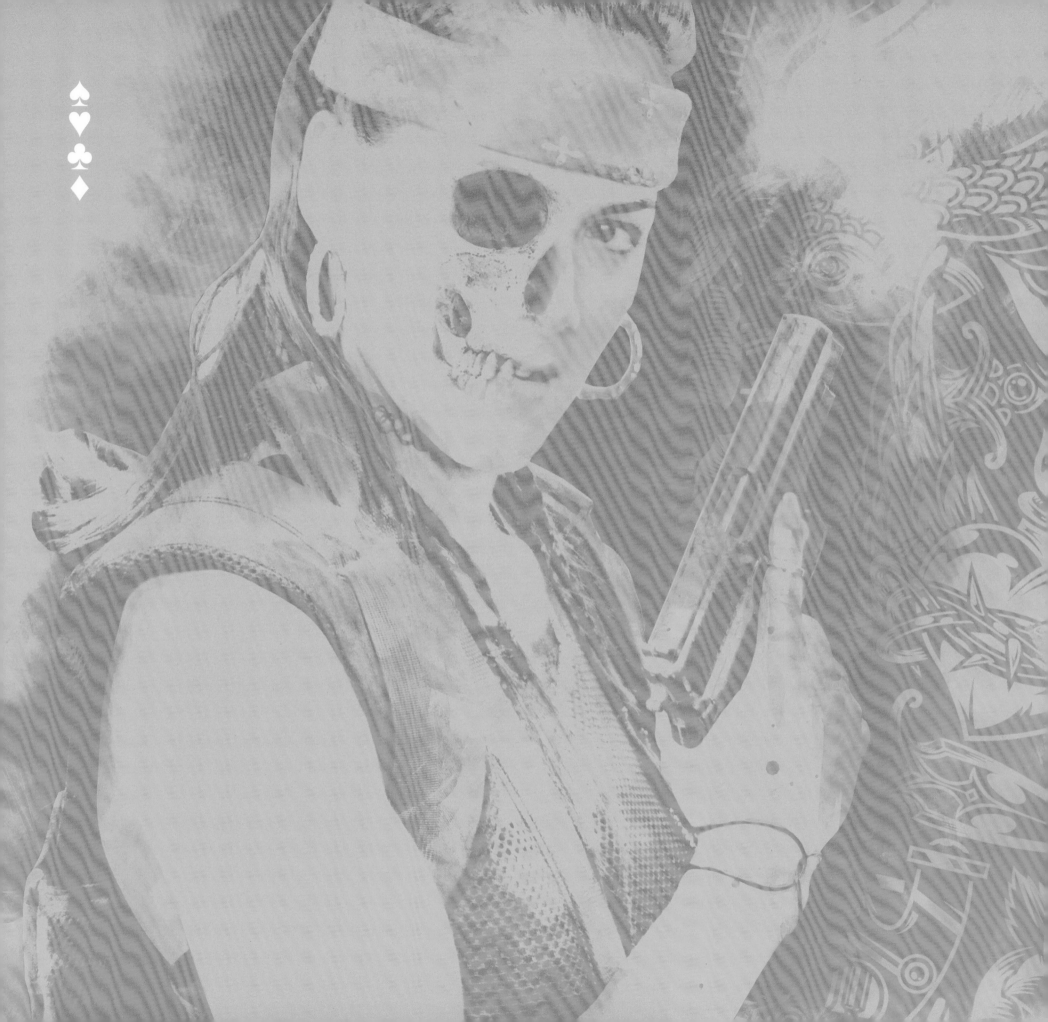

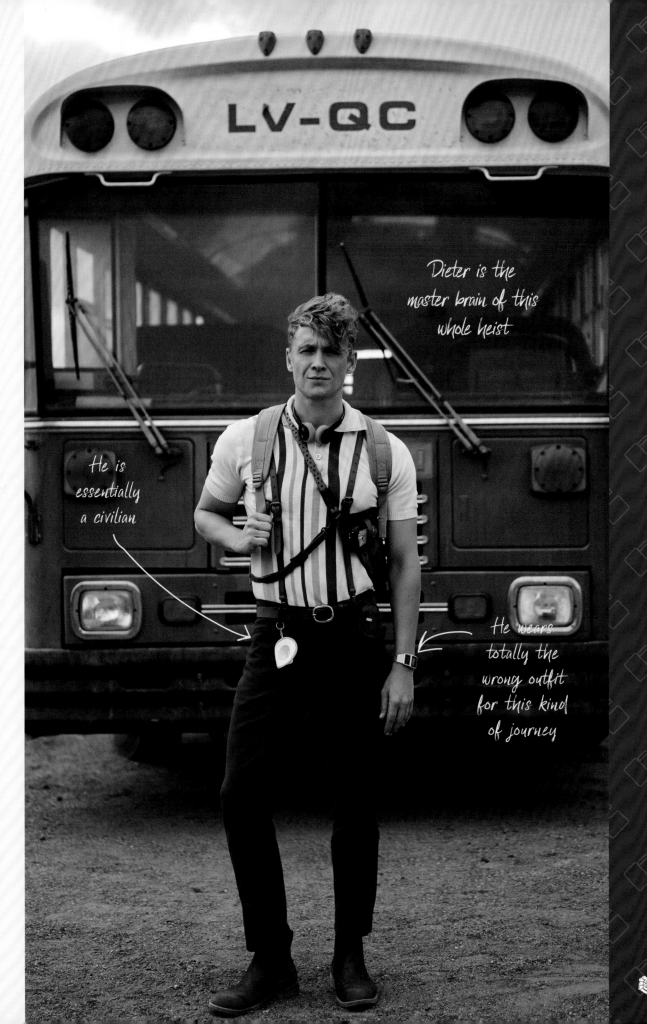

Dieter is the master brain of this whole heist

He is essentially a civilian

He wears totally the wrong outfit for this kind of journey

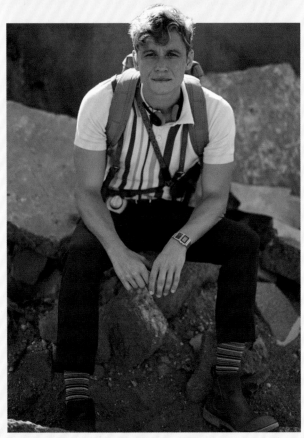

THE WILD CARDS ♦ ♣ ♥ ♠

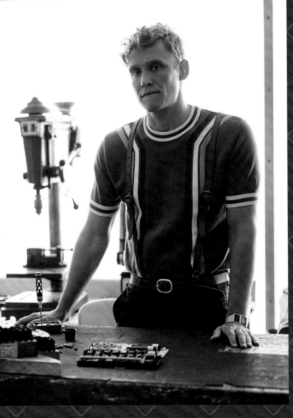

"He doesn't give a beep about killing zombies. All the other people can do that, but no one can crack his safe," Schweighöfer says.

"His safe" is a good way to look at it. The only reason Dieter joined this foolhardy expedition was to have a chance to break into the unbreakable—the almost-mythical 'Götterdämmerung,' the Holy Grail of vaults—and thereby etch his name deeply in the annals of safecracking. "Dieter is going in because it's a challenge. It's nothing to do with the money; he just wants the challenge of breaking into this final safe. It's more about his ego than anything else," says Deborah Snyder.

But first, this delicate newbie must get to the safe alive. Making sure that happens falls squarely on Vanderohe's shoulders, creating a very odd couple. "Dieter is the fish out of water. He's never killed a zombie. He doesn't know anything about zombies. It's Vanderohe's job to keep him safe, to shepherd him through this crazy world, and answer the questions," says Snyder.

Despite Dieter's safety being absolutely critical to the success of the heist, Vanderohe initially is not on board with the role he's been assigned. However, seeing their bromance blossom is a highlight of the film. "Why me? You got all these other teammates and I got to babysit this guy?" asks Hardwick. "This German, bright eyed and bushy tailed, doesn't look like he could bust a grape, let alone pick up a knife and know what to do in battle. That's funny in and of itself. I hope that fans have as much fun watching as we did in playing our relationship. I had a ball playing with Matthias." For Schweighöfer, that relationship with Vanderohe becomes almost familial. "He's my dad, my brother, and my mom," he says.

"What Dieter does for the audience is, unlike all of the other characters who are veterans of this war, Dieter is that person who's coming to this experience with very fresh eyes," explains Coller, "who is equally in awe of the scariness or the craziness or the weirdness. He becomes that person sharing the experience with us as we first enter into this walled-off city." Or, as Snyder puts it, "He is, in a weird way, the audience in the movie."

DIETER LUDWIG

"IF I CAN'T OPEN IT, NOBODY CAN."

Peters' competition for the most important member of the team is Dieter. After all, it does you no good to wade through hordes of the undead if you can't open the vault once you get there. You need a safecracker, and a damn good one. German actor Matthias Schweighöfer (*The Most Beautiful Day, You Are Wanted*) plays the quirky young locksmith, and he was beyond thrilled to get the part.

I'M A HUGE FAN OF ZOMBIE MOVIES... I SCREAMED FOR FIFTY MINUTES!

"I'm a huge fan of zombie movies, zombie games, whatever," he says, "and my agency called me and said, 'OK, you're in.' I screamed for fifty minutes! It

was an amazing feeling. I was super excited, and I just can't hide it."

A nerdy wardrobe went a long way toward conveying the fact that Dieter is essentially a civilian compared to the rest of the battle-hardened veterans. "He is the best-dressed man in this whole film, because he has a very unique style," jokes Schweighöfer. "He's wearing thin brown trousers, and it reminds me of stuff [from the] 70s, 80s in the east of Germany. Totally wrong outfit for this kind of journey." Adept at fashion or not, make no mistake about it: Dieter is quite aware of how crucial he is to the mission. "He feels like the VIP of the whole team," explains Schweighöfer. "We have Scott Ward, a mountain of a man with guns on it, but I think he's not the master brain of this thing. It's me! [Dieter is] the master brain of this whole heist."

THIS SPREAD/
Dieter Ludwig
(Matthias
Schweighöfer):
brain, buddy,
fashion icon.

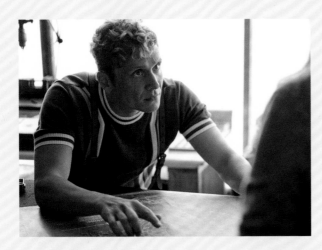

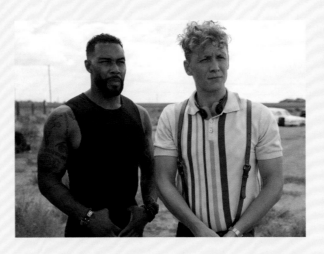

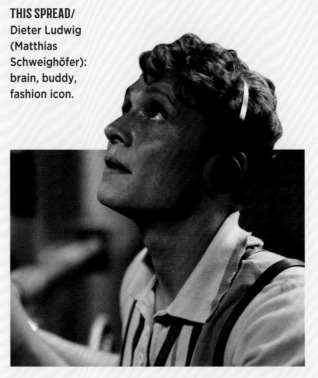

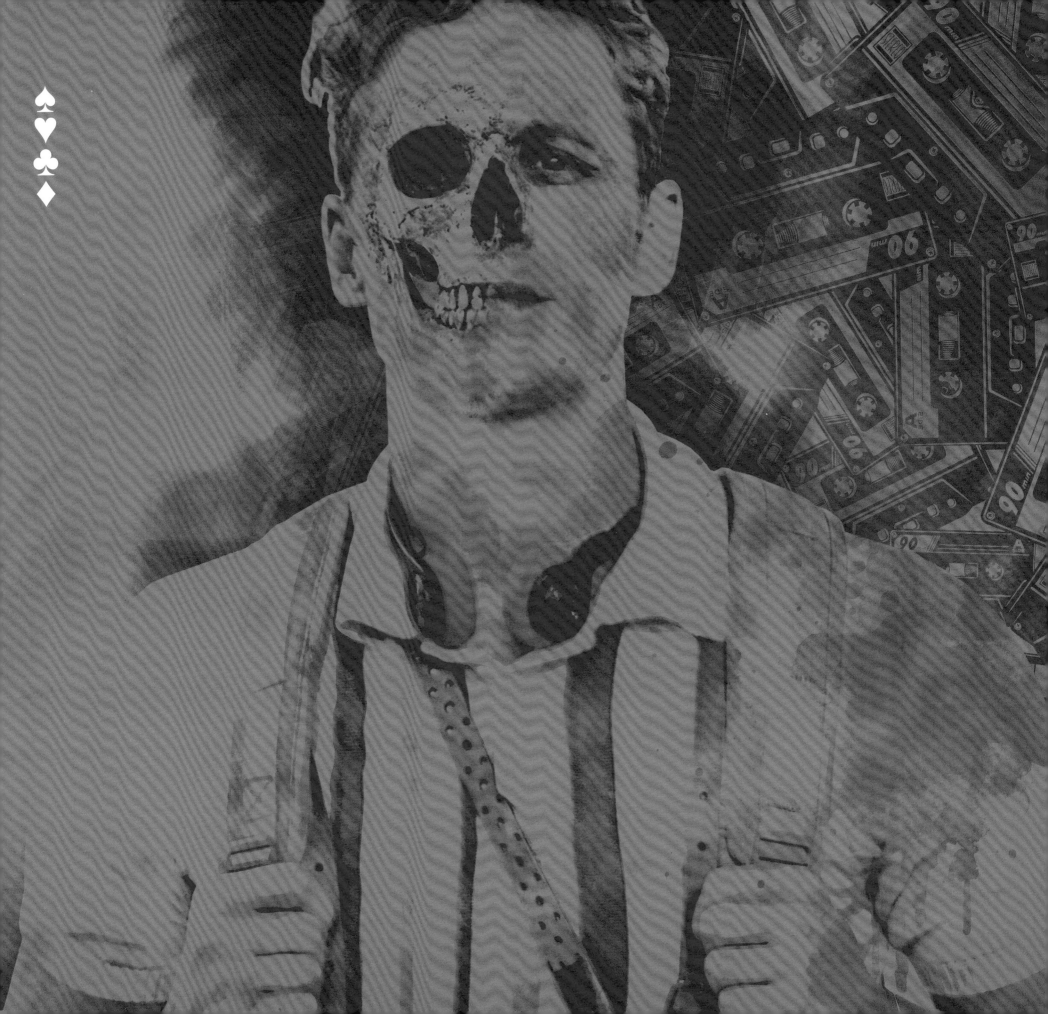

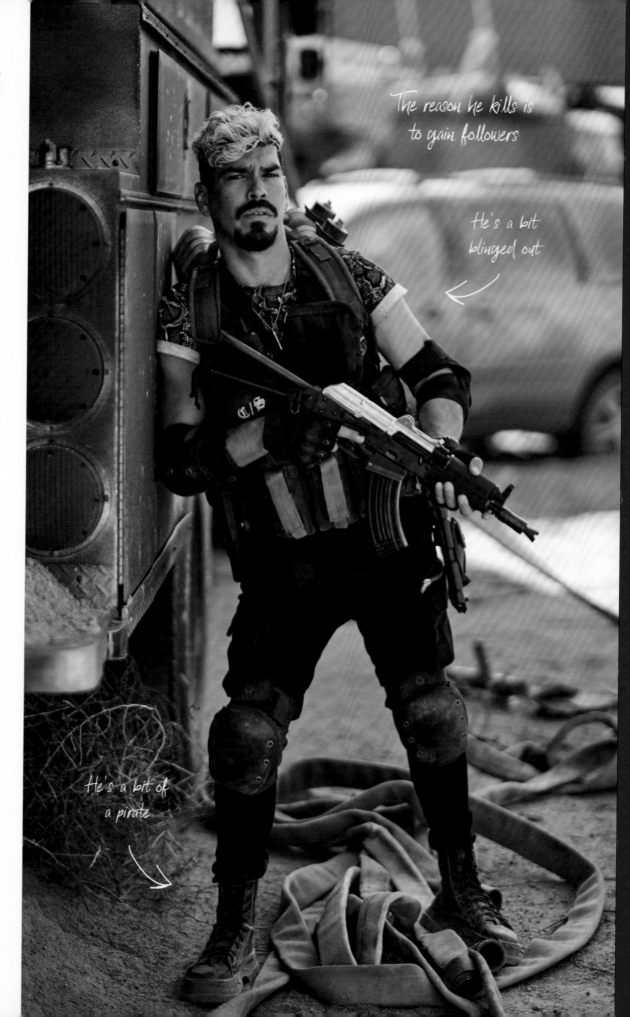

THIS PAGE/ Guzman in zombie Vegas, likely wondering what he's gotten himself into.

THIS PAGE/ Guzman in zombie Vegas, likely wondering what he's gotten himself into.

The reason he kills is to gain followers

He's a bit blinged out

He's a bit of a pirate

this really lovely relationship that we see when he's not taking selfies. It's nice to see the juxtaposition of who we are in our public life, and who we are in our private life. It's really timely."

Coller echoes that sentiment, and gives much of the credit to Castillo. "He proves himself to be much more layered and nuanced than you would first expect. Raúl has been a joy. He's not only a pleasure to work with as an actor, his range is great. He's breathed life into that character in a way that I couldn't have imagined," he says.

Although he admits his first dream was to be a makeup effects artist after watching Rick Baker's work in The Making of 'Thriller' (1983) video when he was a kid, Castillo is now excited to be on the other side of the camera, in the thick of the action. "I've been rehearsing for this movie my entire life, in a sense," he says. "I already imagined these circumstances when I was ten years old in my backyard in Texas, like throwing a grenade, shouting, 'Fire in the hole!' and holding my rifle, and blood flying everywhere. [Now] here I am with Zack Snyder, with Dave Bautista, with Ana de la Reguera, these amazing people, and we get to do this. It just feels really, really lucky that this is my job."

That looting includes grabbing loot on the hoof. Property master Brett Andrews points out something about Guzman and his partner, Chambers, "You'll notice they're wearing very baller custom watches and custom rings. You have a subset group that runs toward zombies, because it's just a paycheck, in the sense of taking their wallets, their watches, their rings—[zombies] are just walking-around bank accounts."

HE'S DEEPER THAN HIS ONLINE PERSONA... HIS TRUE PERSONA IS A LOT SOFTER.

If anyone were to get the idea that Guzman is just a two-dimensional nihilist, however, they would be dead wrong. Over the course of the film, "You see that he's deeper than his online persona," says Deborah Snyder. "His true persona is a lot softer. He and Chambers have

THIS PAGE/ Scott and Cruz get wild-man Guzman on board for their heist.

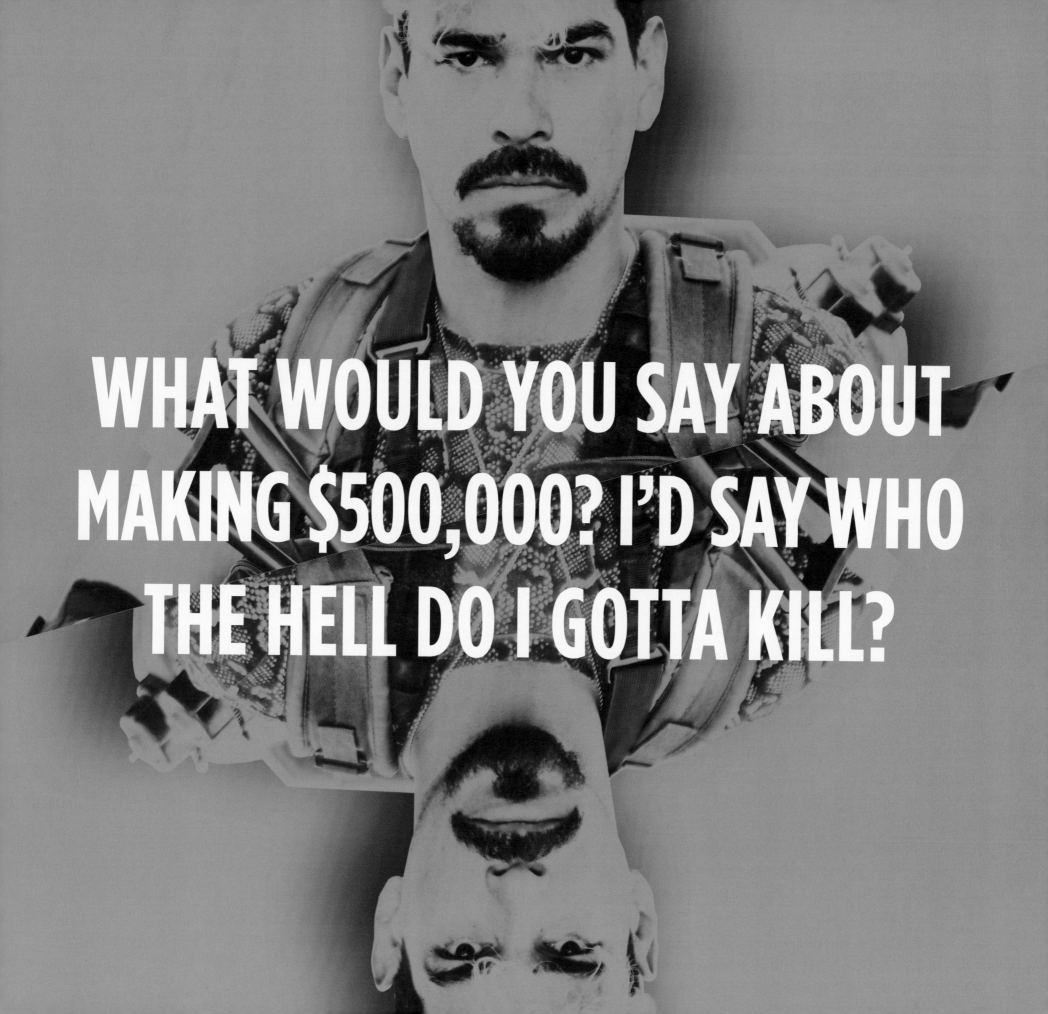

"THERE ARE REDDIT
FORUMS DEVOTED TO
THIS GUY."
MARIA CRUZ

"He comes to this as a super-skilled zombie killer, but in a non-traditional way. In a completely self-taught, outlandish, bombastic, unapologetic way that is grown from internet culture that everyone can relate to," says Coller.

"The zombie apocalypse has taken a toll on him, and I think, as they say in New York, he's wilding out," explains Castillo, "so I try to make some bold choices in order to bring some of that wildness out of him." That wildness extends to his personal style, which starts with a gold-plated AK-47. Castillo describes the look as a "skater or punk-rock kind of vibe, mixed with Southwest. He's very much rooted in my culture, very much a Mexican-American character. My costume for the bulk of the film is this snakeskin shirt, which has these goldish hues to it. I threw out the idea of doing this blond look, and Zack really rolled with it. He's a bit blinged out, [has] a bit of flash to him, because he's a bit of a pirate as well. He's killing zombies and, I think, looting."

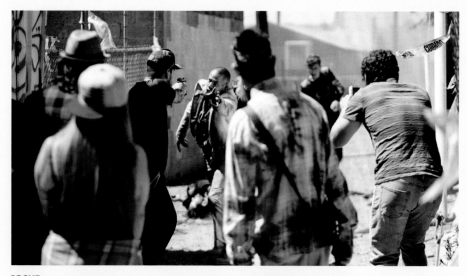

ABOVE/ Guzman attempts to raise his zombies-per-bullet record.

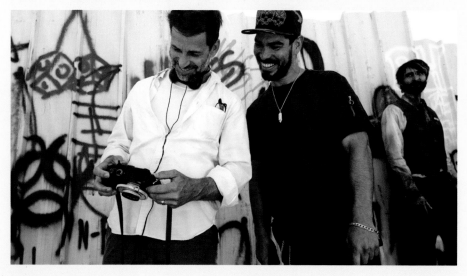

ABOVE/ Castillo and Zack Snyder look at what's been shot.

MIKEY GUZMAN

"CHECK THIS. TEN SHAMBLERS—SIX BULLETS."

Mikey Guzman might be one of the newer members of the crew, but he's certainly no stranger to battling the undead. Played by Raúl Castillo (*Atypical, Knives Out*), Guzman spent the zombie wars like the others, working hard to put down as many zombies as possible. But he did it with style.

THE REASON HE KILLS IS TO GAIN FOLLOWERS.

"Guzman is a man who during the outbreak became a YouTube sensation by finding unique ways to dispatch zombies," says Coller. "He was looking for 'likes' and subscribers when the rest of the team was looking to save humanity."

"His character is definitely a commentary on social media," Deborah Snyder explains. "If we had zombies in our world, you know there would be a ton of people doing Instagram videos and being zombie-famous." Castillo thinks his character stands in the dark nexus between social media, consumerism, and zombies. "The reason he kills is to gain followers. He wants to be famous just for the sake of being famous, which was never something that I was into," he says. "Why are people obsessed with fame? I don't really get it, but my character has his reasons... It's an interesting time to be re-examining this genre."

One of the ways Guzman attracted eyes to his videos was by being over the top and taking risky chances, such as taking out two or three zombies with one bullet.

THIS SPREAD/ Mikey Guzman (Raúl Castillo): marksman, mercenary, influencer.

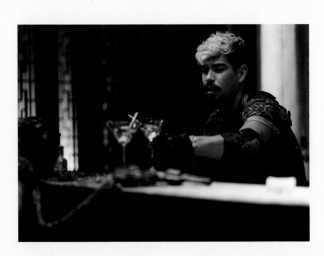

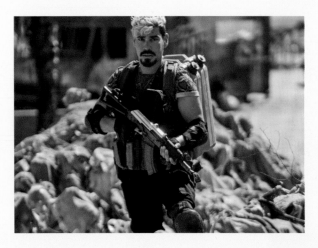

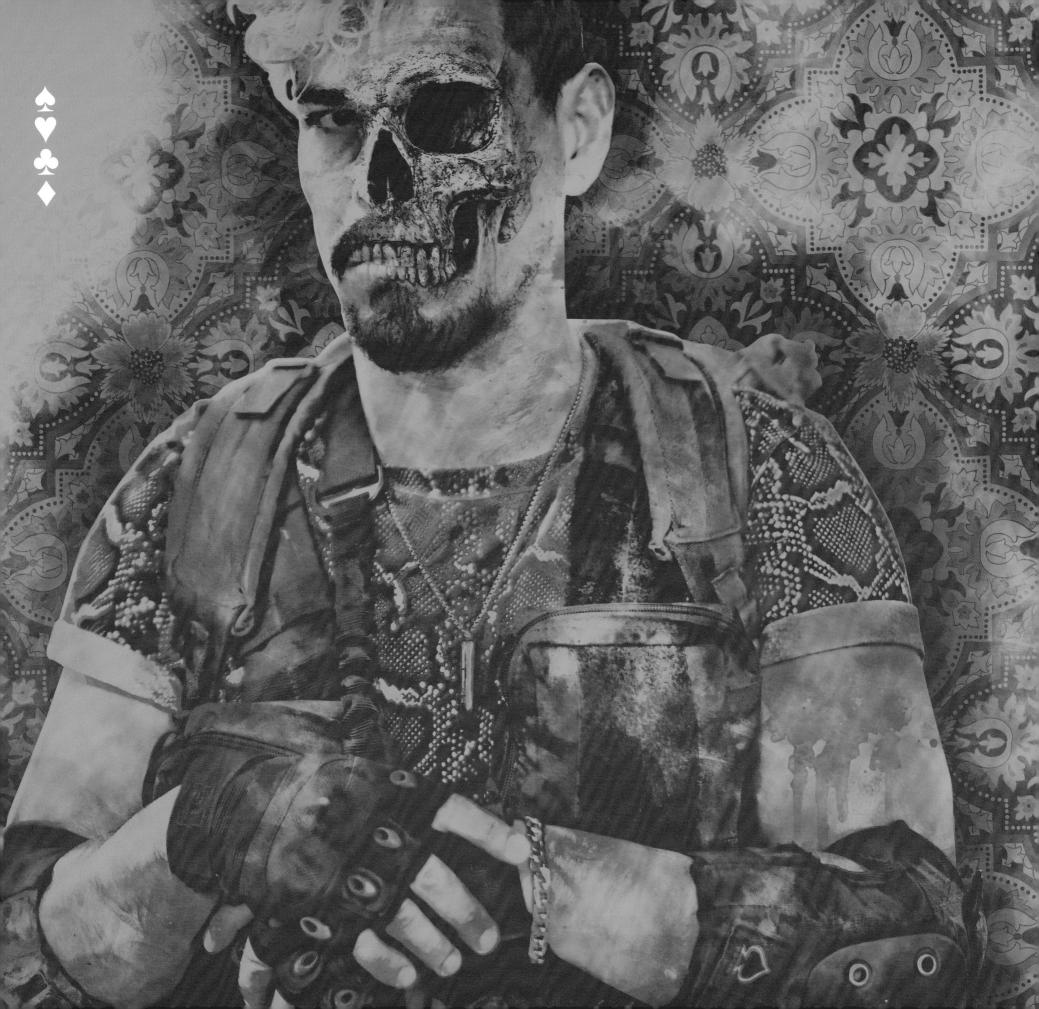

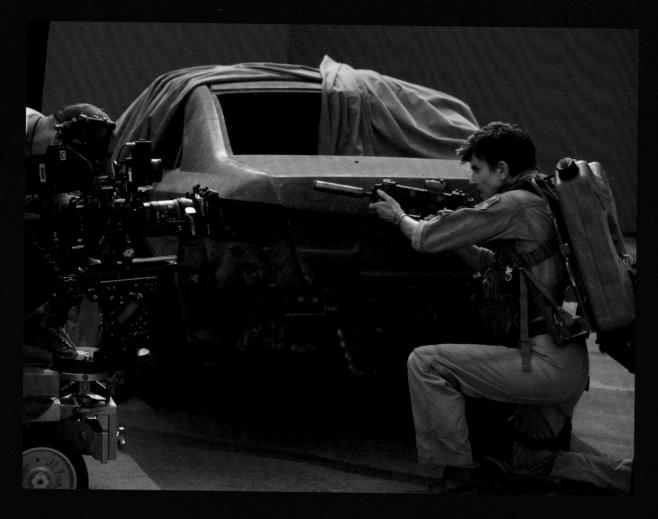

barreled MP7. She also carries a custom skull-embossed lighter from Wicked Zippo Studios.

"Zack, as well as everyone in the wardrobe department, kept telling me how it all seemed to fit my vibe," says Notaro. "I don't think they knew how quickly and easily my look can turn into full-blown Tom Cruise. Especially after someone puts aviator glasses on my face. I'll for sure drop the ammunition and firearms element, but don't be shocked if you see me sporting a flight suit or a dirty old mechanic jumpsuit around town after all this."

Peters' confidence in her abilities might come across as arrogance, but it's definitely earned. "She's very aware of how important she is to the mission, because they've got a limited amount of time and their only way out is on a helicopter and she's the pilot," explains Coller. "Tig makes it really clear, and reminds everybody, that on the hierarchy of people that need to survive the mission for any of them—or a subset, no matter how big or small—to get out, she is an important part of that. Any version [of events] where she doesn't make it to the end, nobody makes it to the end. Her delivery in those moments is a ton of fun."

In addition to her piloting skills, Peters provides something very valuable to the team: her wit. "When we were casting for Peters, we really wanted to get someone who was funny, and who had a dry sense of humor," explains Deborah Snyder. "Zack and I had been fans of Tig for a long time. She offers levity when things are very dire. She breaks the tension, and she allows the audience to take a breath and maybe laugh or just relax a bit, because I think you need that balance."

More than just being funny for funny's sake, "she also becomes the voice of reason in some places," explains Coller. "Tig is the one that points out the absurdity of some of the moments in a way that reflects what the audience, I can imagine, will be feeling in those moments. Like, 'Why isn't anyone saying that?' She's the person that says it."

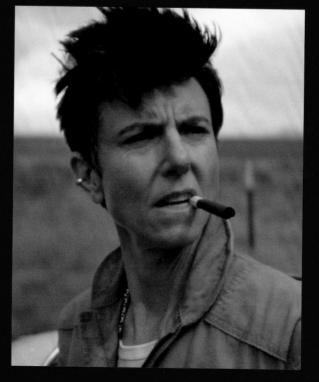

THIS SPREAD/ Peters shoots bullets, as well as one-liners.

Finding out the full extent of her role in the action—and how much ordnance and gear she'd have to carry—was a bit of a surprise to Notaro, but she embraced it. "It was my understanding that Peters was simply the getaway helicopter pilot. I had no idea I would be in the middle of it all and decked out head to toe in ammunition and firearms, with a huge gas can strapped to my back. I was honestly stunned. However, the second I put all that gear on, it felt right. And oddly exhilarating," she says. For personal defense in close quarters, such as a cockpit, Peters carries a short-

Peters has nothing better to do than join the heist

She has a very dry sense of humor

She's very aware of how important she is to the mission

MARIANNE PETERS

"LET ME GUESS, IT INVOLVES A CHOPPER?"

Sneaking into a city filled with the undead is one thing, cracking an uncrackable safe is another, and getting out alive is a whole other thing entirely. Luckily, after all these years, there's still a helicopter perched atop the roof of Bly's Las Vegas—you just need some fuel and a pilot crazy enough to sign up for this harebrained scheme.

SHE'S JUST, 'MY LIFE SUCKS. I'M GOING IN. I HAVE NOTHING BETTER TO DO.'

That's where Marianne Peters comes in. Played by comedian Tig Notaro (*One Mississippi, Transparent*), Peters had worked with the Las Vengeance crew on more than a few occasions back in the day, flying them in and out of rough situations.

When it comes to the question of whether to join her old comrades for this last mission, Peters doesn't even have to think about it—but nostalgia has very little to do with it. "All the characters have a deep motivation for going on this journey into zombie-infested Vegas," says Deborah Snyder, "but for Peters, she's just, 'My life sucks. I'm going in. I have nothing better to do.'"

Notaro agrees that boredom was a factor for her character, but not necessarily the only one. "Scott and Cruz find Peters down and out, working a less-than-glamorous job as a helicopter mechanic. Peters is motivated to join this insane mission because she is broke, hates her life, and maybe is looking for excitement—possibly camaraderie, but she'd be the last to admit it."

THIS SPREAD/ Marianne Peters (Tig Notaro): mechanic, pilot, fighter—and smartass.

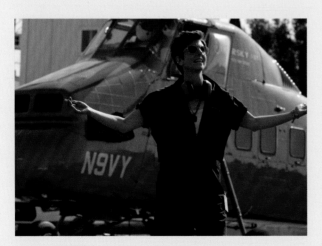

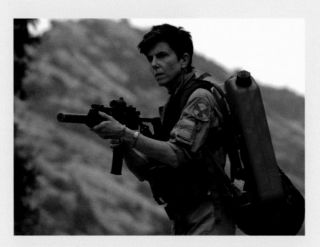

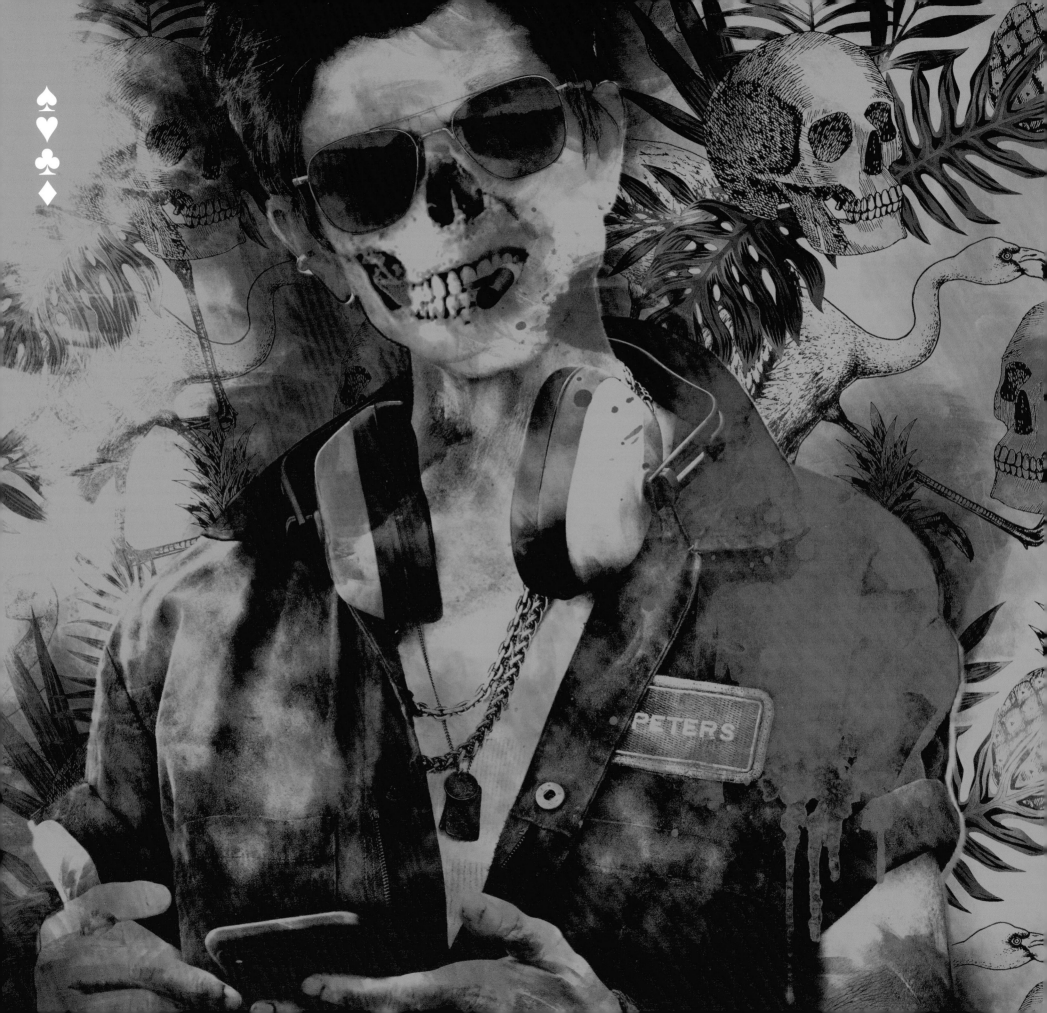

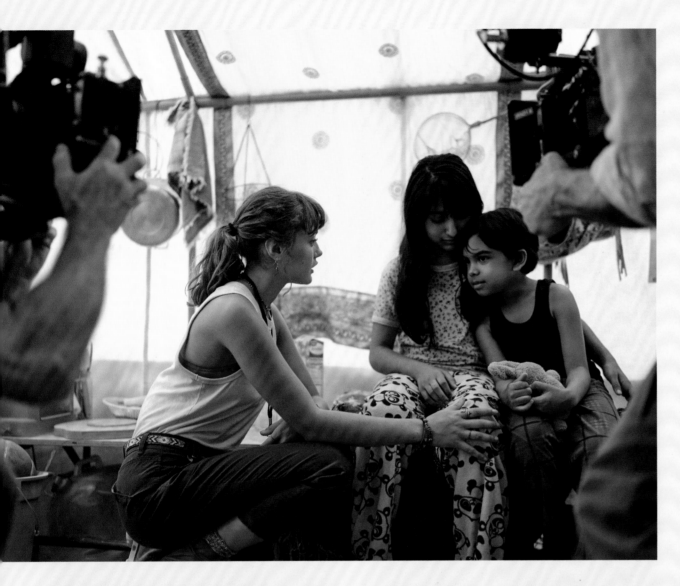

When she started collaborating with costume designer Stephanie Portnoy Porter to develop Kate's look, Purnell had strong opinions on the matter. "You can't fight crime in heels, and you can't do it half naked," she explains, "and so when we had our first call, I was like, 'I'm not wearing shorts.' And she was a hundred percent on the same page. She was like, 'No way! We're not putting you in shorts.'" Practicality became the watchword.

"What would you wear if it was a million degrees and you were working hard and trying to kill zombies? Well, you probably wouldn't wear a little crop top and shorts. You'd wear something dirty," Purnell says. She also points out that they added little touches to bring out Kate's essence: "We kept all my own tattoos, and we gave her little charms, some bracelets and rings, and a little multicolored necklace one of the kids [in the camp] might have made her. That's a huge help for me in building my character."

However, just teaming up with her dad and killing zombies is no guarantee that father and daughter would truly reconnect, which is Scott's ultimate wish. "It's his desperate attempt to get her back in his life, because he's gotten to this place where he has nothing," says Zack Snyder. "The movie, in the end, is about them finding common language and common ground. A heartfelt story about a father and daughter connecting. You take that and put it at the heart of your crazy zombie movie, and it holds the whole thing together."

Producer Wesley Coller feels Purnell was instrumental in grounding that relationship in reality. "Ella's great in that she brings a sure-footedness to a character that has to go toe-to-toe with a big presence such as her father, Scott. Her performance matches his in terms of weight," he says. "What is ultimately a must when it comes to a movie like this, where Scott is seeking reconciliation with his daughter, is for her to have a presence which is believable as she shuns his first outreaches, but then is also nuanced enough as her guard comes down and that relationship starts to heal. Her range has been invaluable in making that a believable arc."

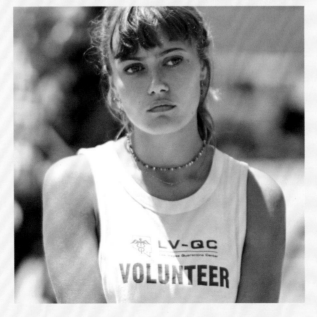

THE WILD CARDS ♦♣♥♠

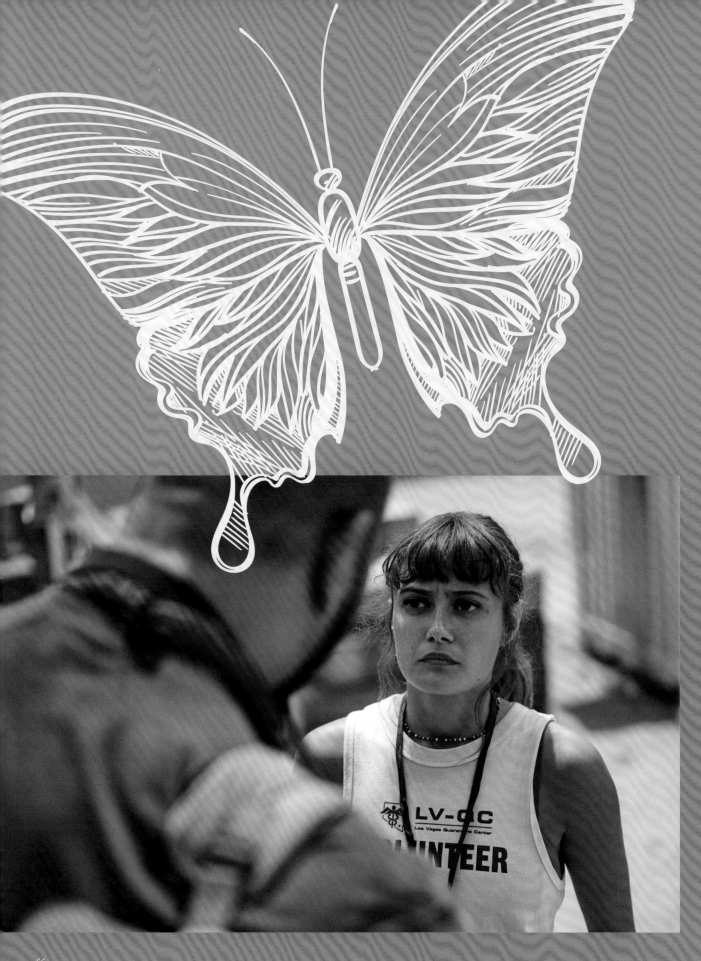

"You can go in [to Vegas], crack a slot machine and get some money, and buy your way out of the camps," explains Purnell, "and that's what Geeta wants to do, because she wants to guarantee financial security for her kids. She had planned to be in and out in twelve hours, but she hasn't come back. My whole motivation is I want to go and find her and let those kids have a mother. Obviously, there's personal reasons involved—I lost mine—but also, she's my only very close friend."

One does not simply jump into a zombie-infested city without training. Like de la Reguera, Purnell found the gun training a bit challenging at first. "I'm British. The gun thing was weird, because obviously I'm just not exposed to that," she explains. "We had zombie-killing camp, which is learning how to handle a gun, the right way to hold it, target practice, and stuff. It was really fun to do stunts and practice, choreograph all the fighting. I learned a lot."

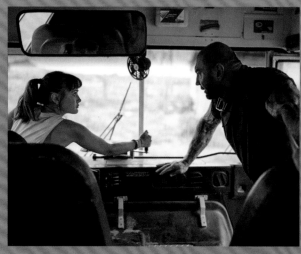

THIS PAGE/ The father-daughter conflict flares up.

NEXT PAGE/ (Top) Kate comforts Geeta's kids, Angela and Adjit. (Bottom) Don't let the soft exterior fool you—she's a fighter.

 ♠ ♥ ♣ ARMY OF THE DEAD

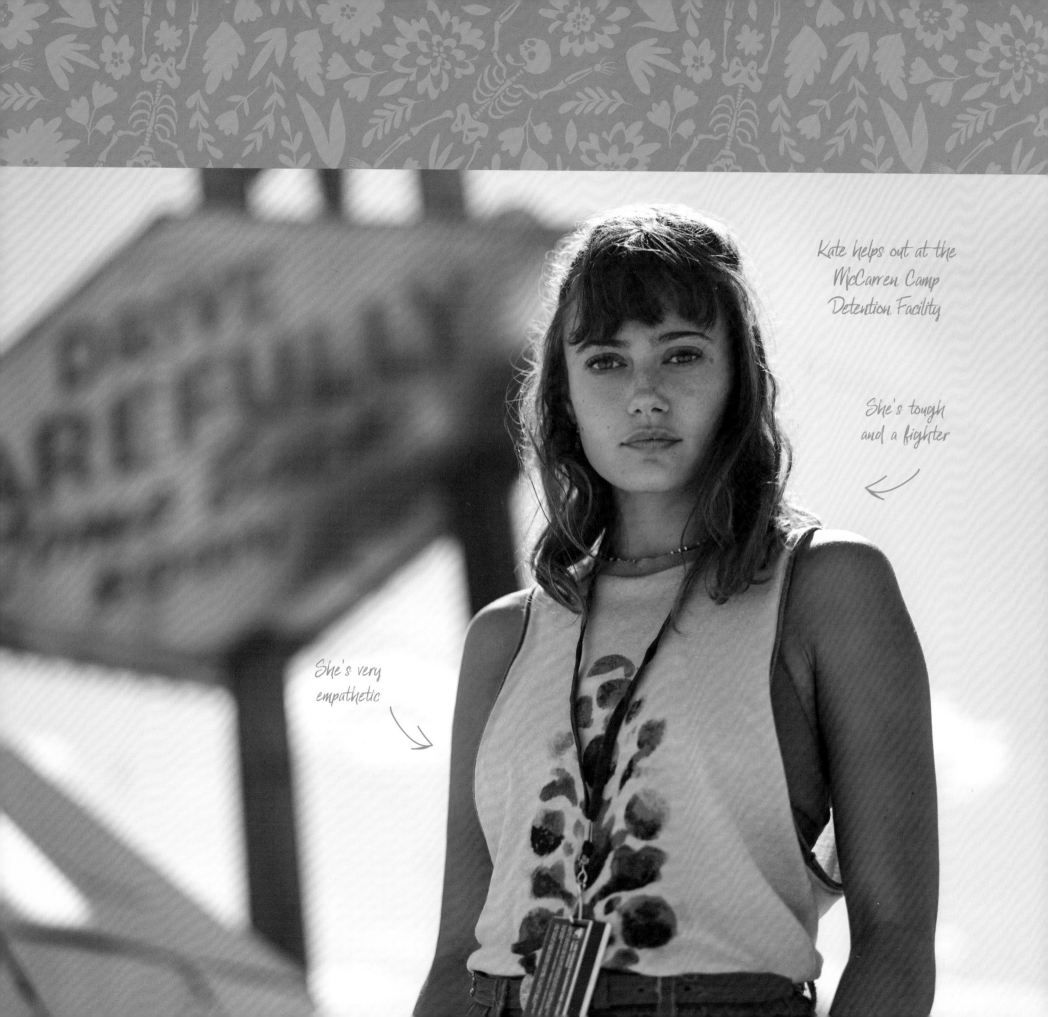

Kate helps out at the
McCarren Camp
Detention Facility

She's tough
and a fighter

She's very
empathetic

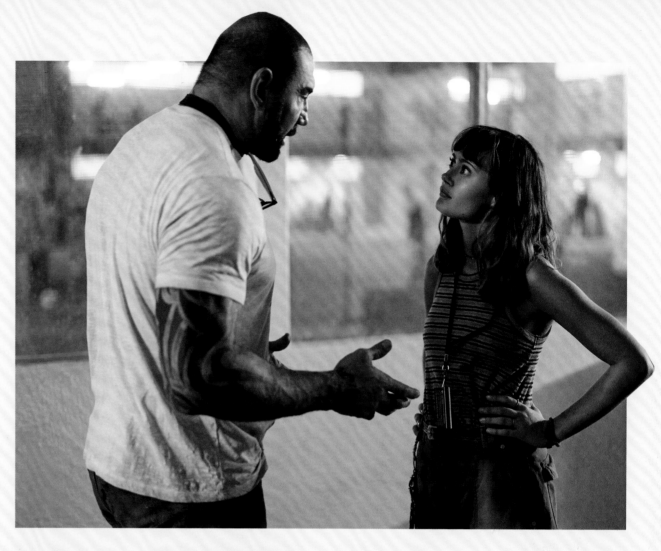

"The quarantine centers are basically refugee camps. They [contain] people who were in the surrounding areas when the outbreak occurred, who aren't actually infected, but they live close enough to say that you might be at risk of infection. [People] are held in these camps and unable to leave. Guards have thermometers and can tell if you've dropped a couple of degrees or raised a couple of degrees, and put you in isolation or just disappear you. It's a big political issue. It's obviously a big human rights issue," Purnell says.

With that as a backdrop, it's perhaps surprising that the camp provides Kate with a sense of home, something she hasn't felt in a long time. "Obviously that is emotionally quite a traumatizing situation, seeing these kids who have been abandoned by their parents or lost parents in the wars," continues Purnell, "but that's where she finds her real family—the people that she shows up for, and that do show up for her." Kate's closest bond in the camp is with a single mother named Geeta and her two children. It is Geeta's disappearance during a foray into Vegas that causes Kate to piggyback a rescue mission onto her father's heist.

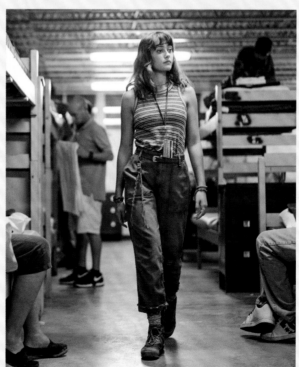

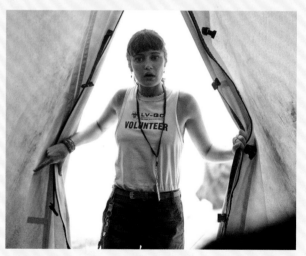

THIS SPREAD/ Kate is not thrilled with her father interrupting her work at the camp.

KATE WARD

"IF I HAD THE MONEY... I'D HELP THE PEOPLE HERE."

Played by British actress Ella Purnell *(Kick-Ass 2, Miss Peregrine's Home for Peculiar Children)*, Kate's young life turned upside down when the zombie outbreak occurred and her mother was turned. Scott was able to save his daughter, but at a terrible price.

HER WAY OF FIGHTING WARS IS FOR JUSTICE, PEOPLE'S RIGHTS AND EQUALITY.

"She's about sixteen or seventeen when she has to watch her father kill her mother, which is quite a traumatic thing to go through," explains Purnell. "He can't really look at [Kate], because she reminds him of her mother. He ships her off to her grandparents,

basically abandons her completely, while he goes off to fight the zombie wars."

Since the outbreak, Kate hasn't finished high school, let alone gone on to college. Even if she wanted to, she doesn't have the financial wherewithal to pursue any further education. But like her father, she's tough and a fighter. However, as Purnell tells it, "Her way of fighting the wars is for justice, for people's rights, and equality. She's very empathetic. She volunteers at the Las Vegas Quarantine Center. I like Kate's spirit. She's a feisty one."

Specifically, Kate helps out at the McCarren Camp Detention Facility, which sits right up against the wall of containers around infected Las Vegas. It's in an area where the U.S. Constitution has been suspended, and she sees firsthand that the way the camp is run is not wholly benign.

THIS SPREAD/ Kate Ward (Ella Purnell) lives to help others at the McCarren Camp Detention Facility.

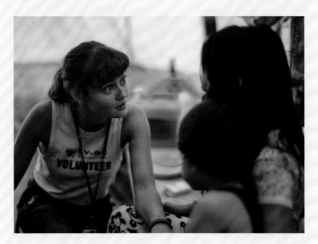

 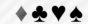

Even with the addition of Martin, Scott's crew required a few other bodies to fill it out. Some were needed for their special skills, some were needed for their muscle, and others joined out of necessity. Everyone had their own reasons for signing up for what looked to be a suicide mission. Sure, most had dollar signs in their eyes, but not everyone.

Casting for these roles continued the diverse, global flavor that had gone before. "We have an amazing international cast in the film," Zack Snyder points out. "We have actors from Japan and Mexico and India and Germany and France and America. We didn't shy away from having these disenfranchised [characters] of the world making their way to this fringe of society where they become these zombie hunters."

"People want to see films about themselves," explains producer Deborah Snyder, "and what's great about this film is it's really organic to the fabric of it—it's not forced. We have characters from all over the world and from different walks of life, and just as many strong female characters as their male counterparts. So, there's someone you can relate to."

CARDS

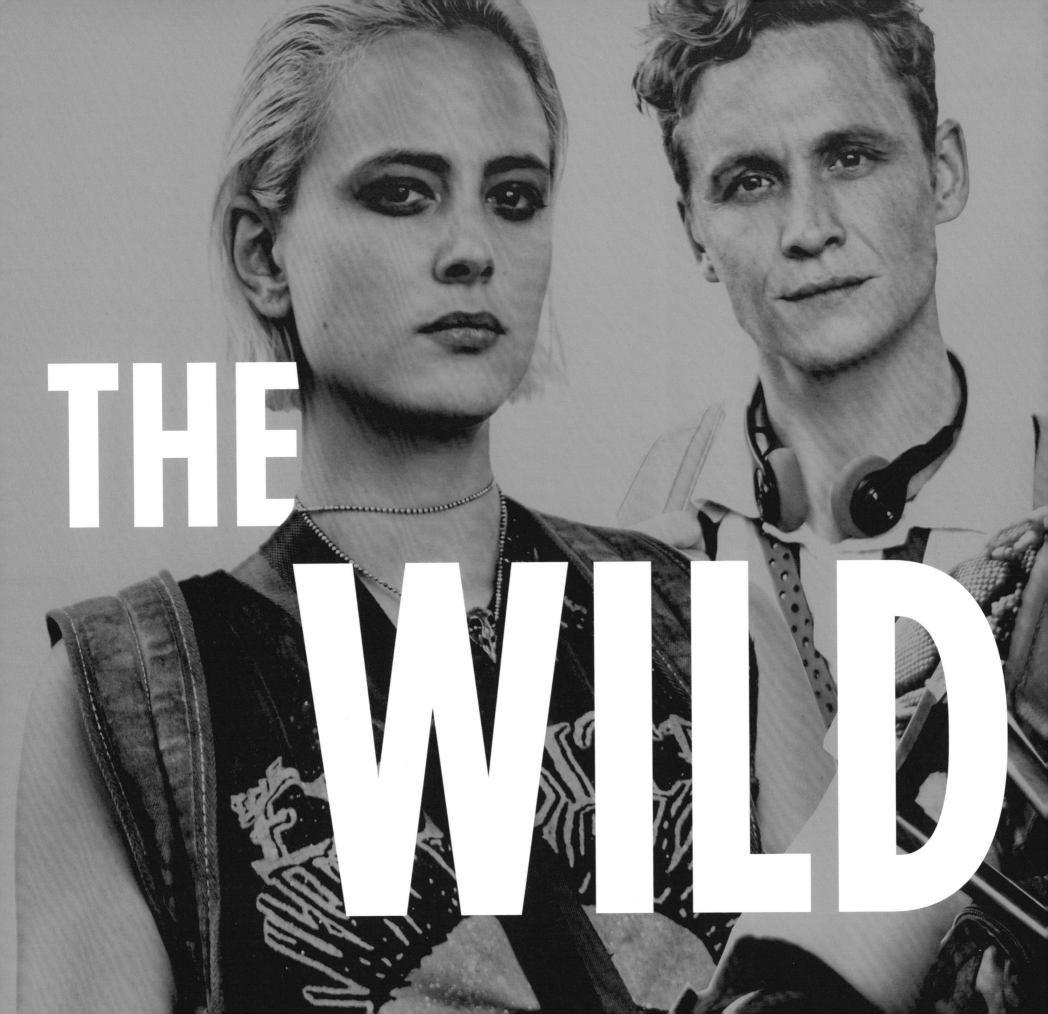

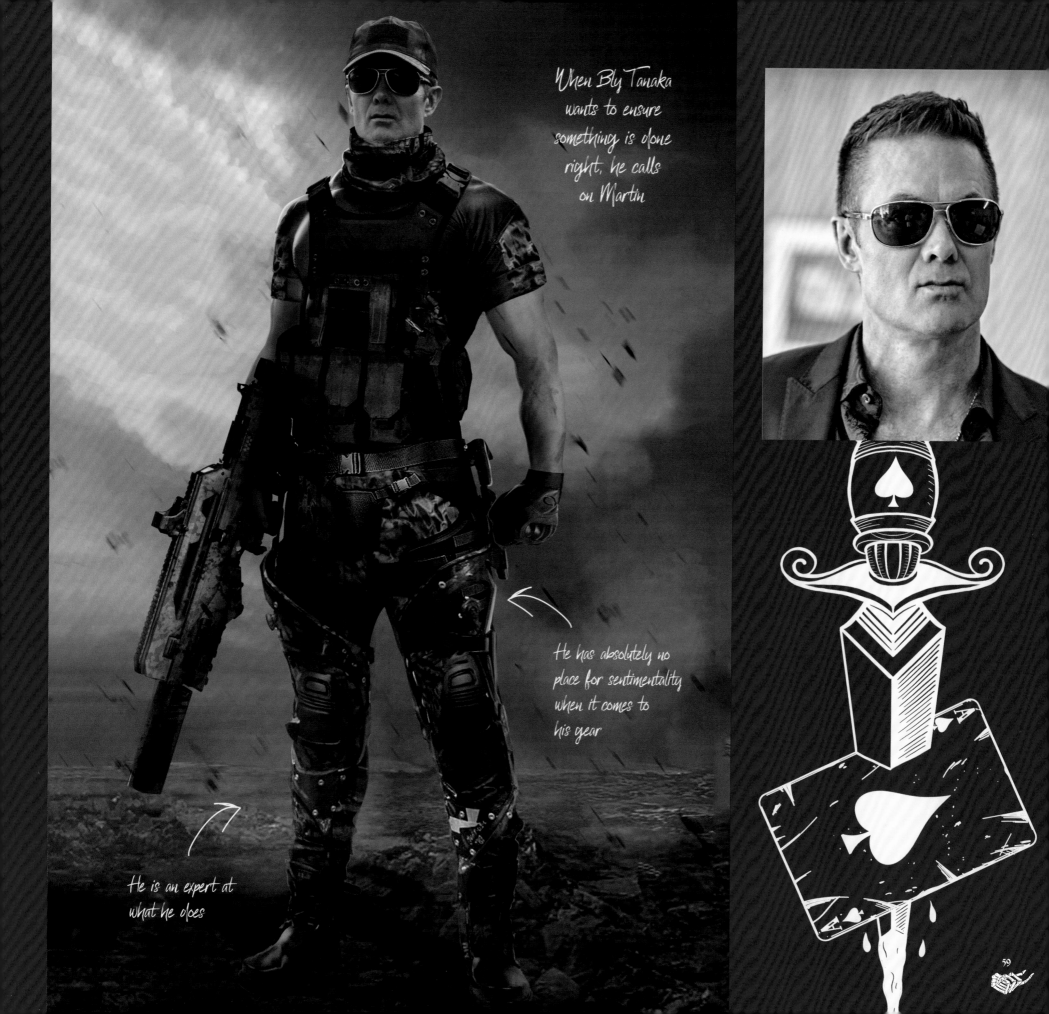

When Bly Tanaka wants to ensure something is done right, he calls on Martin

He has absolutely no place for sentimentality when it comes to his year

He is an expert at what he does

to the vest, but he also doesn't spend a lot of time trying to make friends or ease anyone's concerns."

Dillahunt agrees with that assessment of his character and how he plays with others. "Martin doesn't care. He's a little douchey," he says, "but what saves him—if he can be saved—is he is an expert at what he does. He's good at it."

Another thing that sets Martin apart from the rest of the gang is his look. He has absolutely no place for sentimentality when it comes to his gear. Functionality and efficiency are all that matter. Dillahunt explains, "The other team are like, 'This is my lucky vest that has got me through three tours.' Martin's is the latest [gear]. I'm all in black camo. He has the latest tech, the biggest gun, the most stuff. He can shoot a bolo out of his grenade launcher. I could have waged a one-man war with that thing."

Of course, if you're playing a tough guy like Martin, it helps to have the physicality to pull it off and not rely completely on stunt performers, and Dillahunt definitely has what it takes. "They let me do a lot of my own stuff, or at least do a few takes of it. It's kind of gnarly," he says. "I had never done a lot of wire work before, and I'm getting tossed around. It's me on lots of ropes. I've got [bruises] all over from the harness and being slung around," he adds, "but I'm proud of it. I think it's gonna help give Zack a lot to cut around to make it look really violent."

What Dillahunt found surprising was a director who was his equal in terms of physicality and who could personally demonstrate the moves he expected from his performers. "What's annoying about Zack as a director," he jokes, "is he's a very athletic person. [He'll] walk up and say, 'So, here's what you're gonna do. You're gonna do this. You're gonna scale this wall like this. You're gonna take a look at this thing and then toss it over your shoulder and it's gonna go right in the bin.' He'll do it in one attempt—so you know it's possible. It was very annoying to me."

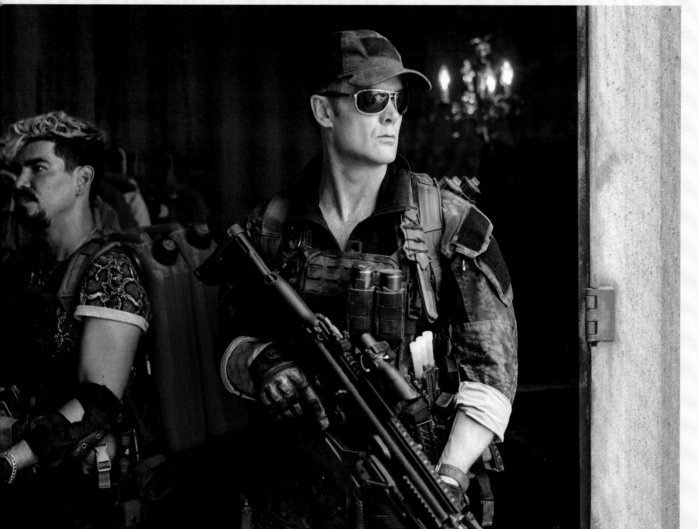

PREVIOUS SPREAD/ Martin (Garret Dillahunt) has a different plan to the others.

THIS SPREAD/ Martin is always alert, always professional. Concept art by Marco Nelor.

MARTIN

"THE HELL YOU GUYS LOOKING AT ME FOR?"

When Bly Tanaka wants to ensure something is done right—and this mission is no exception—he calls on Martin. Garret Dillahunt (*Raising Hope, Fear the Walking Dead*) describes his character rather simply: "Martin is Mr. Tanaka's head of security. He's been with him a while. He's kind of his bodyguard. He likes his sunglasses."

EVERYBODY WONDERS WHAT HIS PURPOSE IS.

"The reason why they say he's coming is because he has knowledge of the casino," says Zack Snyder. "He knows where the safe is. He has all the key cards. He knows all the access codes. He's like their spirit guide through the maze of the casino."

Still, Scott and his tight-knit crew are unsure what to think when Tanaka springs this last-minute addition to the team on them. "They were a little surprised, a little taken aback," says Dillahunt, "because they're used to working together. They don't need some random element thrown in there. So, it's not greeted with love and affection, but I think they understand that he'd be a great guide."

"Everybody is skeptical of him. Everybody wonders exactly what his purpose is. None of them seem to feel like his intentions are good, and so there is an air about him," says Wesley Coller, who remains vague whether those suspicions are valid. "The fun of watching Martin on this journey is, at no point does he seem apologetic or concerned with what they think of him, or [show] a need for acceptance. Martin clearly has a 'why' of being there, and keeps it close

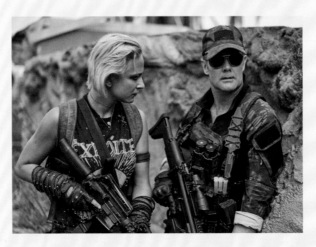

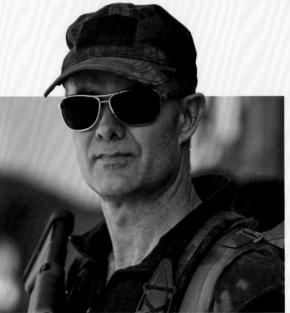

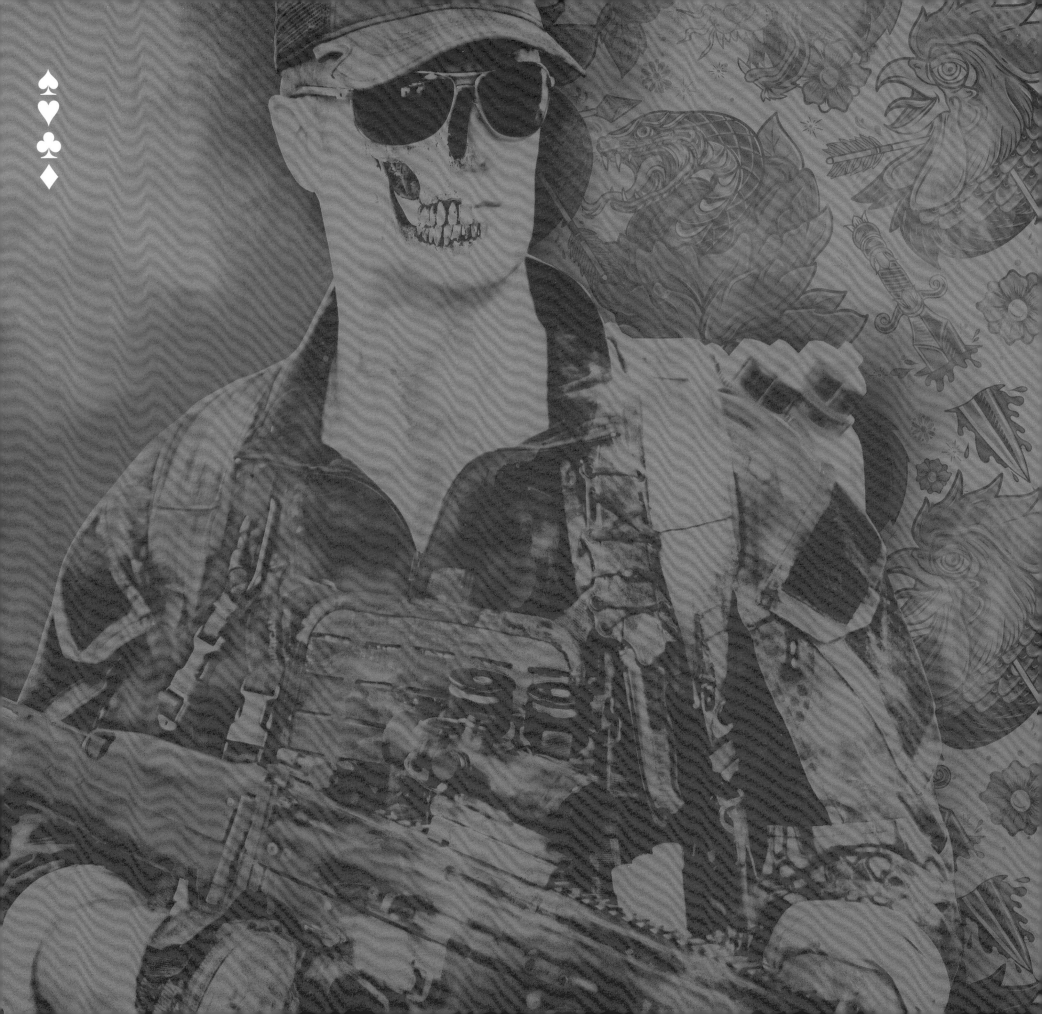

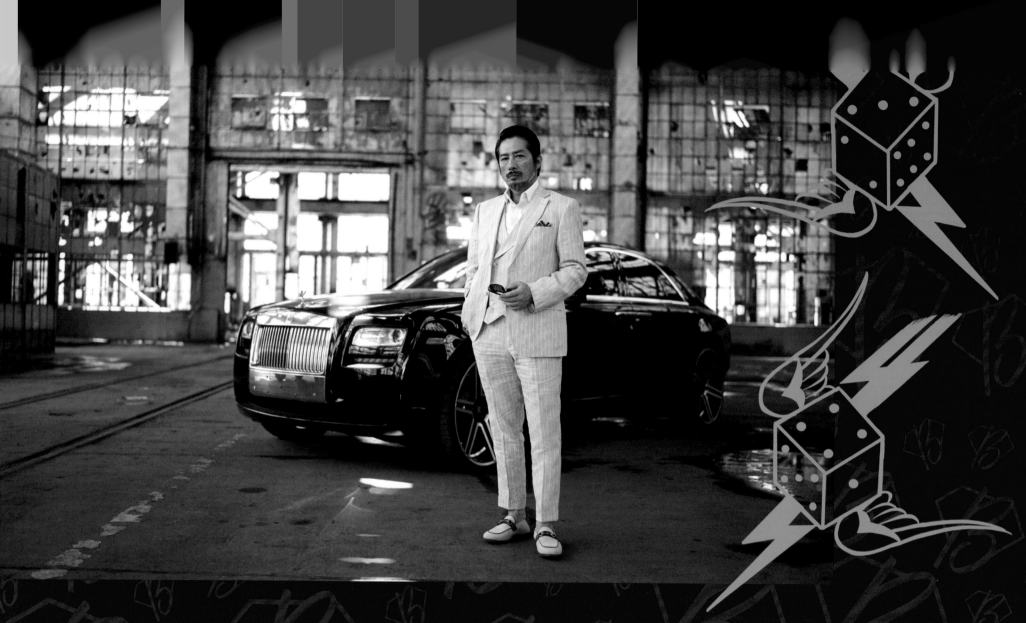

We know, for instance, that Tanaka has an oversized appetite for the finer things in life; he also has an ego to match, if the hotel he named after himself is any indication. "We put a lot of time and thought behind each step. His logo is based on the diamond," says production designer Julie Berghoff. "We try to bring in everything that we as humans are attracted to—glitz and bling, and things like that. His logos and all the restaurants are named after him, for his vanity." As this is the first casino he built, Tanaka might be excused for being nostalgic about it. Unlike many destinations in Vegas, Bly's has no real theme, unless you count opulence. He did, however, name the twin towers of the hotel 'Sodom' and 'Gomorrah,' which might provide further insight into his nature and proclivities.

An additional challenge in playing Tanaka is that the mogul remains somewhat of an enigma, despite his clear-cut reasons for ordering the heist. Sanada says of the situation as the film unfolds, "It's very serious and stressful, but if he has some different idea, no one knows. Maybe Bly is planning to do something not only for the money, not only for the fame."

Producer Wesley Coller agrees that Tanaka is a slippery character. "Bly's interesting… We're meeting this very slick, polished person with this very singular motive that he's very, very transparent about, and it gives him this interesting accessibility to the audience: 'Here's a guy with a need, and it might be sketchy or a little dodgy, but I get him,'" he says.

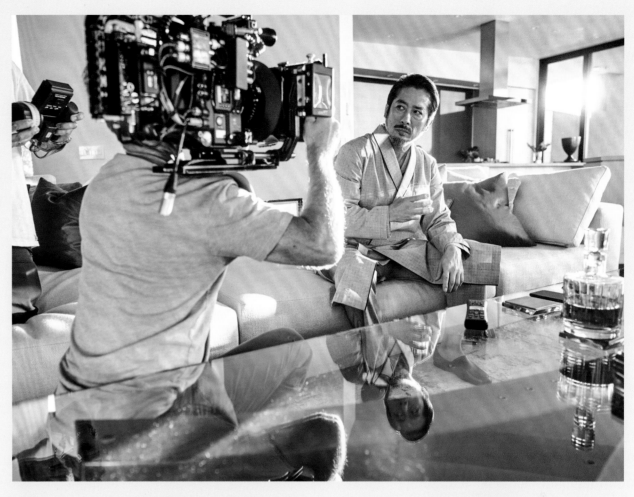

Well acquainted with Zack Snyder's past work, Sanada's appreciation for him only increased as their collaboration developed. "I was a big fan of him from *300*," says Sanada. "So, the first time he called me, oh, my goodness! There's a chance to work with him, and with an interesting script. When I first met him, we talked a lot, [for] almost an hour, one-on-one talking. Then after we started shooting, a surprise: He's so creative, holding the camera by himself. Judgment so clear, a lot of new ideas coming in, and then boom, boom, boom—you choose the best one immediately. Shooting is so quick. I'm happy to work with him."

Wrapping his head around the character of the flashy casino owner required Sanada to do some deep diving into the culture of the rich and powerful. "I researched a lot of people in real life. Some of them are famous American casino owners, or some Asian owners, some politicians. [I] pick up some points from a lot of people, then condense into one [character]. I created some backstory by myself, how he could achieve this kind of position at my age," Sanada explains.

THIS PAGE/ Tanaka works out his next move.

NEXT PAGE/ Tanaka prepares to lay out the plan.

BLY TANAKA

"MY CASH COW... WAITING TO BE MILKED."

Owner of the once-lavish Bly's Las Vegas Hotel and Casino, Tanaka left behind hundreds of millions of dollars in his underground vault when the city was evacuated. Admittedly, insurance payouts fully recompensed him for all the assets he had lost, but he didn't become a billionaire casino mogul by leaving money on the table.

A BILLIONAIRE CASINO MOGUL ISN'T GOING TO LEAVE MONEY ON THE TABLE.

Played by veteran Japanese actor Hiroyuki Sanada (*The Wolverine, Avengers: Endgame*), Tanaka is staking it all on Scott Ward's ability to pull together a team and retrieve the money before the US government nukes Las Vegas to end the zombie threat once and for all. That confidence developed from hearing about Scott's exploits during the fighting. "For me, it's Scott. He's a leader. Whomever he takes with him, I don't care. I don't care for the others," Sanada explains. "That's Bly."

Garret Dillahunt, who plays Tanaka's right-hand man, Martin, says, "We had to find the right people that would be willing to do this, and could do this. So, we found these highly capable, highly decorated, maybe slightly damaged people who needed some money." The money that Tanaka is offering to complete the mission is a life-changing amount. It's enough that Scott feels it's worth the risk, if it means he can provide a better life for his estranged daughter. It's his fervent hope that he can then start to patch up their tattered relationship.

THIS SPREAD/ Bly Tanaka (Hiroyuki Sanada) is used to getting what he wants.

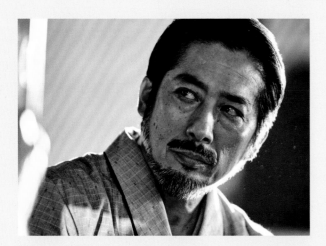

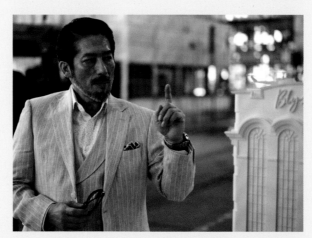

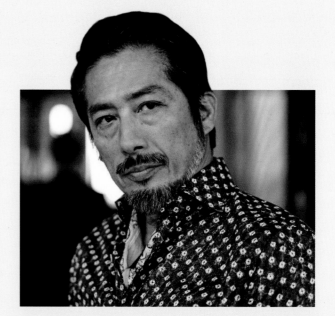

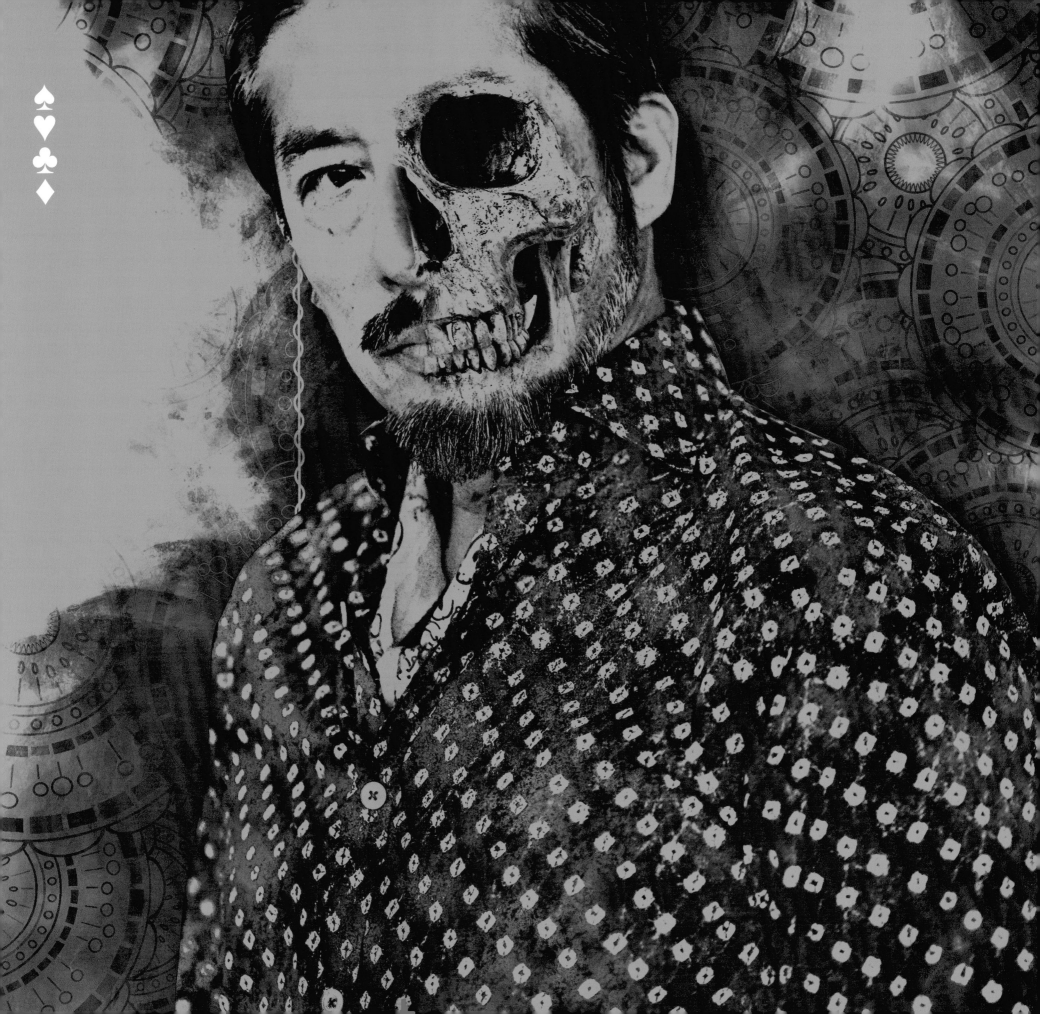

The zombie war has been over for a long time. Las Vegas has been walled off and forgotten by most of the world as life outside goes on. Veterans of the war, like Scott, have largely been forgotten as well. They struggle to eke out an existence in obscurity, their service to the country unrecognized. But there is one man who can't let Vegas go, because of what he left there. Folks with the guts to go toe to toe with the undead are just what he needs to get it back.

ROLL

horde, and a Glock pistol loaded and fired by one of the characters in real time for a YouTube video, all the firearms used in *Army of the Dead* are airsoft guns. "This is something that has never been done on a large feature film like this," explains Andrews. "Those are not real guns. They're custom, [remodeled], with actual, real parts, but airsofts. We had custom reservoir magazines, rechambered with bigger gaskets."

That revolutionary innovation benefitted the production by making it safer for the actors, faster to film, and ultimately less expensive, despite the constant need to maintain the overstressed guns in working order. "We were cracking one every other take, because they were never made to the tolerances needed for what we were doing," says Andrews. "That was the most fun aspect to work on, [taking] a product that was used as a toy, and making it a

battle-hardened, proven product to make it through the filming process. [We] could not have done it without friends in Beijing, and Seoul, and Taiwan—real innovators in the industry of airsoft—all putting their heads together. It shows the community of manufacturers globally. We became an R&D project for them."

The results speak for themselves. "We fired off 297 cans of green gas [propellant]," says Andrews. "We literally bought out five major facilities. We used everything they had. Each can costs eleven to fifteen dollars. Each can does three to four thousand rounds." So, at a conservative estimate, around 900,000 rounds of airsoft ammunition were fired throughout the making of the film. "The math works out to something ludicrous as to what was saved," as opposed to using blank-fire guns, Andrews concludes.

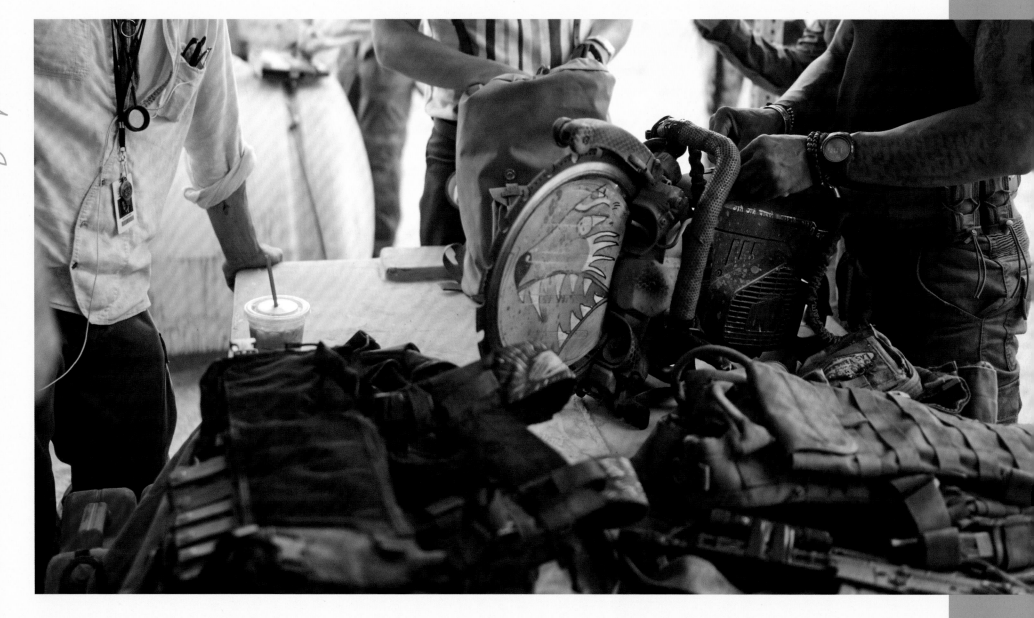

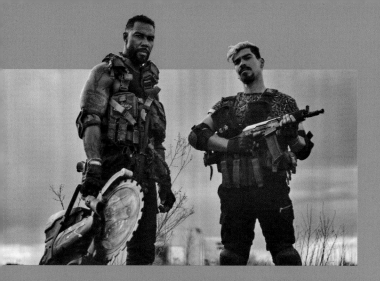

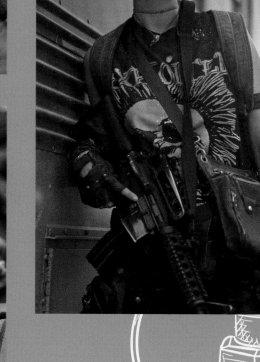

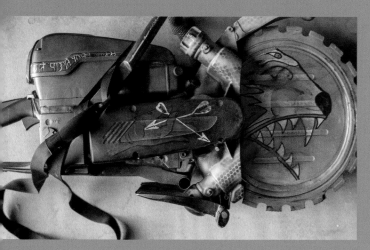

In fact, all the members of Las Vengeance use different versions of that same gun to show the well-oiled machine they became over months of fighting side by side. "The idea was that their pistols all run the same ammo, all the time, their rifles all run the same ammo, so when one goes down, they can switch out mags, no problem," explains property master Brett Andrews.

For example, Scott takes care of threats downrange with a long-range variant of the M4. "Of course, he's stylized it with designs that were inspired by his own tattoos," says Andrews. Scott's gun then, metaphorically, became an extension of his arm. His ammo also packs as big of a punch as he does. "He's actually carrying fifty-round mags. He's throwing in these larger rounds—'hot rounds'—so audiences will realize from the way the zombies are going down, that's not even a normal round," he says. Scott also

makes use of a Heckler & Koch 40mm grenade launcher, and initially a basic Marine Corps KA-BAR knife for hand-to-hand fighting; he later moves to the Night Stalker version of the KA-BAR, favored by special operations professionals.

Cruz, on the other hand, sweeps away zombies in the short range with her collapsible, short-barreled SBR version of the M4 variant. "Whenever you see her and Scott together, she would help clear and he would move behind. You can see the team-element concept in the way they work," says Andrews. "Her weapon is a little more aged down, and has pin-striping, like from Hispanic custom-car culture or tattoos from famous artists like [Mister] Cartoon. You can imagine her character bumped into them."

With the exception of the .50 caliber machine gun Cruz fires from atop the taco truck, another .50 caliber used by an army unit to try to stop the zombie

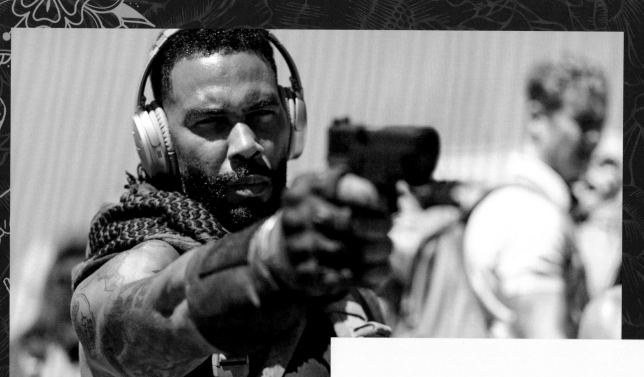

THIS SPREAD/ Surrounded, our heroes use every weapon at their disposal.

NEXT SPREAD/ Details of some of the arsenal the crew carries.

VANDEROHE'S SAW

Each member of the core team has their favored weapons for dealing with the unquiet dead and, like their clothing, these have become extensions of who they are over time. "You can imagine that thing would become fetishized into some other sort of object. It's more than a gun. It's like this weird tool that they use when they're in a life-or-death situation," explains Zack Snyder.

"We thought about each character and what they would be into," says Berghoff, "and customized the weapons according to their personality. We gold-leafed some things, we did pin-striping on some, and some tribal tattooing. Over the course of the apocalyptic situation, there was one or two shifts of their weapons becoming more and more evolved."

Vanderohe's saw and his rifle are decorated with the Shiva Omkar and verses in Sanskrit, reflecting his belief in the larger spiritual concept of death as a part of life. His choice of gun—a sub-compact paratrooper model of an M4—is indicative of his role as a close-combat fighter.

Vanderohe's circular saw is probably the most conspicuous of the personal weapons. "I wouldn't have thought that I was going to play a character like this, who was walking around with a saw that he's sort of adopted, if you want to personify the saw as his child. He's using that to dismantle zombies," says Hardwick.

"[Originally] we thought we'd use a concrete saw," explains Berghoff. "Well, those things weigh like a hundred pounds. They're the size of a man! So, we decided that we would modify a circular saw, and go with the biggest circular saw we could come up with and still be able to be handled by Vanderohe. We cast it and we sceniced it." ('Scenic' is a term that refers to the process of decoration, aging, and embellishment of anything from an individual prop to a bloody tableau of hundreds of corpses.)

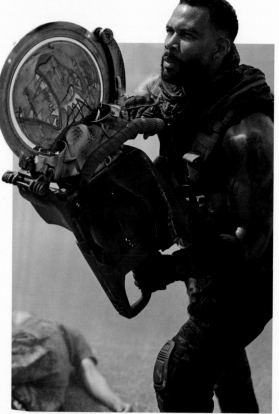

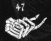

MORE THAN GUNS

LAS VENGEANCE WEAPONRY

For Scott's costume there's a nod to practicality, while never letting the audience forget that he's the leading man. "There's the basic stuff that you wouldn't necessarily see on a military uniform, because it's a zombie-killer costume. You have bite guards, and things that are really heavy, like leather wrist straps," Bautista says. "Stephanie is so funny, because she wanted to play up my muscularity in this, which is something I'm not used to."

"I WANT TO PLAY UP THAT SUPERHERO IMAGE."

"I was a little self-conscious. A lot of times people are trying to play it down. She put me in really tight-fitting stuff, especially tight-fitting pants, which I commented on a couple times: 'These are really snug.' She was like, 'I know. They look great. You look like a superhero.' I trust her completely, and I know she's right, because I want to play up that superhero image [here]. In this particular role, I think the muscularity helps."

"I think I'm the one who's more classic army looking, because I'm all in cargos and green," says de la Reguera. Cruz can also be seen wearing mementos of her literal history. "I love my cuffs. They are leather, they have bites in them, bites of zombies that I fought, because my costume [in the present] is the same thing I was wearing when I was fighting the zombies in the past. Probably you will never see those in the movie, but that attention to detail is lovely," she says. Attentive viewers will also note that Cruz wears a key on a necklace. "That key opens a locker in my body shop," she explains, "and in my mind, that key opens all my memories of when I fought in the war with Scott. It's very sentimental."

"Vanderohe's thought is that when you're in the fight, your uniform could do a lot for you," explains Hardwick. "Comfort yet functionality at the same time. So, Steph and I decided to show my arms, and that was cool. They got a lot darker than the rest of me. I had a farmer's tan every day as a black man. But it was really great. The uniform nonetheless was definitely functional and comfortable, because we knew the discomfort that was looming in carrying the gas tank, the backpack, and the saw on top of that."

Vanderohe's look also incorporated his evolution as a person and philosopher. "He's [working] at a convalescent home now, and he's finding the Namu Myōhō Renge Kyō-centric element or essence to who he is now, versus the guy that was the brooding killer. A spiritual connection that he didn't have prior," says Hardwick. "So, we decided to add beads that meant something to him. The beads that he has around his neck, the beads he wears around his left wrist, his right wrist, Tibetan Sanskrit in the scarf, those were important. The journey was very important."

That individualistic style naturally bled over to the team's personal attire. The responsibility for nailing that aspect of the production fell on the shoulders of costume designer Stephanie Portnoy Porter. "Stephanie's been great," says Coller. "We've had the honor of working with Stephanie within our costume departments in the past. She's creative. Her ideas are fresh and fun. She gets the nuances when we're still in the script stage and she's reading the various scenes. She's getting the energy and the subtext, and those things immediately start to populate the designs, the ideas, and boards we start to see."

Regarding the team's wardrobe, Deborah Snyder explains, "Along with the photography, it was important to keep everything grounded and realistic. Aging was also a big part of it. They were veterans, so it was aged and it was gritty, and they had seen war atrocities in these costumes. She did a great job creating these really believable soldier costumes for our team."

"They all asked the question 'What am I?' when they got inside the wall themselves," says Zack Snyder. "Stephanie was able to really express those elements of their personalities through the costumes at every turn."

PREVIOUS SPREAD/ Keeping score with the undead.

THIS SPREAD/ A motley crew.

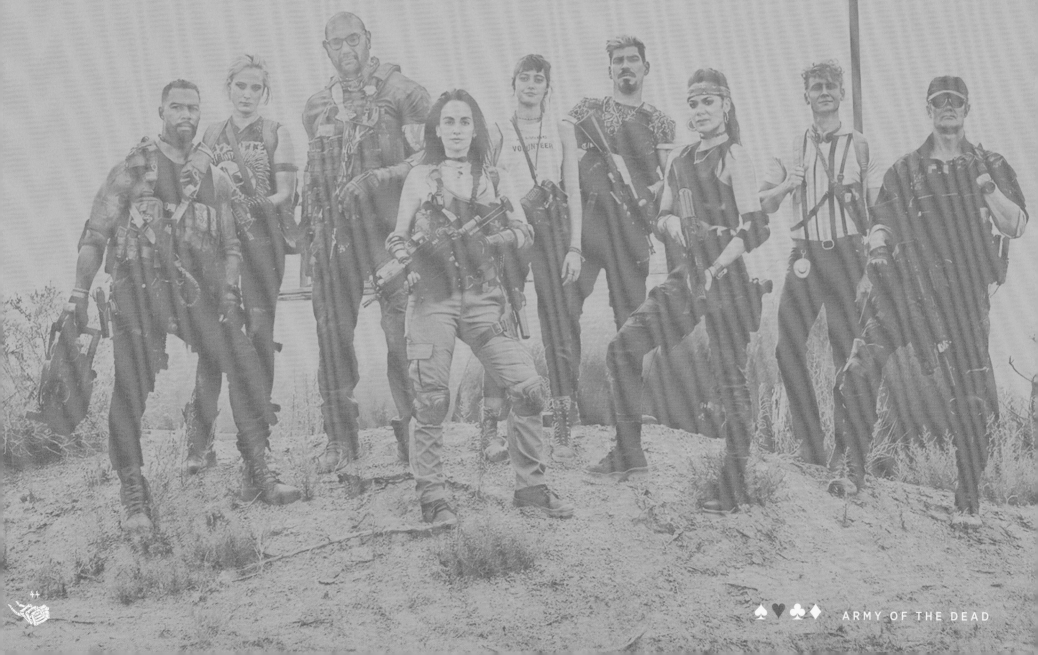

44

SHARP-EYED VIEWERS WILL ALSO NOTE A MENU THAT'S BECOME A SCORECARD, COMPLETE WITH POINTS FOR VARIOUS TYPES OF KILLS; ON THE DOOR THERE IS ALSO A RUNNING TALLY OF ZOMBIES TAKEN OUT BY THE TEAM.

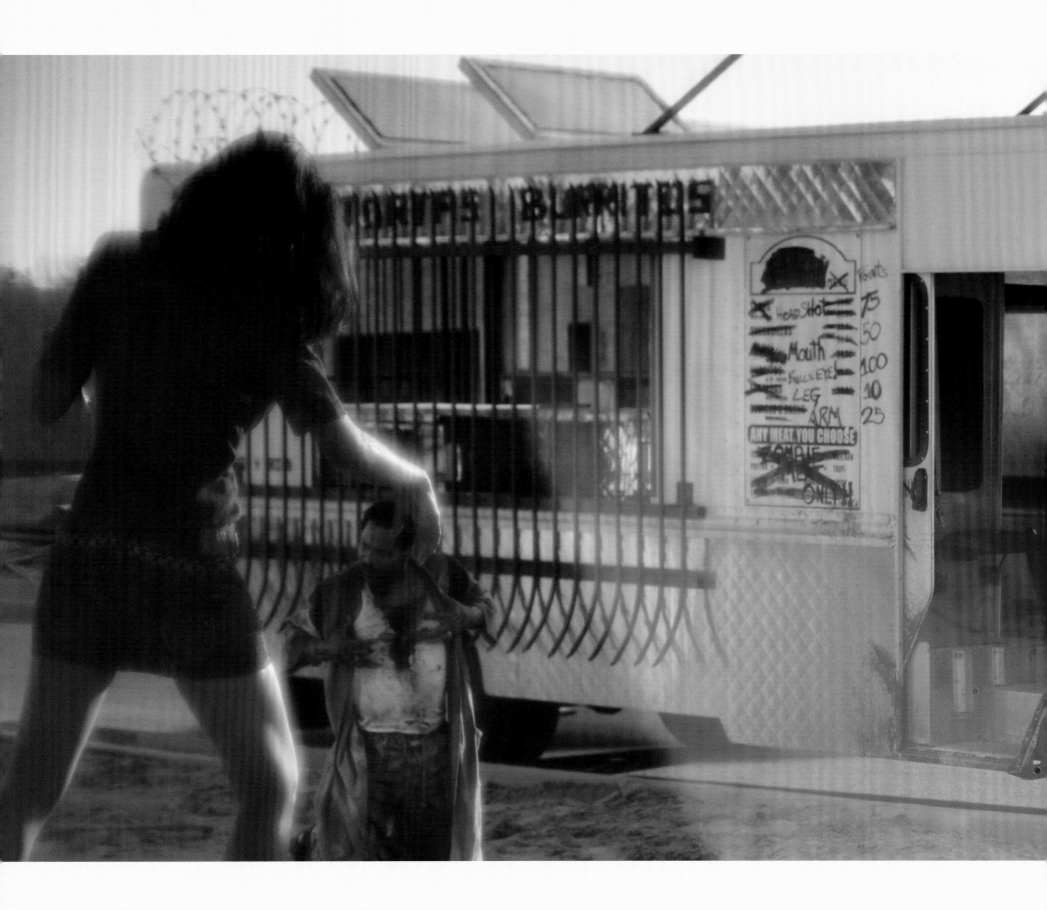

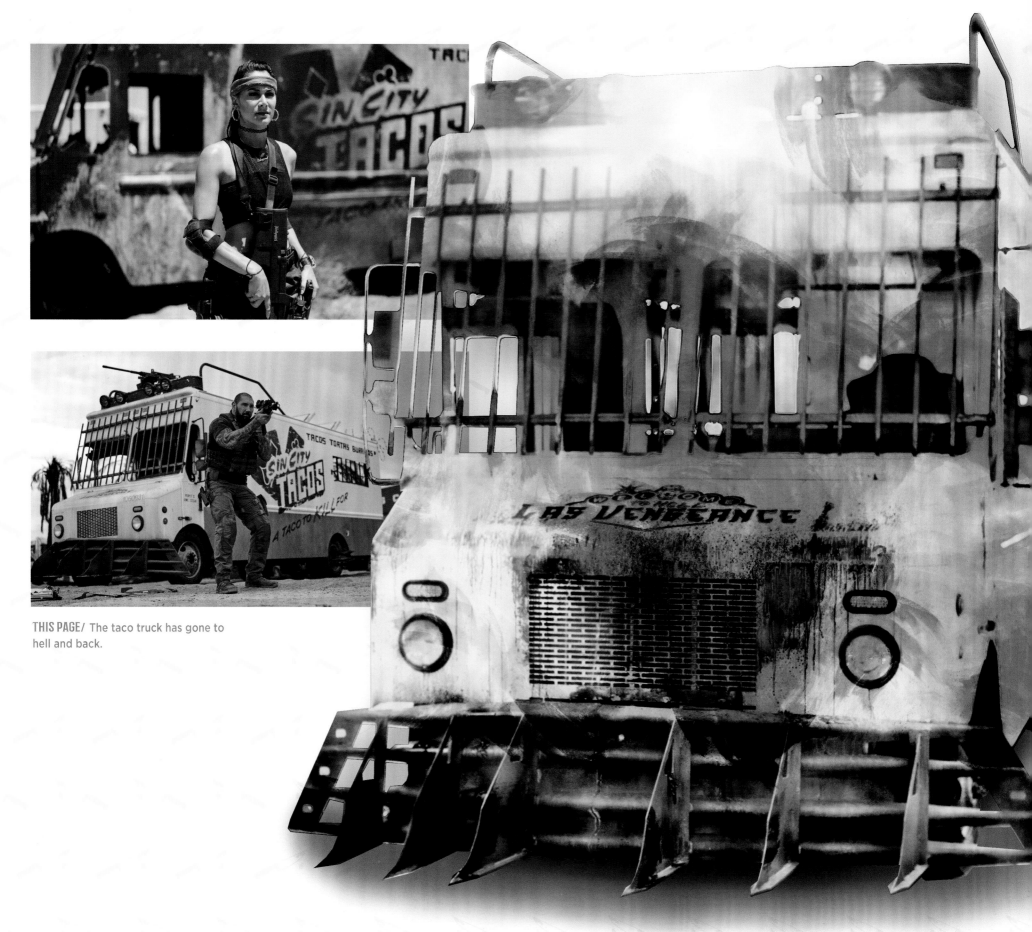

THIS PAGE/ The taco truck has gone to hell and back.

THIS PAGE/ The taco truck at various stages of the zombie invasion. Concept art by Jonathan Bach.

Bautista recalls how one of their teammates evolved into a toughened fighting machine alongside the truck. "It's almost a mirror image of how Soccer Mom changes," he says. "It goes from being a normal, everyday restaurant on wheels to a zombie-killing menace with spikes, and blood, and barbed wire, and guns. Even the food signs on the side really change dramatically. I'd love to see side-by-side images of the transformation between the truck and Soccer Mom, because I think she has the most drastic change."

"It was very helpful," explains de la Reguera, "because we could save people, and we could sleep in there, or we could put in all our guns and food. That taco truck saved a lot of lives!" She feels that it got some of its quirky styling from Cruz. "I imagined

when I saw the truck that I actually stole some stuff from the border, like from the wall. The wires and all that. Cruz went where they're starting to build the wall between Mexico and the US, and she stole some stuff from there, and put it in the truck," she says.

"We took bread trucks, we broke out the glass, and put wire over the front to prevent [zombies] from being able to crawl in," explains Emmy Award-winning production designer Julie Berghoff. "We put super sharp metal that Cruz did on the front of the truck to basically slice up their legs and things like that. Then we did some gorefest on the front, and we put an M50 [machine gun] on the top. Cruz really tricked it out to become a zombie warrior wagon. That was really fun to design. It was like my *Mad Max* car."

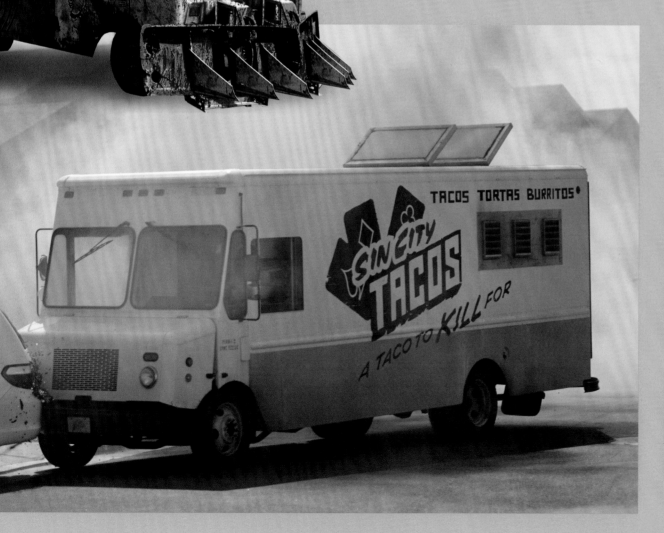

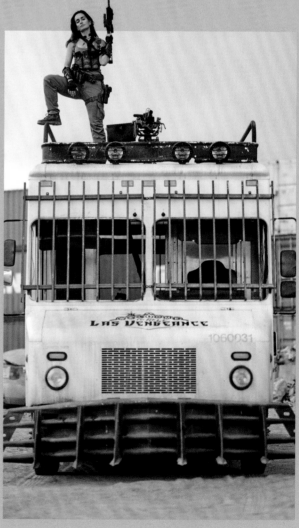

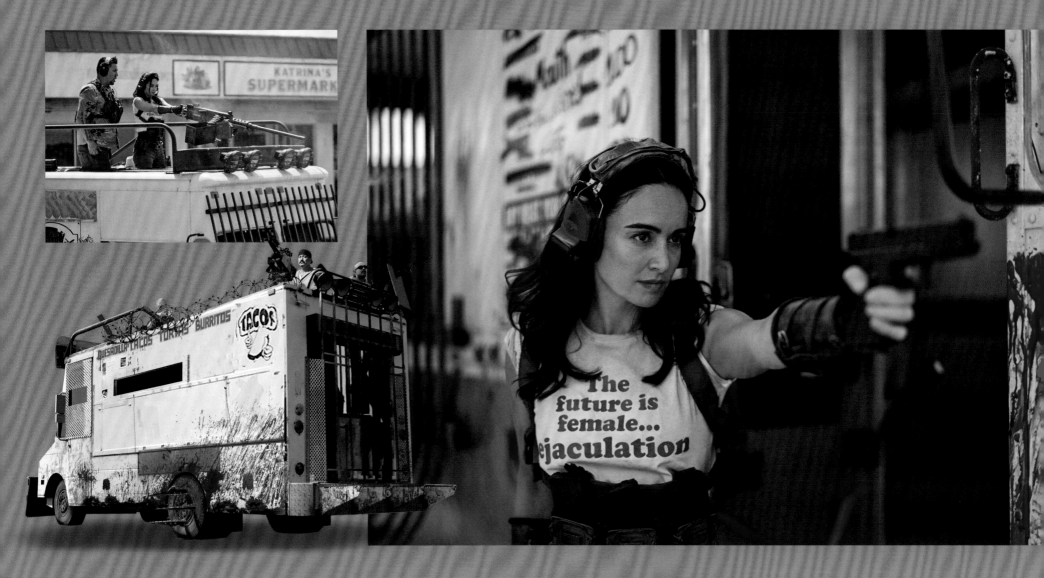

At the height of the crisis, Scott and his ad hoc team did what they could to contain the zombie threat and get people out of the city alive. We get a taste of their exploits through an opening credits montage, as well as through flashbacks at different points in the film.

"During this zombie war, they were basically like a search and rescue," explains Zack Snyder. "Because they were from Vegas, they knew how to navigate the streets where the military was getting slaughtered." As a result, they used whatever gear they could find to get the job done their way. "Even though they were supported by the military, they weren't subject to their discipline, so they were able to have their saws, or Tibetan prayer beads, or paint their guns. They had

this very unique, personal point of view on combat and tactics. They're very practical," says Snyder.

The most iconic piece of equipment they relied on was Scott's taco truck. Its transformation into a war-fighting vehicle in many ways parallels the toll the struggle had on the human members of the team. "The taco truck is the most normal thing in the world. It's benign," Snyder points out. "As a matter of fact, its purpose at its heart is to nourish, or do the opposite of what it turned into. You pull the ovens out and the cook tops. They end up tricking it out into a pretty scary tactical vehicle. So it does both, it expresses two things, which I find really fun." Formerly 'Sin City Tacos,' the truck later proudly sports the name of this ragtag team of troubleshooters: 'Las Vengeance.'

THIS SPREAD/ From concept to reality, Scott's taco truck made an ideal shooting platform. Concept art by Jonathan Bach.

A TACO TO KILL FOR

GEAR AND GACK

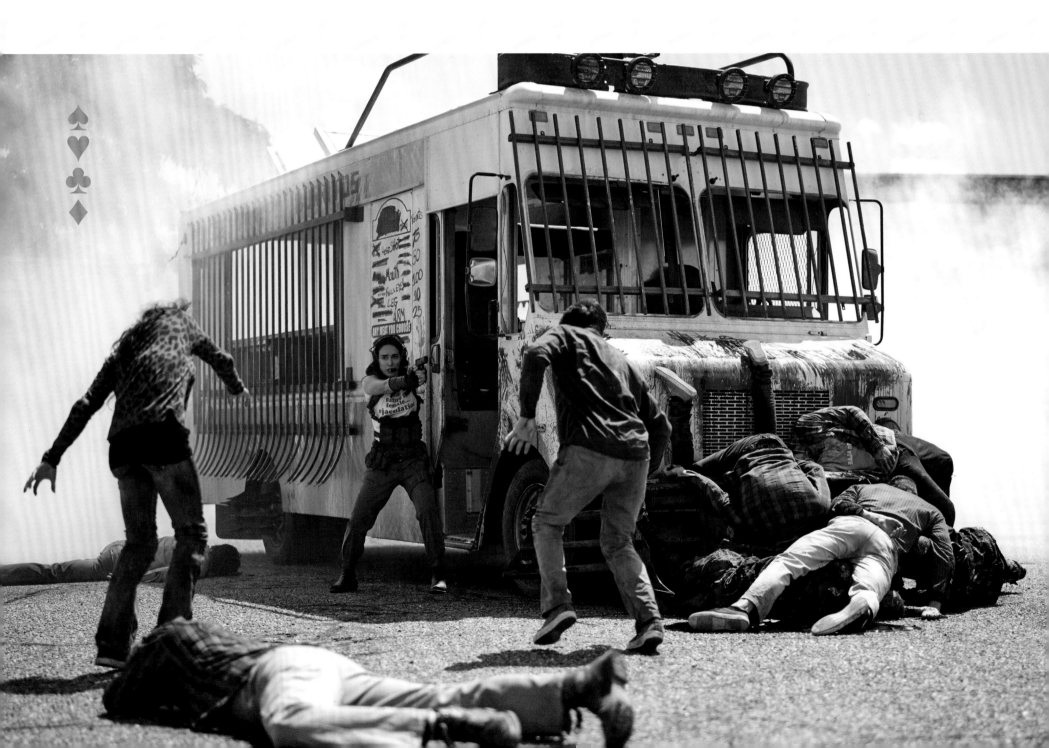

That makes him somewhat introspective about the bigger picture and the world as it currently exists—Vegas, the quarantine, all of it.

VANDEROHE IS A CHARACTER THAT QUESTIONS THINGS.

As Hardwick explains, Vanderohe asks himself, *"Is that the reality of what's going on? Are we able to take people off this earth by calling them zombies? And once we do that, where does that leave you?* Vanderohe is definitely a character that is questioning a lot of those things, outside of the screen and behind the wall. That's deep and it's dope."

Eventually, of course, Vanderohe does rejoin his old teammates on a frankly insane mission to reclaim millions. In doing so, he finds himself playing nursemaid to a young, inexperienced, but ultimately vital addition to the team. "He's in charge of keeping our safe cracker, Dieter, safe," says Deborah Snyder. "At first, he's like, 'This guy is gonna get us all killed. This guy doesn't know how to kill a zombie, he's never been in a war, he's gonna be a detriment.' He's fighting this responsibility, but through the course of the film he realizes that everybody has value, and I think that's kind of a metaphor."

Playing a zombie-fighting warrior/philosopher has its perks, at least in terms of being a parental role model, apparently. "My kid wants to play Vanderohe for Halloween," says Hardwick, "which I think is super cool. He can't do it yet, because I'm like, 'You got to wait, because you'll be saying trick or treat and nobody will know who the hell you are.' But once the movie is out, hopefully, it'll work. Two more Halloweens to wait."

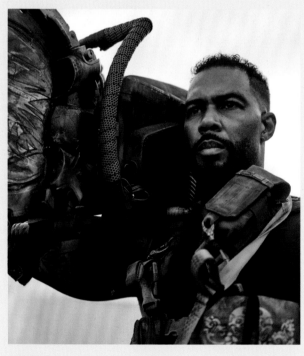

ABOVE/ Vanderohe and his saw.

RIGHT/ Vanderohe and Dieter contemplate the vault.

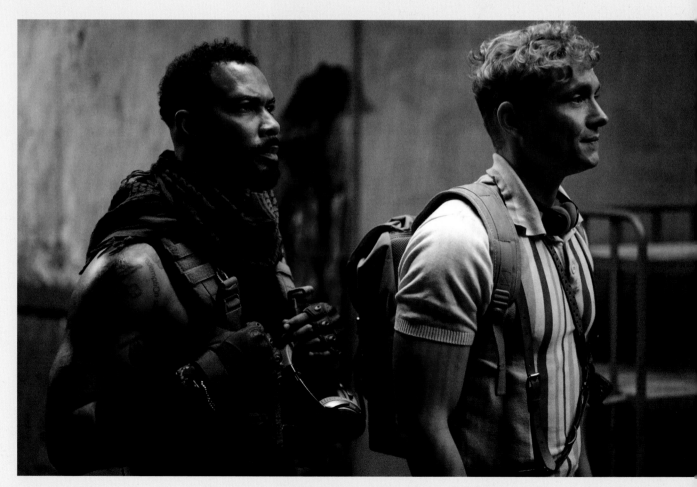

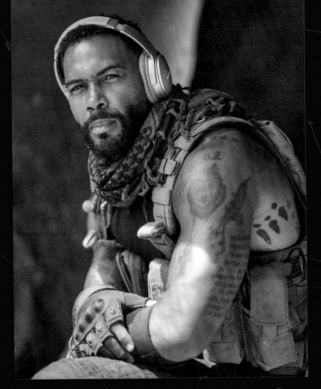

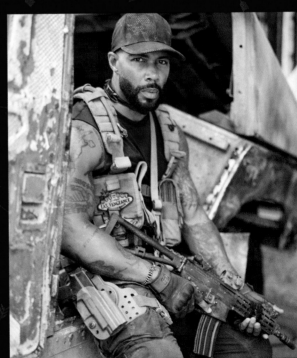

ABOVE/ Vanderohe chilling
with his tunes.

RIGHT/ Vanderohe on high alert.

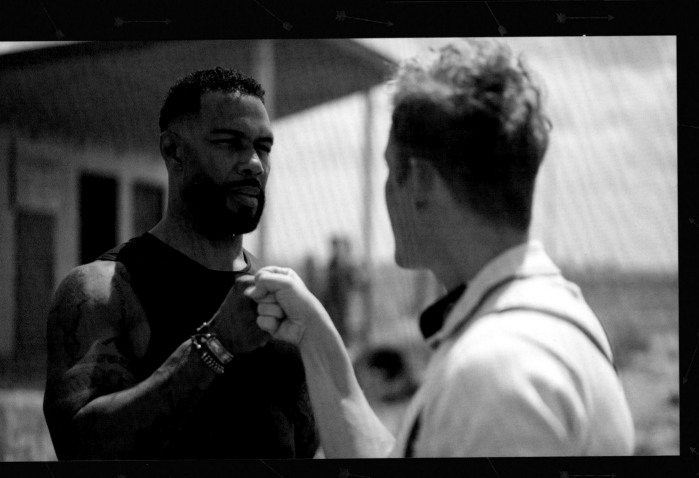

ABOVE/ Vanderohe takes a break.

LEFT/ Vanderohe and Dieter Ludwig
(Matthias Schweighöfer) make a connection.

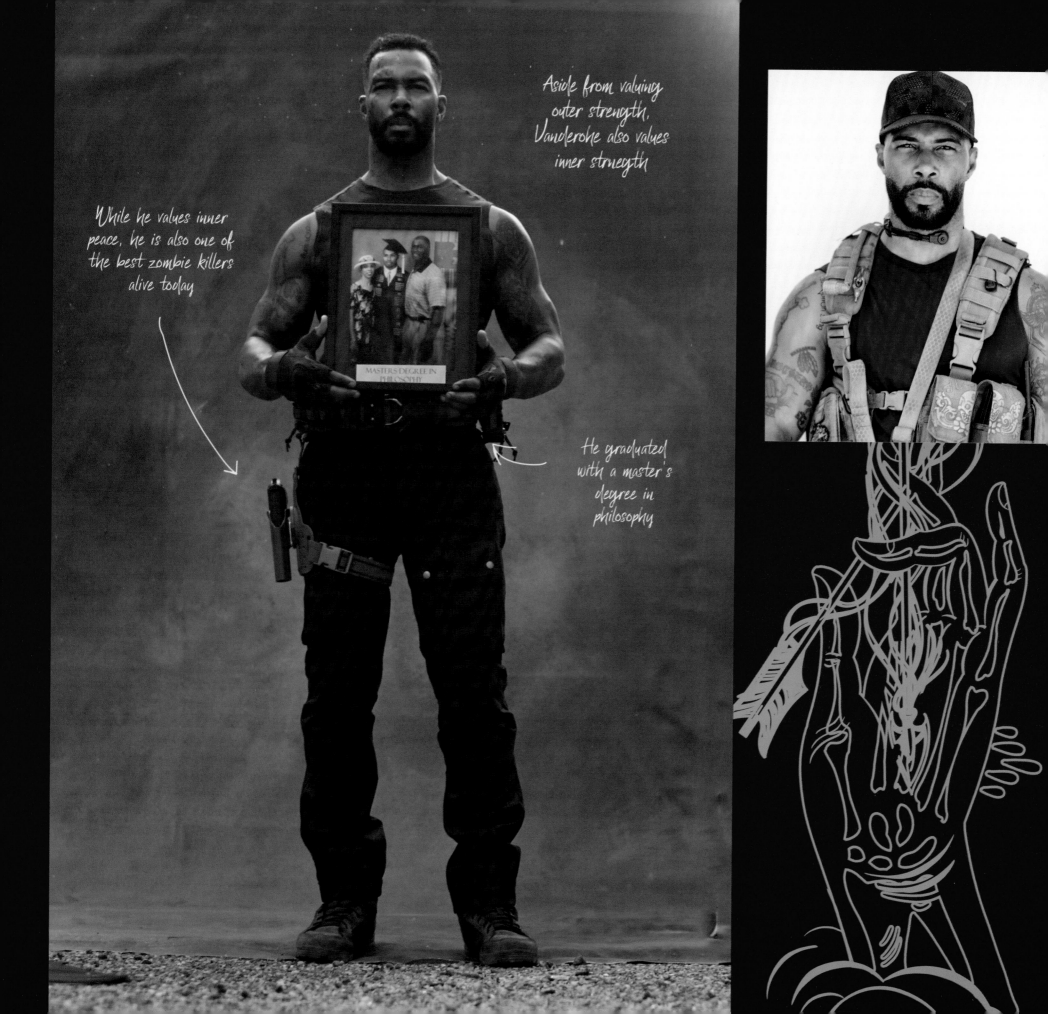

Aside from valuing outer strength, Vanderohe also values inner strength

While he values inner peace, he is also one of the best zombie killers alive today

He graduated with a master's degree in philosophy

MASTERS DEGREE IN PHILOSOPHY

For Bautista, the connection with Hardwick/Vanderohe went deep, but it was mostly a quiet bond. "I've developed a brotherhood with [Hardwick]. I love that dude. Because of the nature of our characters, our scenes are very limited in dialogue. I think we connected even onscreen, just through looks. We're just constantly on the same page," Bautista says.

Hardwick seconds that sentiment, although he admits that while reading the script, he mistakenly assumed that fewer spoken lines would mean less screen time. "It didn't necessarily translate in my brain to how much I would be working," he says. "Vanderohe had so many beautiful moments of not only non-dialogue, but Zack wrote it in such a way where you couldn't always keep up with the number of characters on the page." However, he quickly realized once shooting began that unheard didn't mean unseen. "Some of the best acting moments for me, in a sixteen- to seventeen-year career at this point, have been when I'm not speaking," he explains. "But oftentimes, they don't find you on screen if you're not speaking. [Snyder] kept finding me. And that was kind of cool for me, because I didn't expect that."

But who was Vanderohe before the zombie war? "We decided that he comes from a military background," says Hardwick. "Whether it's a Navy SEAL, whether it's having worked in the Army, whether it would be that of a Marine, we feel he has some military expertise at a high level." That backstory, along with his unusual choice of weapon, led Hardwick to pack on some extra muscle for the role. "I gained ten pounds for it, partly because he's carrying so much freakin' weight," he says.

Battling hordes of the undead for weeks on end, however, can have an effect on the toughest of warriors, and Vanderohe is no exception. "He saw something," says Snyder. "I'm not one hundred percent sure what it was, but he went down a rabbit hole with these zombies back during the zombie war and it changed him. When we find him later, he's working in a nursing home taking care of people. He's like, 'I don't want to get out of here. This doesn't get any better.'"

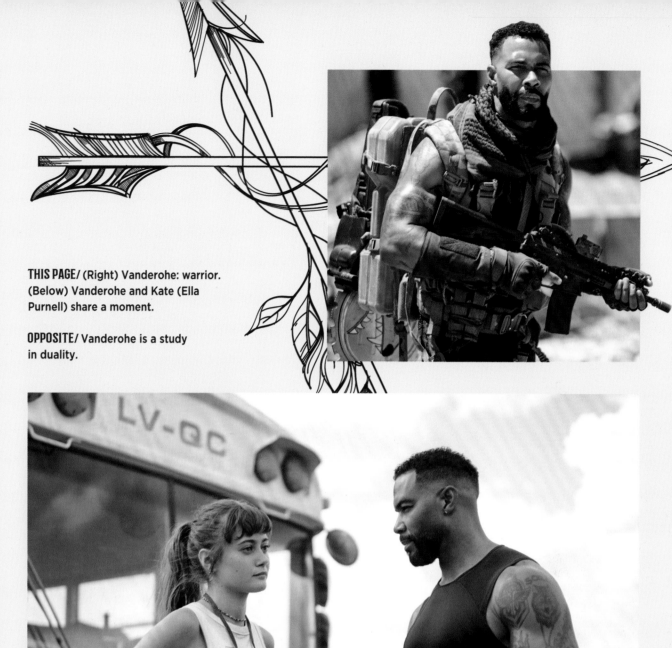

THIS PAGE/ (Right) Vanderohe: warrior. (Below) Vanderohe and Kate (Ella Purnell) share a moment.

OPPOSITE/ Vanderohe is a study in duality.

VANDEROHE

"I DON'T WANT OUT. THIS SUITS ME."

The last surviving member of Scott's original crew is Vanderohe, who cuts through broad swaths of the undead with his signature saw. He's also a case study in not judging a book by its cover.

HE'S A SUPER-TOUGH ZOMBIE KILLER, BUT HE IS ALSO A PHILOSOPHER.

"What's great about Vanderohe is he has this big saw and he's a super-tough zombie killer, but he is also a philosopher reciting Joseph John Campbell," says Deborah Snyder. "I think it's great that you're seeing both sides of him. I think that's true about the world: At first blush you might think someone is a certain way, and they're really not a certain way."

Played by Omari Hardwick (*Power*, *Sorry to Bother You*), Vanderohe is at his core a team player, devoted to Scott and Cruz as if they were his own family. "Coming from sport, the team aspect stood out to me," says Hardwick. "The whole recruitment, not only in terms of new players we now need to complete this mission, but the recruitment of the old characters, I thought that was super cool – familial. I guess I'd be the avuncular character. [Vanderohe] is definitely that guy who will sacrifice whatever for the team. I don't even think the prize money at the end of the quest matters as much to him."

The genre and director also drew him into the project. "Once I knew it was a zombie movie, and I knew who was in the driver's seat—that being Zack Snyder—I was like, 'Man, this will be great. It'll test something in me,'" says Hardwick.

THIS SPREAD/
Vanderohe
(Omari
Hardwick):
caregiver,
philosopher.

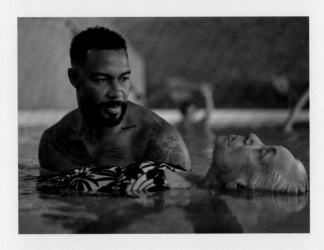

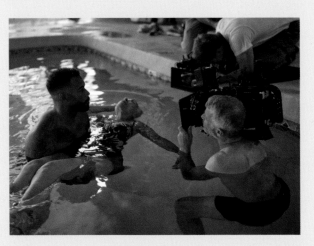

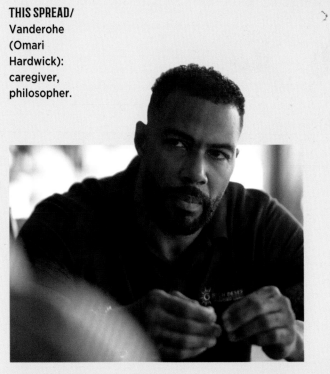

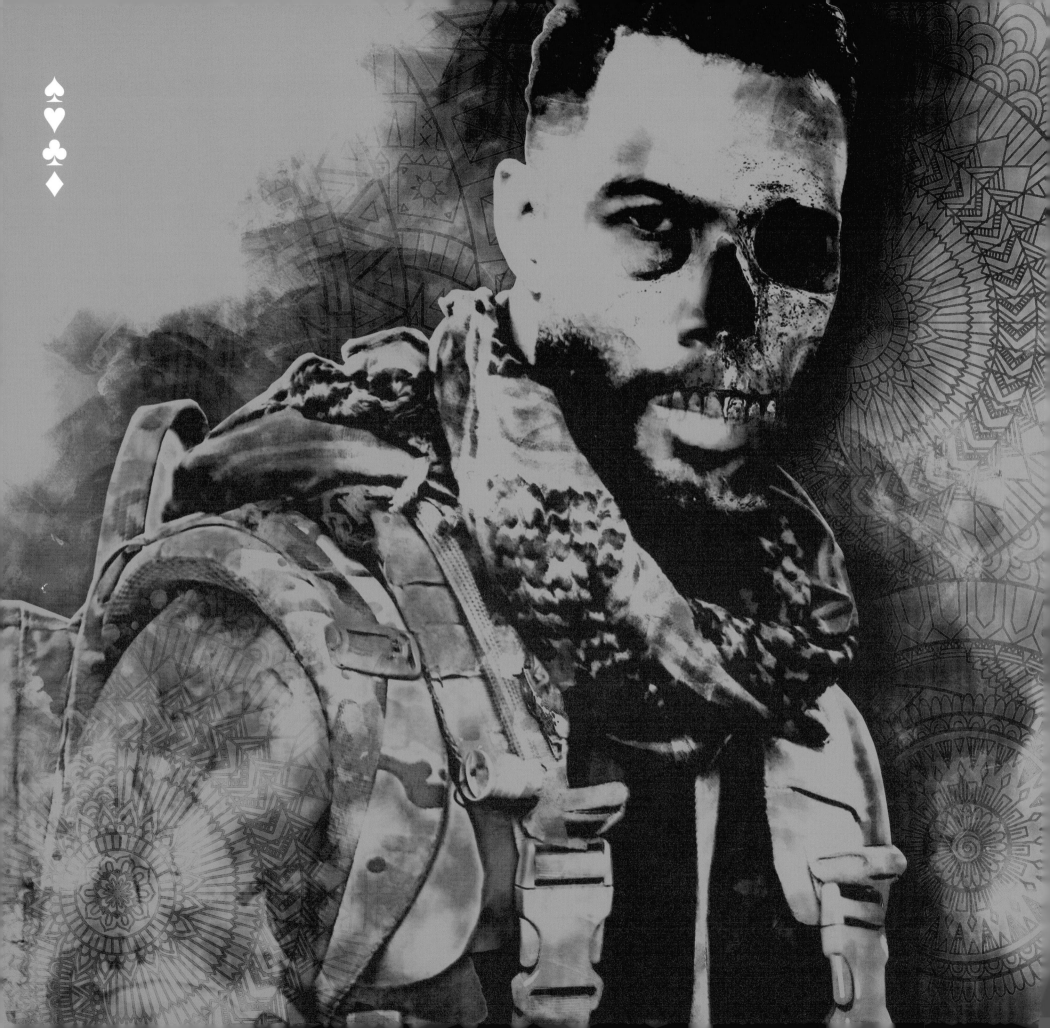

want,' and I said, 'Zack, it's weird, because I'm the immigrant and I'm the Mexican. Shouldn't someone else say it?' And he's like, 'No. Exactly. I want you to say it.' I thought that was pretty cool, because there's so many people like [Cruz] that are war veterans, and they have risked their lives, and they're from other countries, and they're part of this country, and sometimes they're not treated like that. That's why I like that I had to say that line."

"I love the fact that we have a Latinx woman playing that role," says Deborah Snyder. "Just trying to be in this global world, inclusive of all ethnicities, is something that was really important to us when we were casting the film. Even though our team is comprised of both men and women, that's not what it's about. It just represents the world that we live in today."

Getting to embody such a strong female character with depth, like several others in the film, was a refreshing change from other action fare from de la Reguera's viewpoint. "We're playing tough characters, and characters that would be played by men, probably, if this movie was made twenty years ago," she observes.

Snyder agrees, adding, "She kicks ass. She is an equal to Dave Bautista's character."

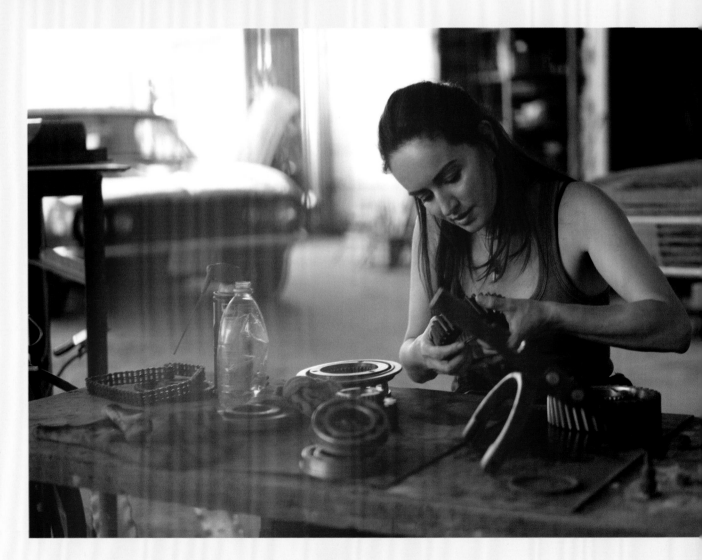

Another challenge (or at least a perceived challenge) for de la Reguera was the language barrier. Given such an international cast, this issue was bound to come up eventually, but she was encouraged to turn it into a positive. "Ana was a little self-conscious at first about having such a thick accent and saying [English] words that weren't grammatically correct," Bautista recalls. "I was like, 'You're Mexican. Speak some Spanish. Fill it in. It sounds better when it's a little broken. It sounds more real. It sounds more organic.'"

The actress's accent and background also had a real impact on some of the social commentary within the film. For example, de la Reguera relates a moment on set, "I have a line where I say, 'Well, it's a free country... You can look at whoever you

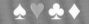

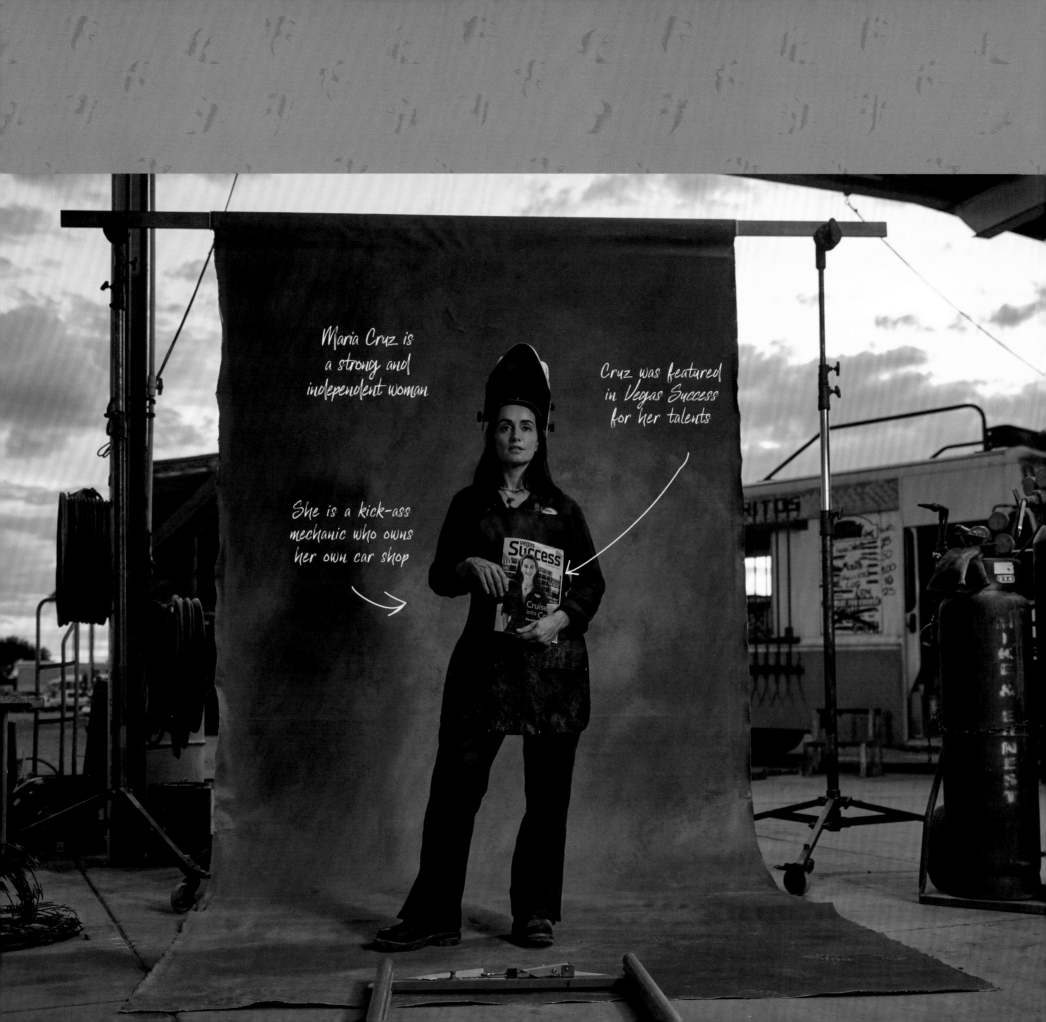

"The movie's about human relationships, and human nature, and how we do anything to survive and to take care of the ones that we love. I couldn't ask for something better. So, I was in right away."

The pervasive use of firearms the shoot demanded proved to be a challenge for de la Reguera, but a challenge that she met head on. "We had to go to a shooting camp, and to be honest, I wasn't that crazy about that because I'm against guns," she explains. "But they convinced me. Then, when I did it, I was so happy that I did. Even if it's a rubber gun, they teach you how to give it back in a proper way, how to handle it, and where to put it. When you have a real gun, it's about safety. I'm wearing a huge rifle, and I'm little. You have to be in the right position, so it doesn't move and you have a better view. All that makes sense when you actually have to do it for real. Also, you want to look cool."

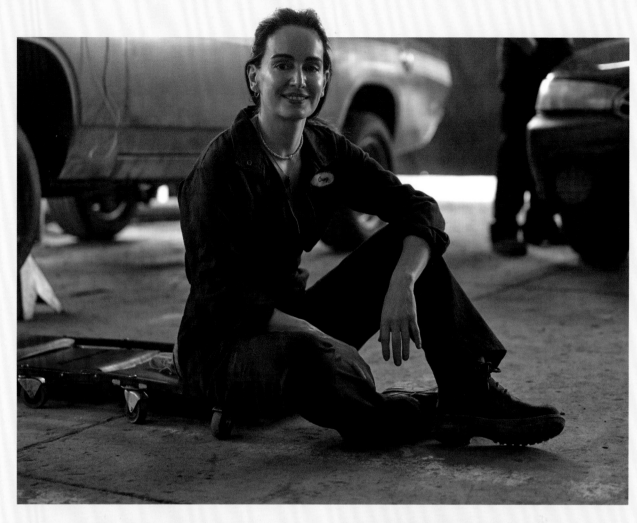

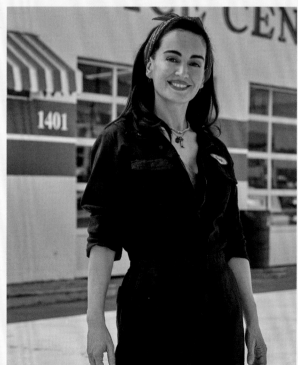

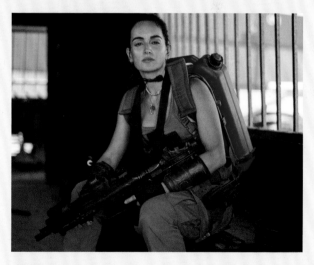

THIS PAGE/ The many sides to Maria Cruz (Ana de la Reguera).

OPPOSITE/ A snapshot of Cruz's life before the fall of Las Vegas.

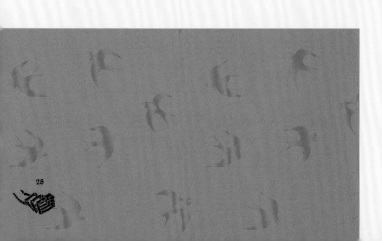

MARIA CRUZ

"DO YOU EVER MISS IT? CUZ I DO."

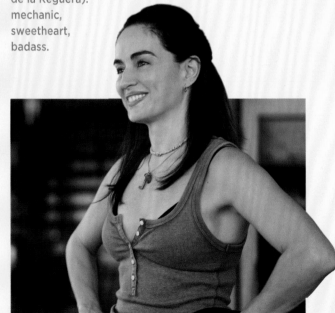

Usually going by just 'Cruz,' she is an integral part of Scott's team, both back in the day and now. "Cruz is his right-hand, so to speak. I think Cruz is actually probably the brains of the outfit. I don't think Scott could've put together the team without Cruz.

I THINK CRUZ IS ACTUALLY THE BRAINS OF THE OUTFIT.

"He was a little lost when it came to that. He's a good soldier. He's not stupid by any means, but I think he wasn't quite sure how to put together a team for a heist," explains Dave Bautista. "Also, there's definitely an underlying love interest tone there."

Hailing from Veracruz, Mexico, Ana de la Reguera (*Nacho Libre*, *Narcos*) has had a distinguished and varied career on both sides of the border. Her versatility made her a natural to play the feisty mechanic-*cum*-zombie-killer. "She's been amazing in everything from her sheer badassery as she sat on top of the modified taco truck with the machine gun, mowing down zombies to the flip side of that. She has an energy that brings out the genuine bits of Scott, the parts of Scott that he has trouble accessing himself," says Wesley Coller.

For de la Reguera, being offered the part of Cruz was a bit of a surprise, but accepting it was a no brainer. "I never thought someone would be interested in me doing this role. I was shocked," she says. "They just told me it was a movie with Zack Snyder, and I knew I didn't even need to read the script. But I did, and it was fun. I love the combination of a zombie movie with a heist. I love how the characters interact.

THIS SPREAD/
Maria Cruz (Ana de la Reguera): mechanic, sweetheart, badass.

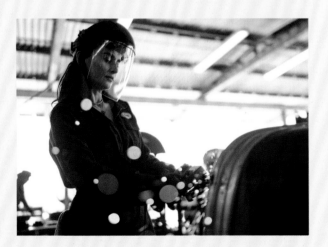

are successful. "Now that he's out of it, he's being pursued again to do a job he doesn't necessarily want to do, but he does out of necessity. Most of that necessity is just redeeming himself with his daughter, Kate. [He wants to] reconnect with her, and also help her out financially to make sure she doesn't have to worry about anything for the rest of her life," explains Bautista.

One way Bautista and his team prepared for the demanding action sequences of *Army of the Dead* was through intensive training on unit tactics, led by retired US Navy SEALs Steve Sanders and Mitch Hall. It was also crucial for building the dynamic of a tight-knit group of people who had fought side by side before. "It makes you feel more confident, and also makes you think when you're getting in certain scenes about how you should be moving," Bautista says. "The cool thing is, since we all trained together, we're all kinda on the same page and we're all thinking the same thing. We're working as a team. We are a team before we even get to the scene and we start to put it together. We know exactly what we're doing."

Deborah Snyder points out that many of the traits that made Scott Ward so in demand are shared by Bautista himself: "He's really been the leader of this team. You see it. He's such a presence that everyone wants to follow him, whether it be the actors or the characters."

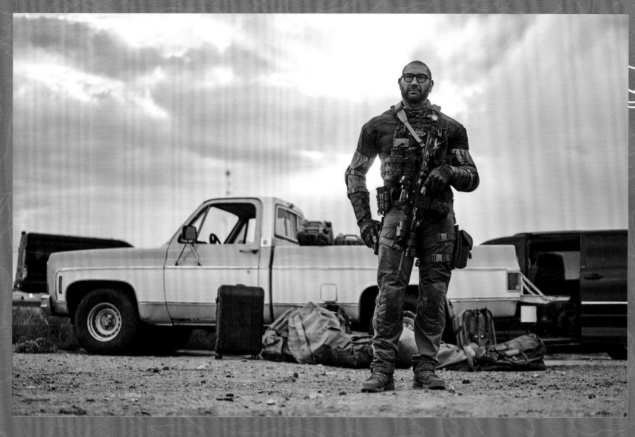

So, who was Scott Ward before an invasion of the undead destroyed everything he had ever known? "He was just a normal guy, pursuing his dream of having a food truck, having his own business," explains Bautista. It just so happened that Scott had other talents as well.

SCOTT IS VERY GOOD AT SOMETHING HE REALLY DOESN'T WANT TO BE GOOD AT... HUNT AND KILL ZOMBIES.

"Scott is very good at something he really doesn't want to be good at. He has a natural gift, and that is to hunt and kill zombies," says Bautista. "He was good at it. He has a cool head about him. He's a good leader. He was necessary."

Now Scott is presented with a devil's bargain: lead a team back into Vegas and risk almost certain death, but with the possibility of a huge payday if they

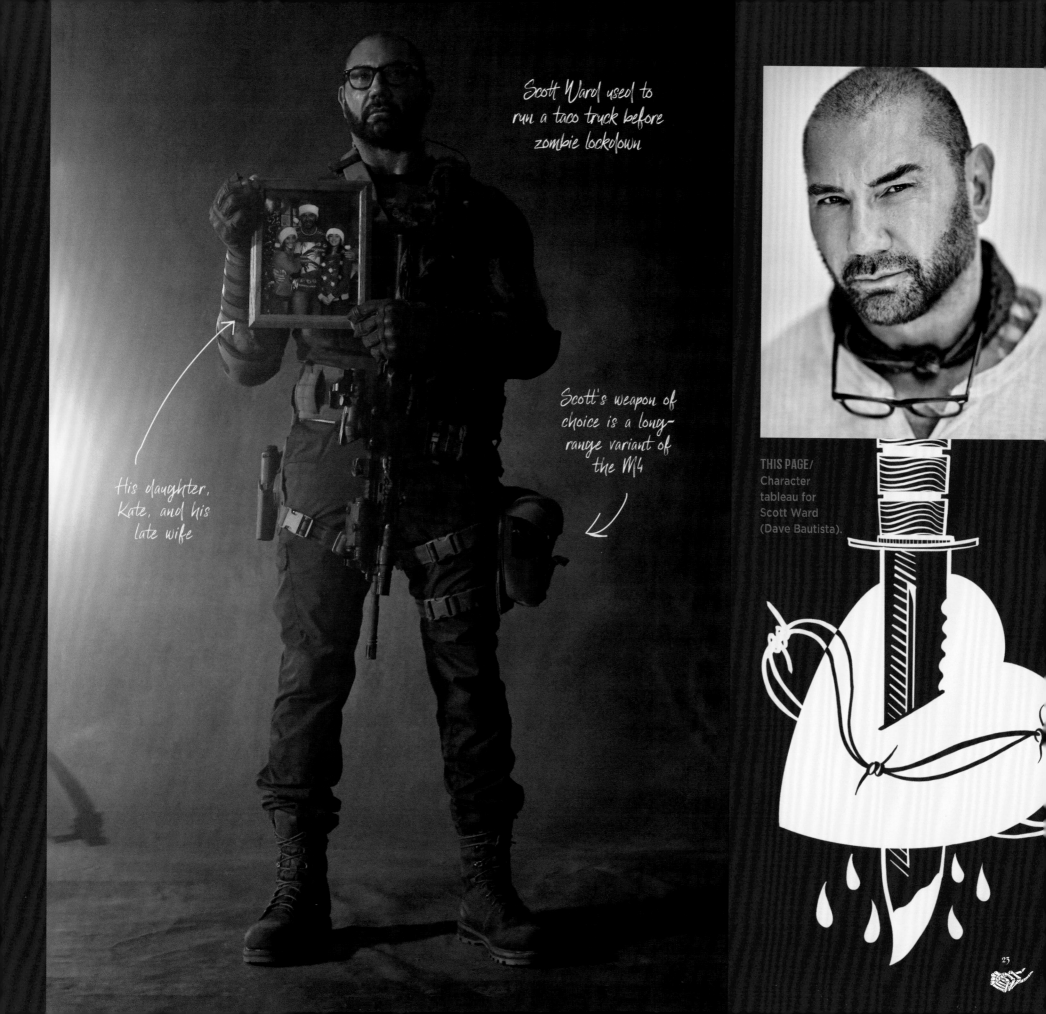

Scott Ward used to run a taco truck before zombie lockdown

His daughter, Kate, and his late wife

Scott's weapon of choice is a long-range variant of the M4

THIS PAGE/
Character tableau for Scott Ward (Dave Bautista).

23

That ability to balance sensitivity with physicality serves Bautista well in a film that depends on human connections as much as undead mayhem. The actor recalls the discussions he had with Snyder to understand Scott's character. "We talked more about the relationship he was having, and the struggles he was dealing with, being estranged from his daughter," he says. "It was more a relationship thing with Scott and Kate that we were focused on, because to me, that's the heart of the film. Scott is trying to redeem himself with his daughter that he loves so much."

"Dave is a great person to play this character," says producer Wesley Coller, "because it requires a presence that is not just big and strong and a force to be reckoned with, but it also needs someone that can be softer-spoken and can live in the moment. So you believe it when he seems lost, in search of the right thing to say to his own daughter."

ABOVE/ Scott Ward (Dave Bautista) argues with his daughter, Kate (Ella Purnell).

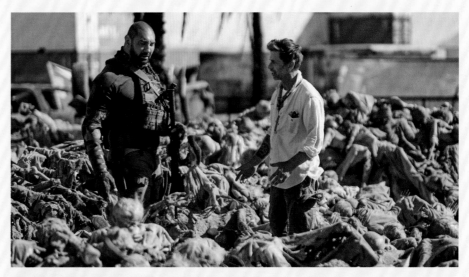

ABOVE/ Bautista and Zack Snyder survey the carnage.

> # "SCOTT IS TRYING TO REDEEM HIMSELF WITH HIS DAUGHTER THAT HE LOVES SO MUCH."
> *DAVE BAUTISTA*

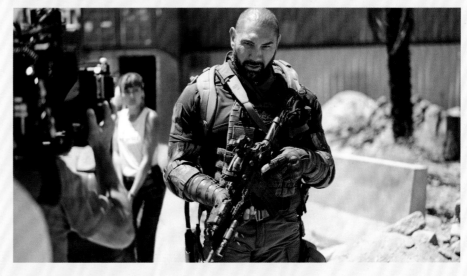

ABOVE/ Bautista leads the team into Las Vegas.

SCOTT WARD

"I'M WELL AWARE OF MY SITUATION."

Zack Snyder knew he wanted actor Dave Bautista (WWE, *Guardians of the Galaxy*) for *Army of the Dead* before he knew for sure which role he wanted him to play. "I've always wanted to work with Dave. I've been a huge fan of his for a long time," says Snyder. "I find him incredibly sympathetic, but strong, and capable of incredible action."

IT'S AMAZING TO SEE HIM ONSCREEN BEING SO SOFT AND GENTLE, LIKE THE GENTLE GIANT.

"We've been trying to work on a project together for years," Bautista explains. "Originally, I guess,

when they wrote Vanderohe, they thought of me. Then, as they came close to casting, [Snyder] said, 'Dave's not Vanderohe. Dave's Scott,' and he called me and asked if I'd do the part. I really appreciated that Zack Snyder was personally asking me to play this part. That meant a lot to me."

Producer Deborah Snyder completely backs up her husband's casting choice. "Dave Bautista is the perfect Scott," she says. "We're so used to seeing Dave in *Guardians of the Galaxy* as this larger-than-life, very funny character. Some people know Dave from wrestling. But to see Dave playing a serious father character who is dealing with a lot of emotional issues with his daughter is something really unexpected. It's amazing to see him onscreen being so soft and gentle, like the gentle giant."

THIS SPREAD/
The several looks of Scott Ward (Dave Bautista).

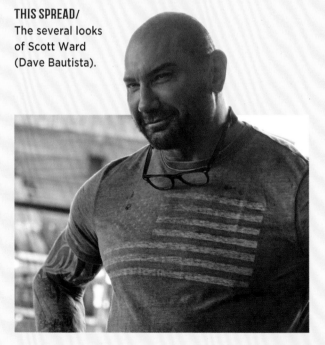

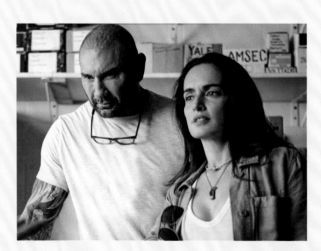

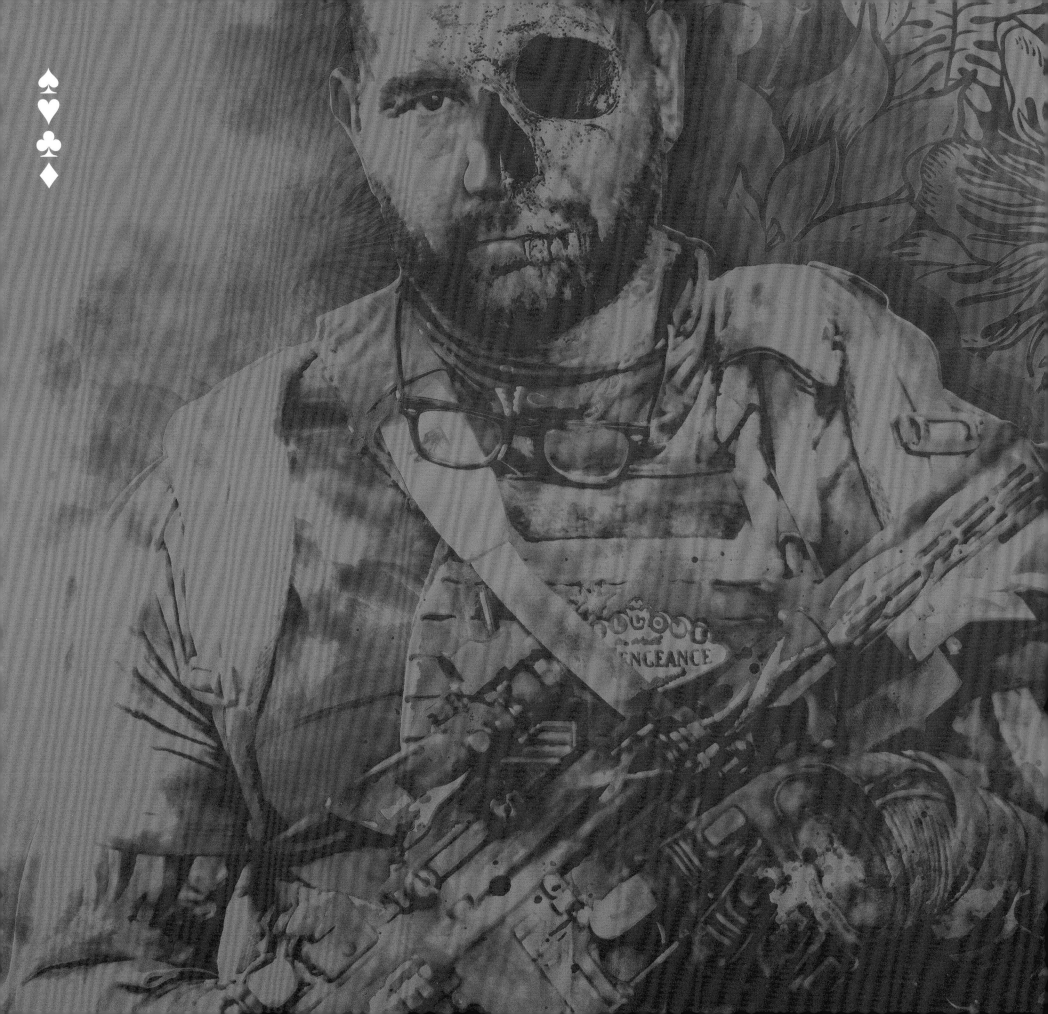

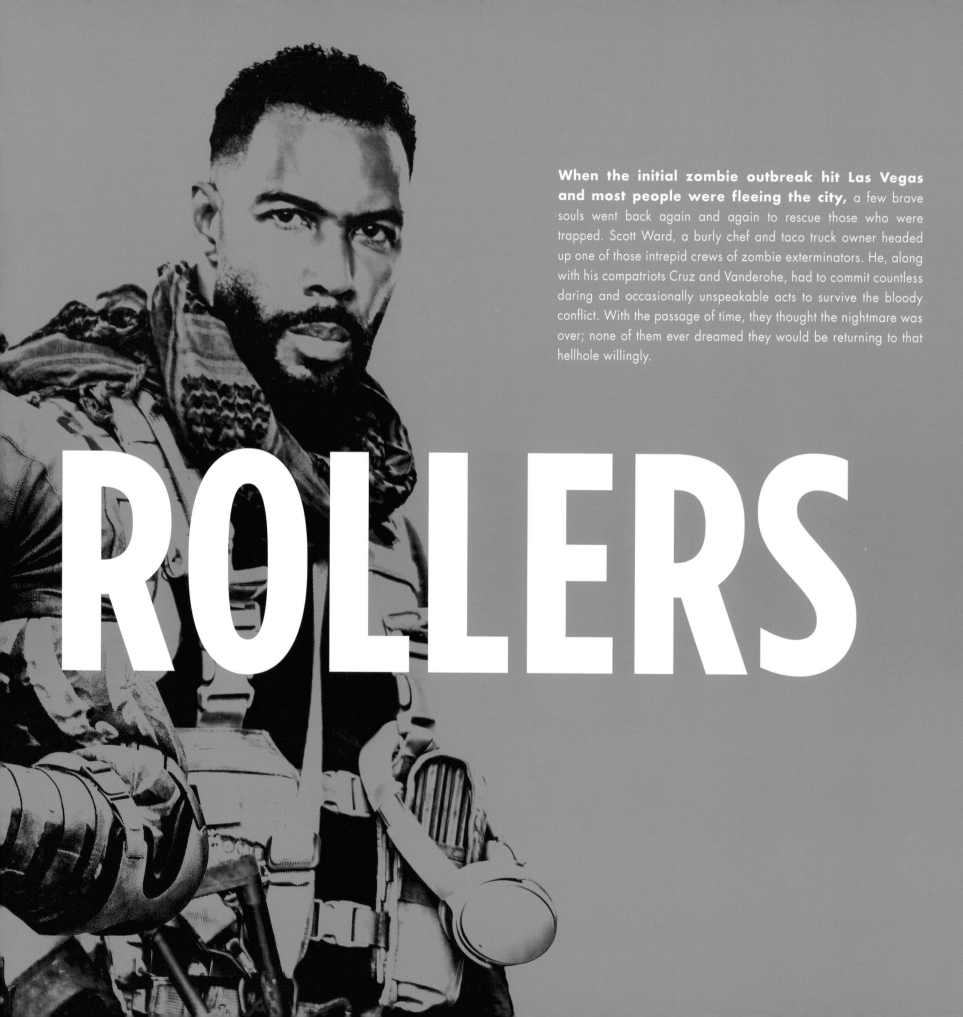

When the initial zombie outbreak hit Las Vegas and most people were fleeing the city, a few brave souls went back again and again to rescue those who were trapped. Scott Ward, a burly chef and taco truck owner headed up one of those intrepid crews of zombie exterminators. He, along with his compatriots Cruz and Vanderohe, had to commit countless daring and occasionally unspeakable acts to survive the bloody conflict. With the passage of time, they thought the nightmare was over; none of them ever dreamed they would be returning to that hellhole willingly.

ROLLERS

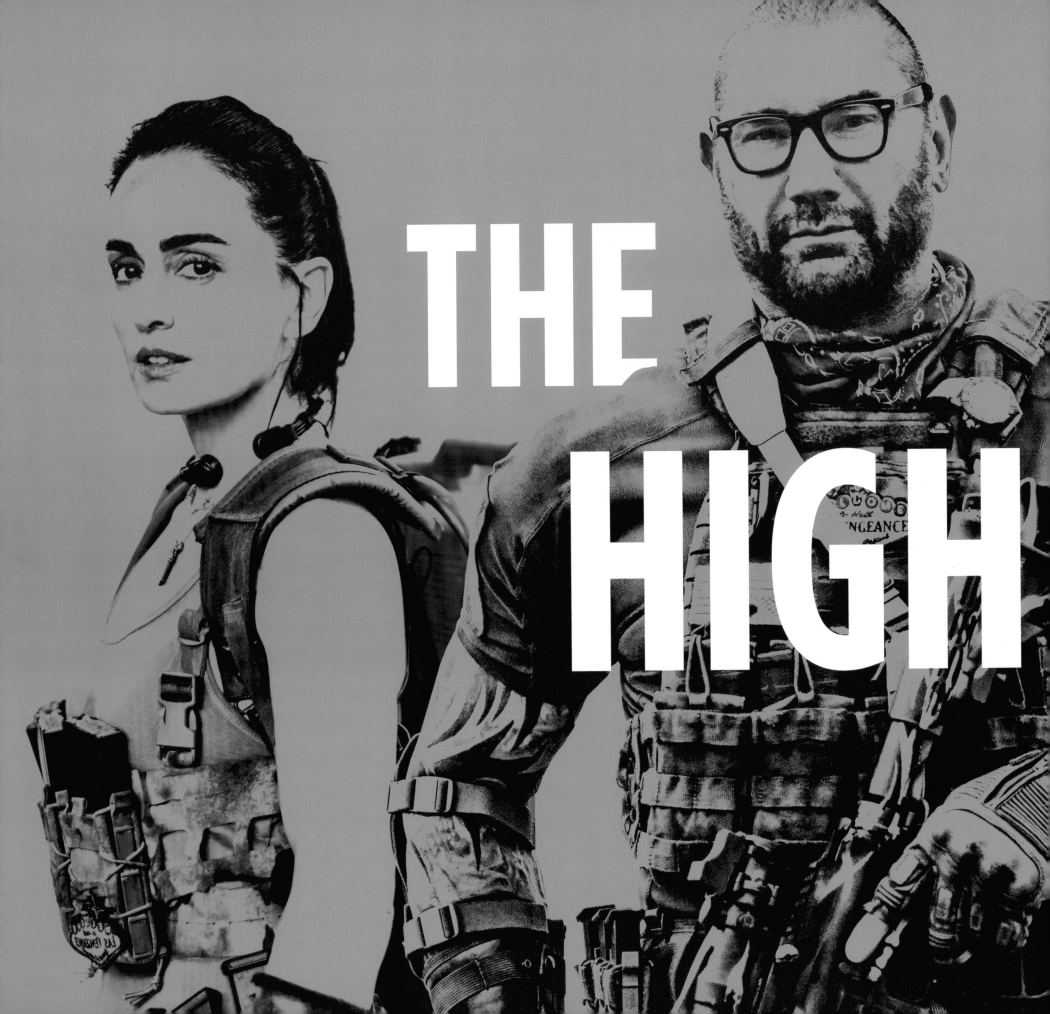

To add to the creepiness, Snyder shot much of the film with natural or minimal lighting. He was able to do this by not using the F-stop on the cameras and letting all ambient light in. "Jared over at RED has been amazingly supportive of helping me design and build these cameras especially for the movie, and I had it in my head that I would make the entire film without putting a stop on any lenses on the film. We shot the entire film wide open. Every shot in the movie," says Snyder. "The team that had to deal with me saying, 'No stop ever!' have risen to the challenge and done an amazing job. The movie is way more in focus than I thought it would be. It's .95 the whole movie, so it's crazy."

Dave Bautista, who plays Scott Ward in the film, can attest to the results. "I've been watching some of the shots and they're just so captivating. I couldn't look away. I think that's what's really gonna suck people in visually. He's creating something new, and something different and interesting. That goes back to Zack just being an artist, which is what I love about him," he says.

For Snyder, this film has been a homecoming in many ways, but he's made sure there's been some remodeling and upgrades. "It's been an artistically satisfying experience working with this team, with those cameras, with those lenses, and with this subject matter. It's been really fun," he says.

Will there be a homecoming for the team venturing back into zombie-infested Las Vegas in search of millions? That remains to be seen.

ABOVE/ Snyder discussing the scene with Bautista.

RIGHT/ Snyder will go anywhere to get the shot.

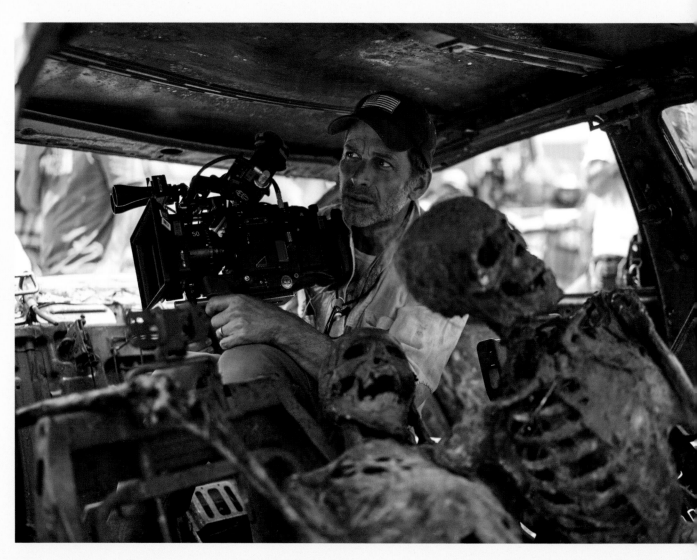

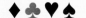

"THE SHOTS...
THEY'RE JUST SO CAPTIVATING.
I COULDN'T LOOK AWAY."

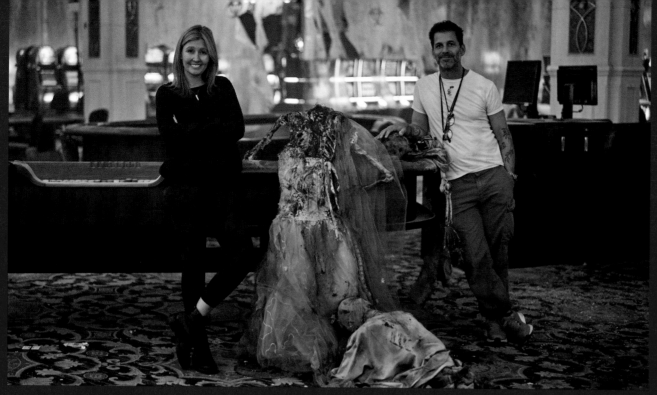

Interestingly enough, Snyder then decided he wanted to fit these brand-new cameras with fifty-year-old lenses. "I had done a lot of photography with these Canon Dream Lenses, built in the 60s by this Japanese lens maker," he says. "They're not perfect and they're weird, and there's just this super-shallow depth of field. But to me, it really gives this incredibly organic and beautifully soft look that I thought was a great contrast to this incredibly hard, unapologetic zombie film." Coller explains the effect the lenses have on the images captured, "The focus is very, very slim, and so in the dark scenes, in the zombie scenes, it gives you this great quality, where unless it's right in front of you, it gets mysterious and creepy pretty quickly as things fall off."

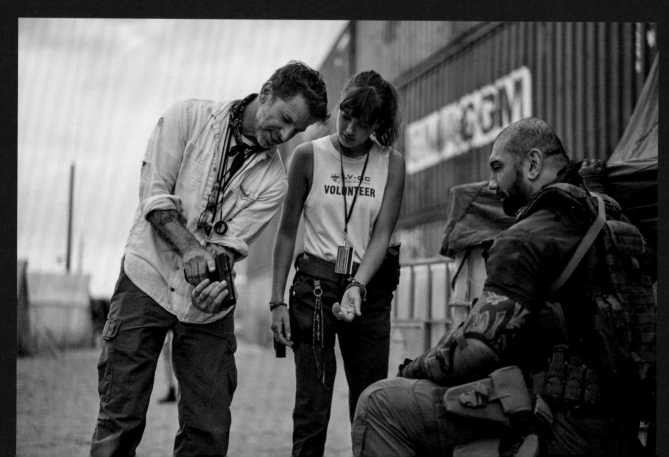

15

Army of the Dead represents another type of return for Snyder, in that he acted as his own director of photography (DOP) throughout the shoot. Snyder is credited as producer, director, "story by" writer and screenwriter, cinematographer, and camera operator B camera for *Army of the Dead*—something he hasn't done professionally since his days as a commercial director. "I was a director/cameraman in the commercial world for twelve years. The majority of the spots I shot myself," Snyder says. Only recently had he gotten behind the camera—literally behind the camera—once again, in a serious way. "I had done this little iPhone [short] film [*Snow Steam Iron*] a couple of years ago, and it got me reconnected with the camera and reconnected with my shots, because it was just me and the camera," he explains. "I was like, 'Wow, this is really fun. I'm kind of—I'm OK at

this!' So, it felt like a great opportunity to continue that conversation."

Of course, a Snyder project always comes with a twist, or even two or three. For one, this will be the first feature he's shot using digital cameras. "Zack, for as long as I've worked with him, has always shot on film," says Coller. "Jarred [Land] from RED [Digital Cinema] approached Zack a couple of years ago, as the Monstro [digital camera] was being developed, and gave Zack a Monstro. He just said, 'I want you to have it. I want you to have fun with it.'

Literally, over the course of a year, Zack shot all sorts of random stuff around the house and got to know the camera inside and out. I think what we realized is that digital cameras had evolved to a place where he wasn't compromising by shooting digital, and so we decided to go down that path."

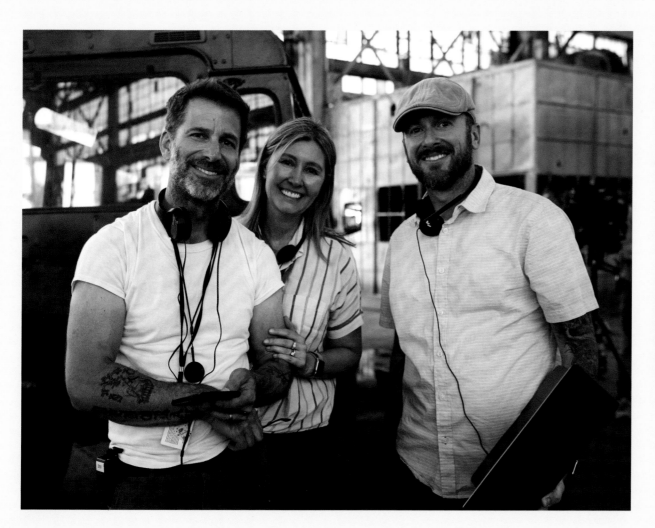

LEFT/ Zack and Deborah Snyder and Wesley Coller on set.

ABOVE/ Snyder has a sit down between takes.

greed, mass consumerism, or any of a number of cultural ills, zombie films and television shows have been vehicles to send them lurching into the light so that we can look at them from a new perspective.

Snyder explains that placing the action in a once-glitzy, over-the-top Las Vegas was perfect for that very purpose. Whereas *Dawn of the Dead* was the "wish fulfillment of being in a mall with no rules. Vegas is then the next ultimate playground to examine. When you go to Vegas, everything is an extreme of reality, in every way—the ultimate fun-house mirror that lets you see a distorted vision of yourself," he says.

When Snyder felt it was finally time to revisit the zombie genre, he decided to revamp the feature screenplay he'd developed over a decade earlier. Then Netflix expressed an interest in getting the project off the ground immediately, and Snyder knew he needed a writing partner to help speed things up. Coller says, "We brought Shay [Hatten] in and sat down with Zack and tackled the work of rewriting the screenplay, and it was amazing the ease with which the ideas came together and flowed." Deborah Snyder agrees that the *John Wick: Chapter 3 – Parabellum* scribe infused the script with an irreverent and bold energy. "It's really balls to the wall, no holds barred. It's pretty fun and bombastic," she says.

PREVIOUS PAGE/ (Top Left) The intrepid camera department. (Top Right) Zack Snyder and Dave Bautista discuss the next scene. (Bottom Left) First assistant director Misha Bukowski likely pointing out an approaching zombie horde to Deborah and Zack Snyder.

BELOW/ Zack Snyder captures the action.

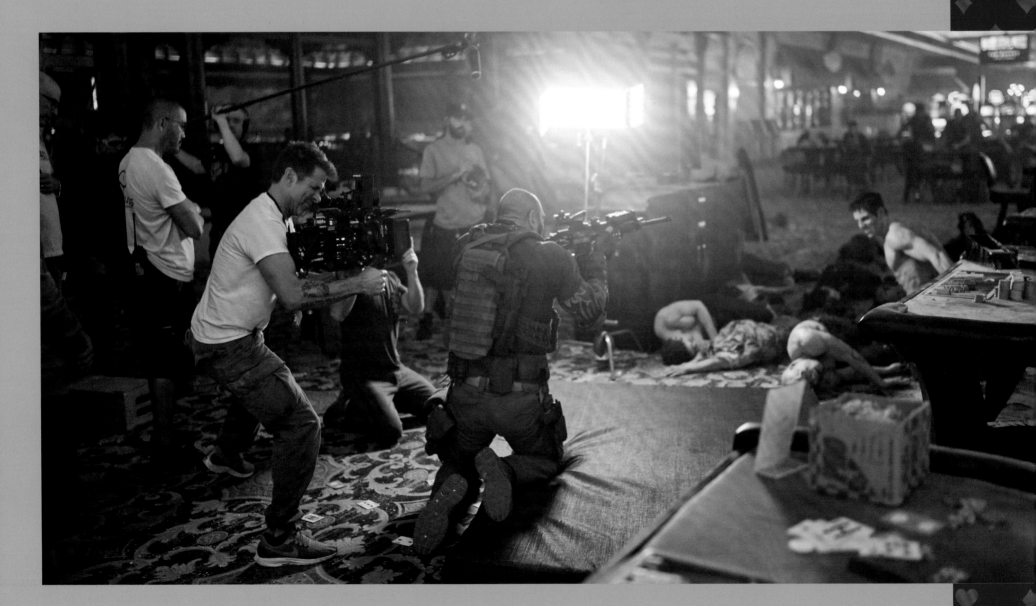

Snyder concedes that can be like walking a tightrope, but therein lies the joy. "The fun of doing a genre-busting film is that you have to satisfy the basic need of the genre film, but if the film is too genre perfect, you know how it's going to end, right?" he says. "You have to acknowledge what would happen, what is natural to the genre, but at the same time subvert it. Project the audience's expectation for that outcome and then turn it on its head. Get them back, and then do it again and again and again."

Snyder's deep grasp of the zombie as a film subject brings with it an appreciation of their use beyond violence and gore. "The thing that makes the zombie genre timeless is the fact that most of the time it's not about zombies at all. It's about the human condition," says producer Deborah Snyder. "When faced with zombies, you see the worst and best of humanity." Since George Romero's seminal *Night of the Living Dead* (1968), social commentary has walked hand in hand with the dead. Whether it has been racism,

ABOVE/ Bautista and Ana de la Reguera show off their new rides.

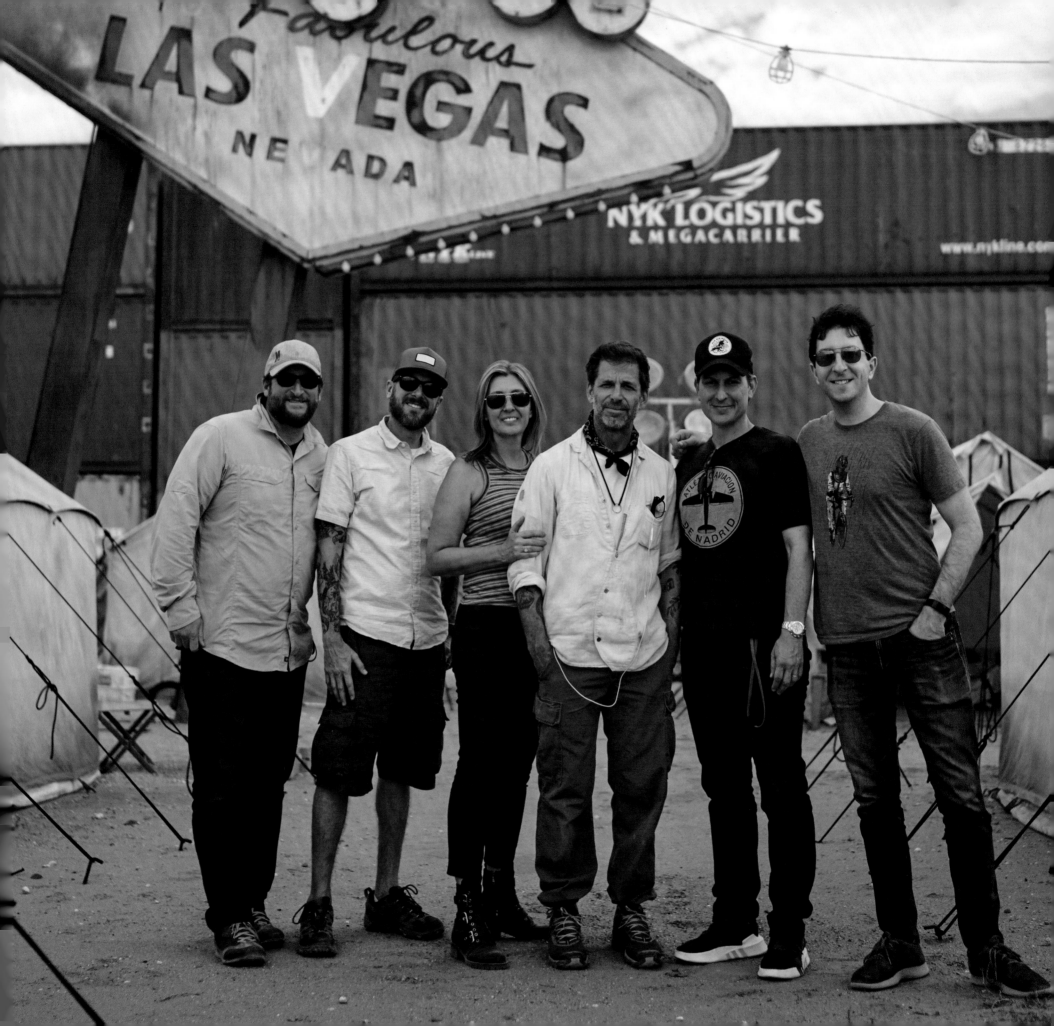

THE *SHUFFLE*

INTRODUCTION

Zombies... These reanimated corpses that feed on the living have been recurring antagonists in popular media for over fifty years. Sometimes in vogue, sometimes out, but they always seemed to be shuffling in the background. They've been enjoying a major resurgence since Zack Snyder shocked new life into the genre with his reimagining of *Dawn of the Dead* (2004), his first feature film. His sprinting zombies were a welcome innovation that seriously upped the terror factor of these otherwise familiar ghouls.

Army of the Dead then, despite taking place in a completely separate cinematic universe, represents Snyder's return to a subject very near and dear to him. In fact, the thought of making another zombie movie occurred to him right after completing *Dawn*, but other projects kept it on the back burner. Even then, he knew he had to put his own novel twist on it to keep at bay any accusations that he was simply trying to copy his early success. His solution: set it in Las Vegas and add a heist.

"*Army of the Dead* is a zombie heist film, where the zombie plague found its way to Vegas," Snyder explains. "In order to stop the plague from spreading, the government built a wall around Las Vegas. Then some time later, a rich casino owner hires a group of ex-zombie-killers to enter the city and get the money he left behind. So, it has this element of classic zombie warfare, as well as breaking into a casino, finding the safe, getting the money, with the constant threat of being eaten by a zombie—which is not cool, if you can avoid it." He also decided they needed to have two distinct kinds of zombies (more on them later). Add a ticking clock in the form of a planned nuking of the city, and you have the recipe for a high-stakes, action-packed, blood-pumping thrill ride.

Successfully mashing up one venerable genre with another takes quite a bit of skill. "Zack brings a boldness and unapologetic approach," says producer Wesley Coller. "Zack has proven himself to be one of the best when it comes to leaning into tropes or deconstructing a genre, not being afraid to completely swim upstream and do something different. The fearlessness he brings as a director in terms of the ideas and the way he decides to shoot it, keep it from falling into the realm of 'Oh, just another zombie film,' or 'Just another superhero film.' Zack has, time and time again, proven himself to be someone who's not afraid to think outside the box."

OPPOSITE/ Netflix manager, physical production Mike Bartol, producer Wesley Coller, producer Deborah Snyder, director Zack Snyder, and Netflix executives Ori Marmur and Andrew Norman on set at the McCarren Camp Detention Facility.

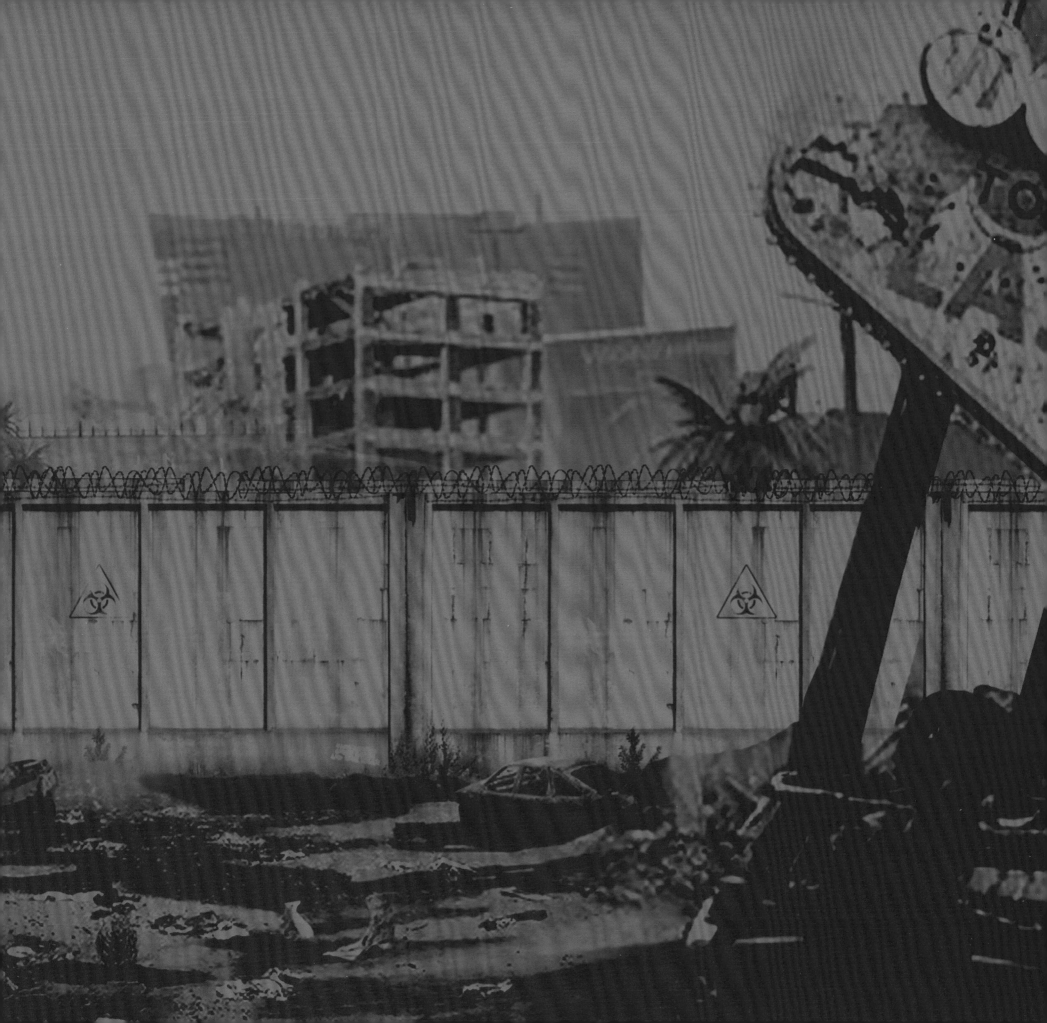

FOREWORD

BY SHAY HATTEN

In January 2019, I got a call from my agent asking if I was a fan of Zack Snyder, to which my immediate response was "Um, of *course*." *300* (2006) was the second R-rated movie I ever saw in theaters (I still remember the weeks of lobbying I had to do to get my parents to take me to see it), and to this day, few moviegoing moments have ever topped seeing Gerard Butler's King Leonidas yell, "This is Sparta!" before kicking a messenger into a well, and hearing the ensuing cheers of the packed audience. Other moments from Zack's filmography—such as the zombie baby from *Dawn of the Dead* (2004)— have similarly been burned into my brain since my earliest days as a lover of movies. These films were no doubt largely responsible for instilling in me the love of a genre that has fueled my work thus far, so the prospect of getting to collaborate with him on something was beyond exciting.

When I first went to meet with Zack about coming aboard to help write *Army of the Dead*, I didn't know what the project was about, but within thirty seconds of him starting to pitch the idea, I knew it was something I wanted to be involved in. "A mercenary crew ventures into a zombie-infested Las Vegas to pull off the most dangerous heist of all time." Who wouldn't be enticed by that log line? It was an idea so good, I'm tempted to lie and try to take credit for it. It wasn't just the prospect of contributing to the zombie cannon—it was the fact that I could immediately tell that Zack's intention with this project was to make something that transcended any single genre. Was it going to be a heist movie? A zombie movie? A comedy? A throwback to the kind of over-the-top, self-aware action movie that doesn't get made anymore? The answer to all of those questions seemed like a glorious and resounding "yes." It was that balance of different tones that made me so excited about the possibilities of the story. It was an idea that would refuse to be constrained by the rules of any one genre—that begged us to mix and match the tropes and expectations of different genres to create something fresh. (I can say all of this objectively, because all the credit goes to Zack—when I came onto the project, so much of it was already crystal clear in his head, and a large part of my job was just trying not to mess up a vision that was already so vivid and exciting.)

Working on the script was a blast, and walking the constant tightrope between different tones was a fun challenge as a writer—but the best part of the process was always reading pages Zack had written and being able to precisely envision what the final product would look like. The sequences were already fully formed in his brain, and seeing how he transferred action ideas onto paper made me a better writer. Visiting the set and walking through the recreation of the demolished Vegas strip was one of the absolute highlights of my career thus far.

Of course, since we embarked on our draft of the script, the world has changed radically. In the imagined future of *our* story, a deadly outbreak has altered life in America forever, and the kickoff to the story is the President making the questionable decision to drop a nuke on American soil because he thinks it'll be cool—with no regard for the consequences. I'm sure I don't need to belabor the parallels between our story and the realities that were unfolding in the real world as the movie was actually being made. But in our film, against the backdrop of a divided country, the message only stands out more clearly—in a harrowing time, when people are making selfish choices driven by greed, it ends up being the love of family that matters more than anything. Even in the context of our wild zombie movie, I hope that's a message audiences take to heart.

And to that end, I hope the movie accomplishes what was always its primary goal—to offer viewers a fun escape. I'm beyond excited for people to see what we've come up with. As I write this, even I haven't seen the 100% completed version of the movie. And just as a fan of crazy violence, I can't wait to see the finished version of the scene where the zombie tiger rips [character name redacted]'s face off. I'm thrilled to have been a part of this project. I hope people enjoy it, and I hope people come along for the insanity-filled ride of the future installments as well. Things only get crazier from here.

CONTENTS

A FILM BY ZACK SNYDER

ARMY OF THE DEAD

THE MAKING OF THE FILM

WRITTEN BY **PETER APERLO**

PHOTOGRAPHY BY **CLAY ENOS**

TITAN BOOKS

ARMY OF THE DEAD
THE MAKING OF THE FILM

ISBN standard edition: 9781789095425
ISBN limited edition: 9781789097276

Published by Titan Books
A division of Titan Publishing Group Ltd.
144 Southwark St.
London
SE1 0UP

First edition: June 2021
10 9 8 7 6 5 4 3 2 1

ARMY OF THE DEAD ™/© Netflix. 2021. Used with permission.

ILLUSTRATIONS by Adam Forman, Natasha MacKenzie, and © Shutterstock.

DID YOU ENJOY THIS BOOK?
We love to hear from our readers. Please e-mail us at: readerfeedback@
titanemail.com or write to Reader Feedback at the above address.

To receive advance information, news, competitions, and exclusive
offers online, please sign up for the Titan newsletter on our website:
www.titanbooks.com

A CIP catalogue record for this title is available from the British Library.

Printed and bound in China.

A FILM BY ZACK SNYDER

ARMY OF THE DEAD

THE MAKING OF THE FILM

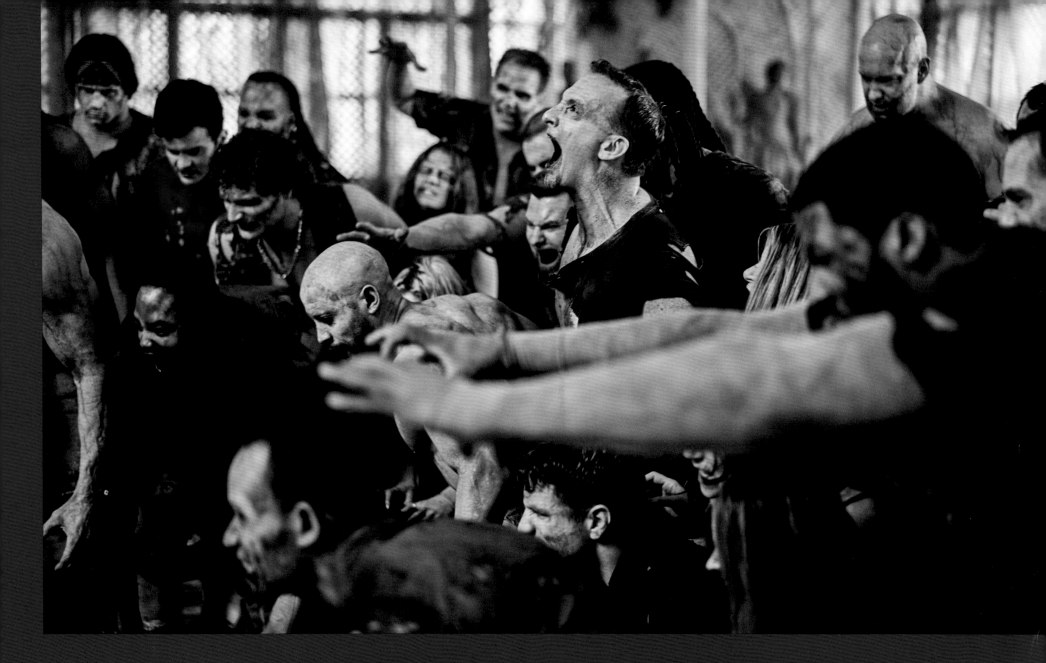

The newest breed of zombie, they are faster, stronger, more agile, and smarter than even the 'fast zombies' of Snyder's *Dawn of the Dead*. They are the Alphas, whose very existence is known to only a few in the outside world.

"The Alphas evolved out of this idea of what we would become if the zombie plague made us stronger, as opposed to decomposing. We're getting better, and other parts of our bodies are getting more fine-tuned," explains Snyder. Part of being "more fine-tuned" includes how coordinated the Alphas are. "A specific thing that sets them apart is there is a tangible awareness, a tangible connectedness," says

Coller. "We like to say that they're reminiscent of wolves, that there is a pack mentality. They understand their surroundings and each other."

That primal awareness gives rise to an instinct never before seen in zombies: self-preservation. "Imagine a zombie that doesn't want to get shot in the head, and that understands that that's its most vulnerable point," says Snyder. "So, they have this instinctive understanding that if they move back and forth very quickly [they can avoid that]. If you've ever tried to shoot something running right toward you [like that] and you have to hit it directly in the forehead, it's pretty much impossible. So, our guys have to really be on their game."

OPPOSITE/ Zeus assembles the Army of the Dead.

ABOVE/ The Alphas smell blood.

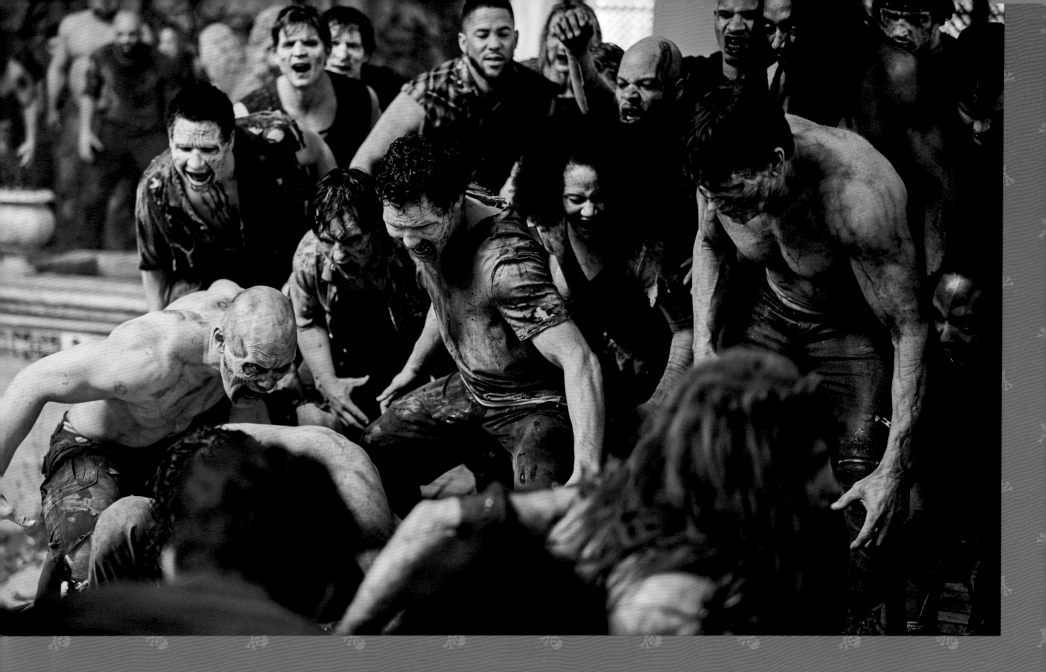

For the performers portraying them, learning the 'Alpha zigzag' took some doing. "We had a couple of movement specialists on our core stunt team, and once we developed the movement, we taught all the stunt people," says stunt coordinator Wayne Dalglish. "There were even extras that came in, and we had to put them through some workshops as well, so everybody moved the same. They ended up looking awesome and moving well."

That acknowledgment that Alphas have a basic sense of self makes it possible for the audience to have some degree of empathy for them, one of

Snyder's goals from the outset. "My hope was that we could create a zombie movie where you sympathize with the zombies," he says, "and that's difficult to do, because most zombies aren't protecting anything, they're not emotional. They're just these mindless things, so they're kinda hard to like."

Organized under the leadership of Zeus (see page 113), the Alphas can even be bargained with, to a certain extent. "They're starting to have some sort of primitive culture, allowing people to negotiate with them on the most basic level," says Snyder. "They will still tear you apart and eat you, but there is

some moral code that they operate under. It's not too specific, but I wanted you to feel that they have a sense of duty and honor." Just don't dare to double-cross them.

THEY ARE INTELLIGENT AND STILL VERY AGILE AND POWERFUL.

The job of creating the unique look of the Alphas went to Raleigh and his talented team at Fractured FX.

"The challenge with the Alphas was to make them look very different, since they are intelligent and still very agile and powerful," Raleigh explains. "We wanted to give them a taut, sinewy kind of look, where it feels like they're just vacuumed out to pure muscle. Super-lean swimmer's body, with zero body fat, very vascular, and have a certain level of translucency [to] the skin, so you're starting to see the vein and artery network, start to see the separation of muscle sinew. Also, a gaunt, powerful look in their facial features, as well."

Attaining the desired look that was both fantastic yet anatomically realistic took a considerable amount of research. "We started looking at translucent shrimp and weird aquatic kinds of things to get that translucent look to the flesh. [We] even looked at Gunther von Hagens' Body Worlds kind of stuff to see what the anatomy looks like, and see all the capillaries and vascularity to the body," says Raleigh.

All that required the application of massive amounts of silicone prosthetics. "The average, generic Alpha was about two and a half hours. For any of the heroes [Alphas seen close up onscreen], two and a half to three hours with two makeup artists," Raleigh says. The results speak for themselves: The basic look of the Alphas and their rapid movements were all captured in camera, with little to no visual effects enhancement added in post-production.

THIS SPREAD/ Alphas congregate around the indoor pool at the Olympus Hotel.

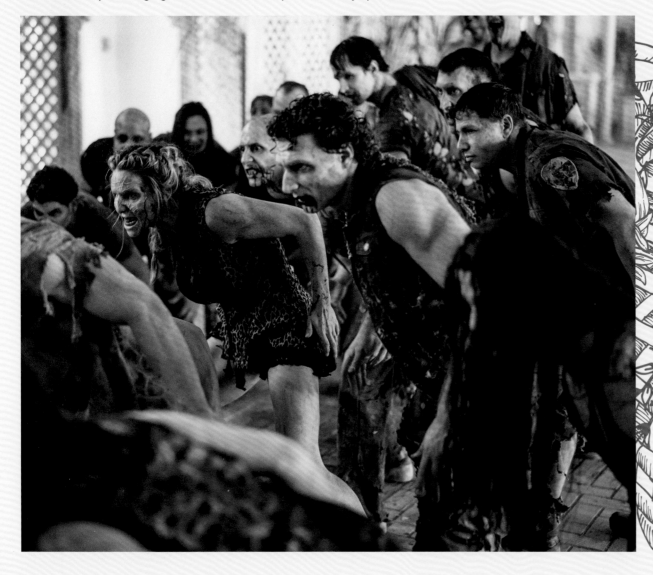

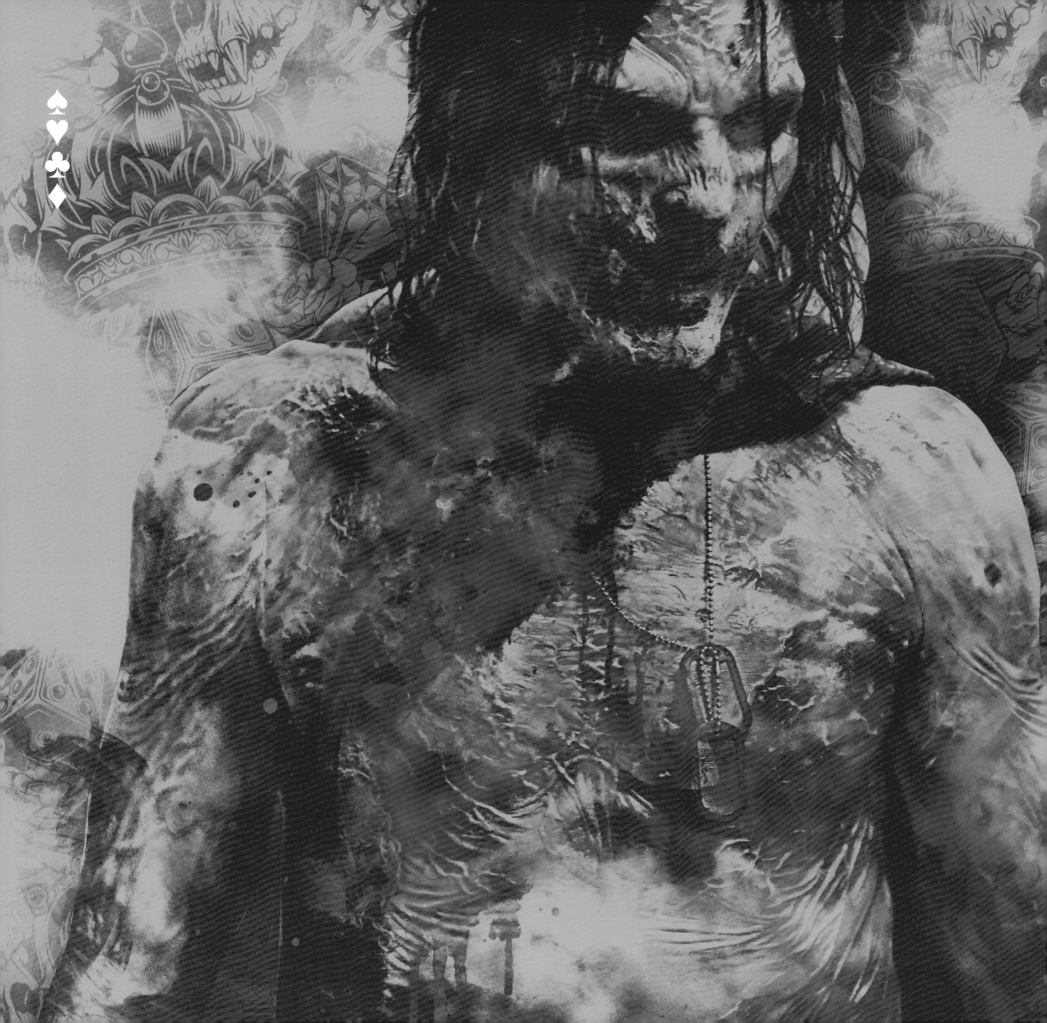

ZEUS
NOT YOUR TYPICAL MONSTER

The alpha of the Alphas, Zeus is not only their leader, but their 'father' as well. Only a bite from Zeus himself results in the creation of an Alpha. "Depending on your importance, your physicality, if you're a good candidate, then Zeus is more likely to turn you than if you were caught randomly. Zeus is doing that in a very careful way. He's not just turning anyone into an Alpha. He's very deliberate. It's like joining a club," explains Snyder.

Zeus's origin takes place off-screen, but it comes about as a result of a military experiment gone terribly wrong. An unfortunate highway accident while he is being transported out of Area 51 then unleashes him on an unsuspecting Las Vegas. Snyder is quick to point out that Zeus is not your typical monster, however. "Most movie monsters are ambitious in that they want something, they're attacking you," says Snyder. "With Zeus, if you analyze each scene that he's in when he's attacking someone, it's because he's been betrayed or double-crossed.

ZEUS HAS ASPIRATIONS AND HOPES AND DREAMS...

"The motivations for him fighting back always come out of him being defensive rather than offensive. I think that's an important thing. Zeus has aspirations and hopes and dreams, if you will, but he wants to be left alone. There's a line in the movie where Lilly the coyote says, 'You guys keep acting like this place is their prison. It's their kingdom.' That lets you know his motivation." Zeus and the Alphas could easily climb out of the city, but they choose to stay.

THIS PAGE/ (Left) Zeus (Rich Cetrone) consults with Zack Snyder and second unit director Damon Caro on his plan of action. (Center) Zeus hits the Strip. (Right) Zeus, present day.

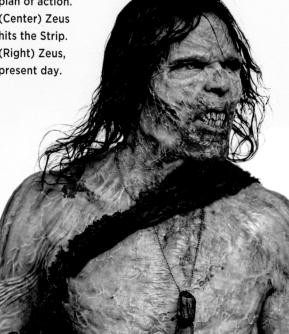

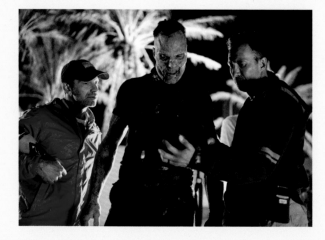

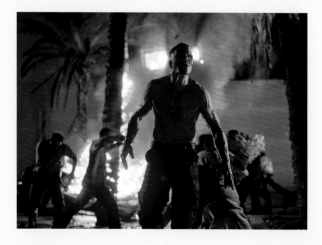

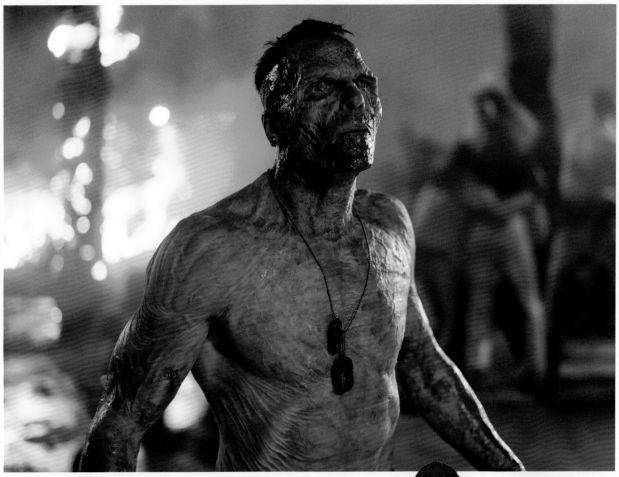

That distinction informed the look of Zeus. "The old him died, but he was not a dead thing, and that goes to the sympathy factor. How do you make him sympathetic with his skin falling off?" says Snyder. "That was the challenge I put to the makeup artist: 'Make him not horrible, but still scary.' So, his look was born out of an evolution that would allow us a muscular, leaner appearance, noble in some ways, with an alien sickness that mutated him into a creature without his previous consciousness."

Another way that Zeus and the Alphas are very different from your typical zombie is that they can heal, and they continue to age, after a fashion. This becomes clear when we meet Zeus again after his first violent appearance years earlier. "When we come back to him later, part of the story is he's got longer hair, and some of those old wounds disappear and are healed into scars. In a way, he's still living," says Raleigh.

Zeus and his Queen (see page 121) were among the most difficult and time consuming of all the characters to create using makeup effects. "He's covered from the waist up in twenty-four silicone prosthetics," explains Raleigh. "All of those pieces are intrinsically colored, and then back-painted. They're somewhat translucent and you get a level of magnification through the piece, so you can actually see a vascular system. Then once it's glued on him, it's painted extrinsically as well. He has a full silicone chest, with part of a stomach piece and a back piece, with oblique pieces that wrap around those; shoulder pieces that include deltoid, biceps, triceps, and forearm pieces; top of the hand piece; full neck; full silicone covering over the head, with six different facial appliances; and a full wig, contact lenses, and teeth. We got him down to three hours with two makeup artists—that was after several times of applying his makeup, and just figuring out a pattern that worked for him."

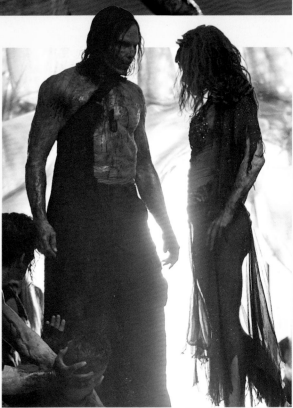

THIS PAGE/ (Top) Zeus surveys his new kingdom. (Above) Documents from Zeus's previous life. (Right) Zeus and his Queen.

Zeus is the leader
of the Alphas

Zeus's mask
makes it harder
to kill him

Zeus carries a
regal staff to
emulate a divine
thunderbolt

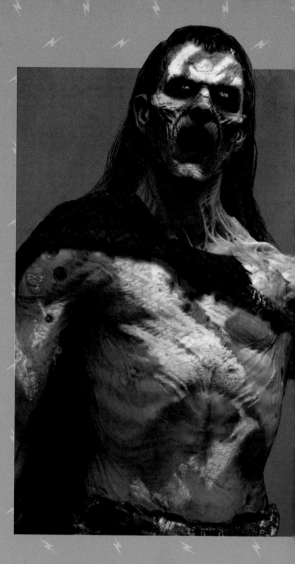

THIS PAGE/ Zeus concept art by
Jerad Marantz.

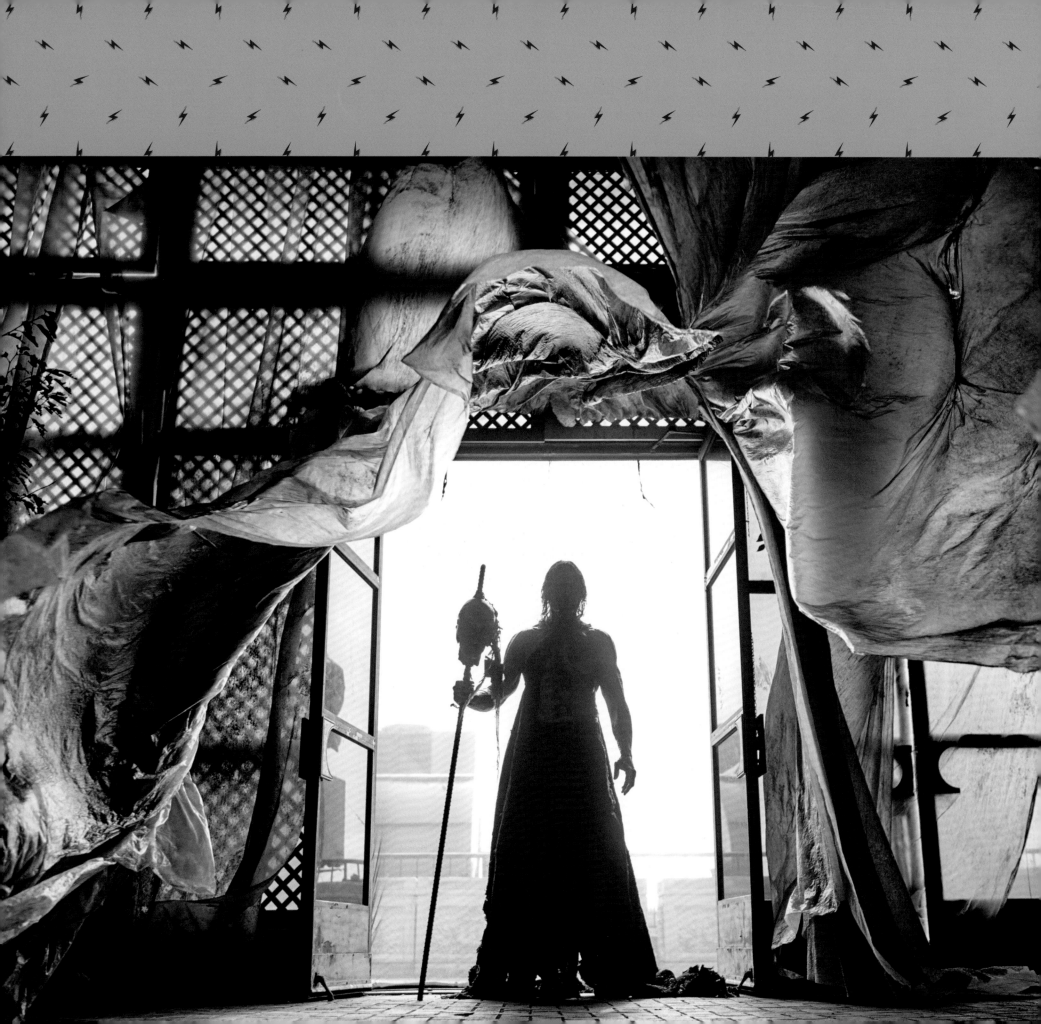

The man inhabiting the role of Zeus is Richard Cetrone (*Batman v Superman: Dawn of Justice, Solo: A Star Wars Story*), an actor and stunt performer who has worked with Snyder many times. It's a testament to Cetrone's skill that he is able to deliver such a range of emotions through layers of prosthetics, shown most powerfully when Vanderohe has several close encounters with Zeus at different points in the film. "What I think stands out about Rich's character [is] he's able to show his humanity," says Omari Hardwick, "and there were moments in the eyes of Zeus—and you can barely even see what color the eyes are—[when] there's those human connections, those moments where he respects Vanderohe and sees that Vanderohe sees something different in him."

BELOW/ Zack Snyder shows Zeus the proper stance with his staff.

OPPOSITE, BELOW, AND RIGHT/ Zeus and his staff at the Olympus Hotel.

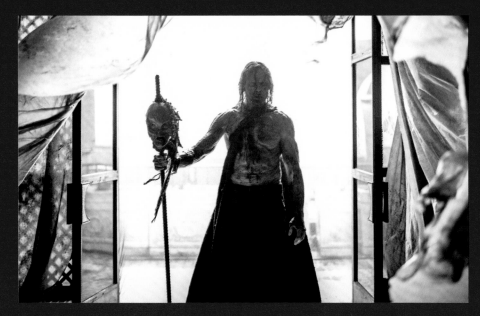

NEXT SPREAD/ Zeus triumphant over Las Vegas. Concept art by Jared Purrington.

ZEUS'S STAFF & MASK

Looking to a statue of the Greek god Zeus standing outside the Olympus Hotel as a personal role model, the leader of the Alphas even cultivates the look of the immortal. In addition to an off-the-shoulder cape reminiscent of a toga, he carries a regal staff intended to emulate a divine thunderbolt. "The weapon that Zeus is carrying is a piece of rebar that has been decorated with a head," says property master Brett Andrews. "We don't know what head is on there—someone he's killed to make his trophy—and then he has decorated it with everything from credit cards, playing cards of certain casinos in the area, chips, striations of feathers, and ribbon."

Unfortunately for anyone who would try to take him out, Zeus is intelligent enough to know that his head is his Achilles' heel, and he has acquired a bulletproof mask to protect it. "It's a ballistic mask that he took from some SWAT guy," says Snyder, "and he's figured out that you can't shoot him in the head. So, he's slightly unkillable."

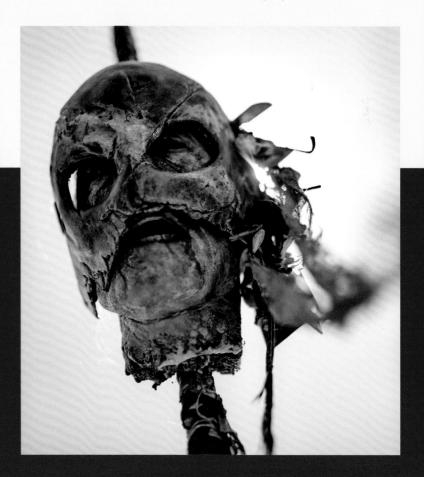

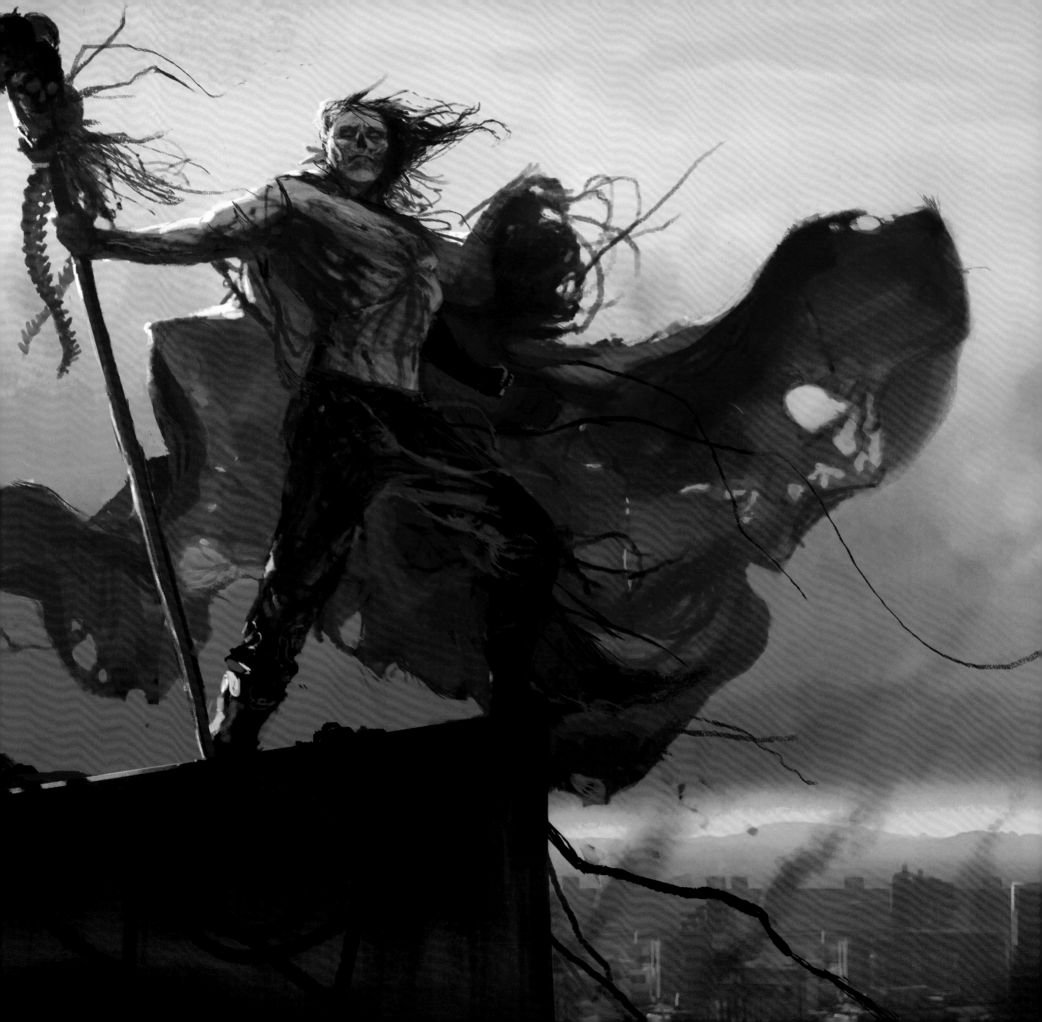

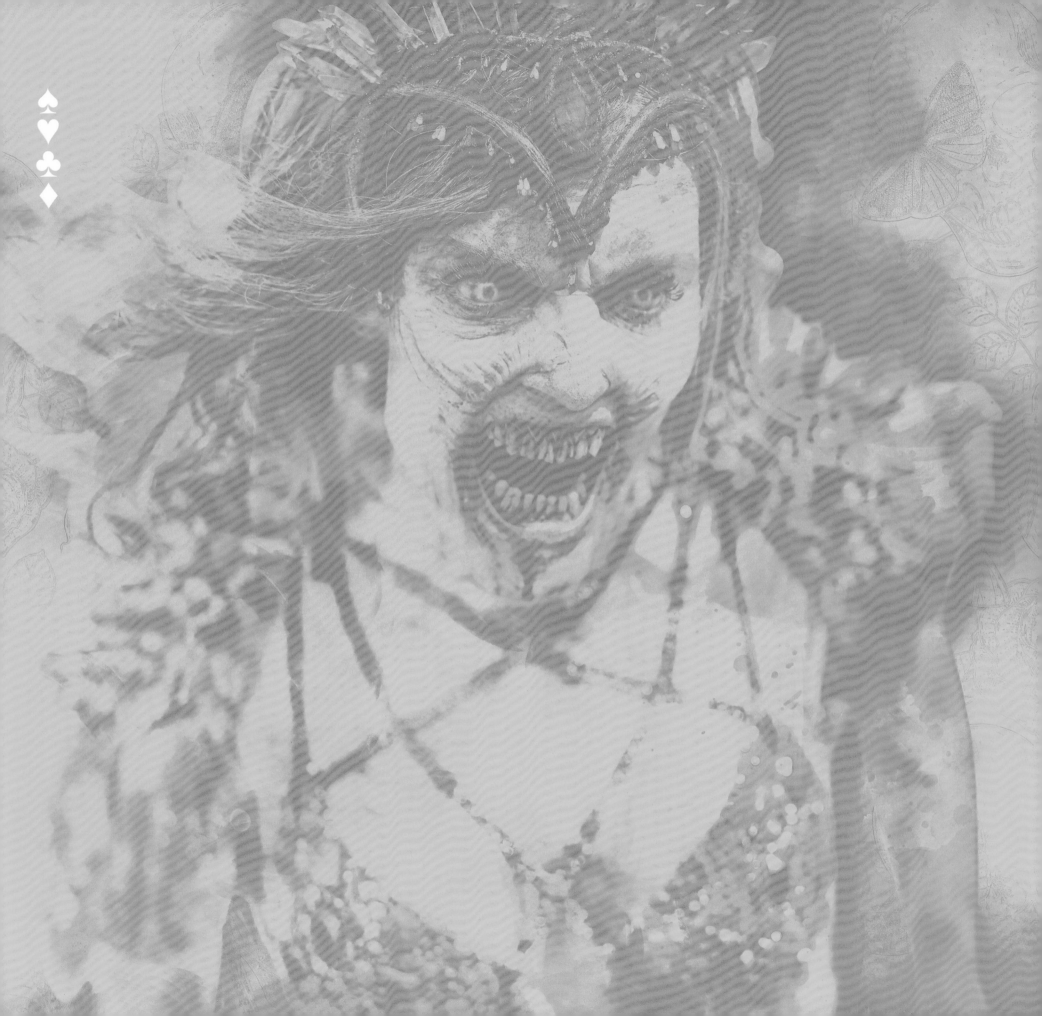

ZOMBIE QUEEN

WE'LL CALL HER QUEEN ALPHA

When it was decided that Zeus needed a queen, initial brainstorming suggested it might be fun to cast a well-known celebrity who happened to be performing in Las Vegas during the outbreak. However, as the screenplay developed and the Queen took on a larger and more crucial role in the narrative, it was apparent that her character needed to be organically grounded and not just a one-off gag. "The thing with the Queen is, her relationship with Zeus has to tell us something about this society and their ability to feel," explains Snyder.

Athena Perample (*Animal Kingdom, Terminator: Dark Fate*), an accomplished stuntwoman and actress, checked off all the boxes. "I met her and I was like, 'Athena is the Queen,'" says Snyder. "She embodies all the things you'd want: she's scary and beyond athletic, and so expressive with her eyes. It's a role you have

to do all your acting just with your facial expressions, even through makeup."

It took a lot of makeup to turn Perample into the showgirl-cum-zombie-matriarch. Her daily treatment was closer to that of Zeus than a regular Alpha. "She is also about twenty-two prosthetic pieces from the waist up—she had a bit of costume that would diffuse her stomach area—but full arms that are exposed, and full head, wig, contact lenses, and teeth. Athena was around three, three and a half [hours] with everything," says Raleigh.

"The Queen really jumped off the page and became something else—the movie became something else—once we found Athena," says Snyder. "When you look at her physicality and acting ability, very few actors could have done all of the things that Athena could. I couldn't be happier and more excited about the job that Athena did, and how lucky we are to have her."

THIS SPREAD/
The Zombie
Queen (Athena
Perample) is
beyond fierce.

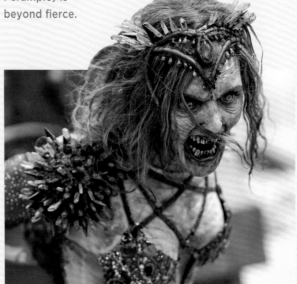

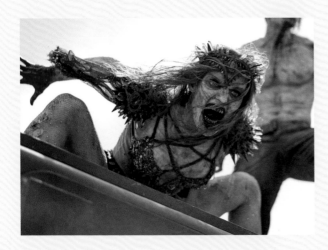

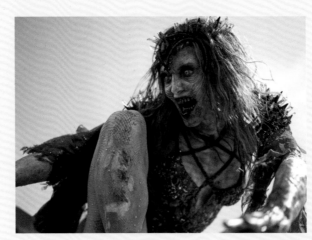

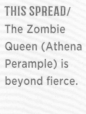

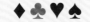

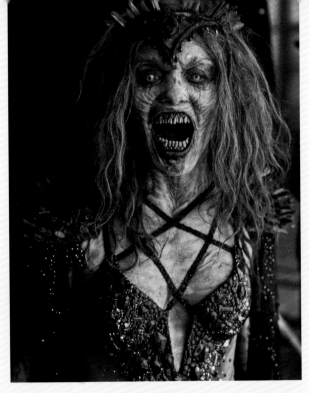

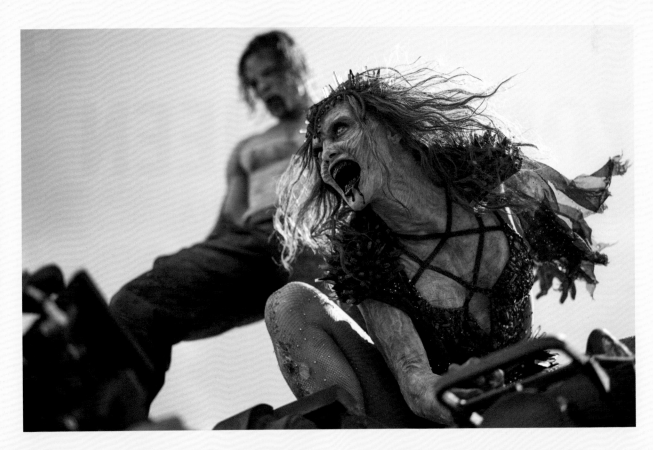

THIS PAGE/ The Zombie Queen and her general return with a prize.

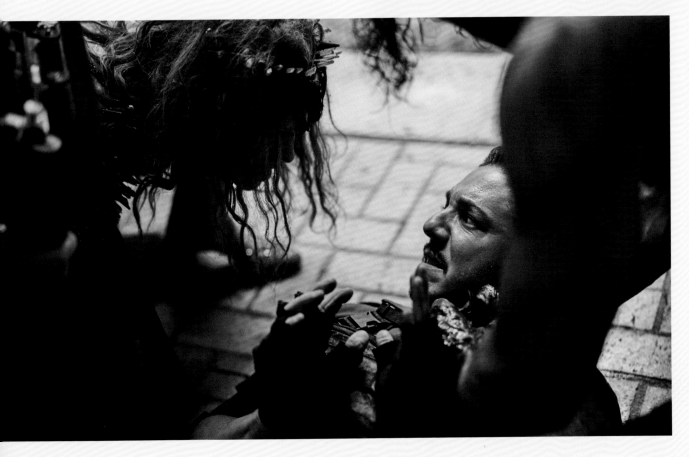

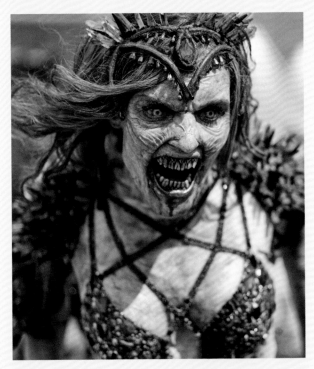

OPPOSITE/ Costume concept art for the Queen by Alan Villanueva.

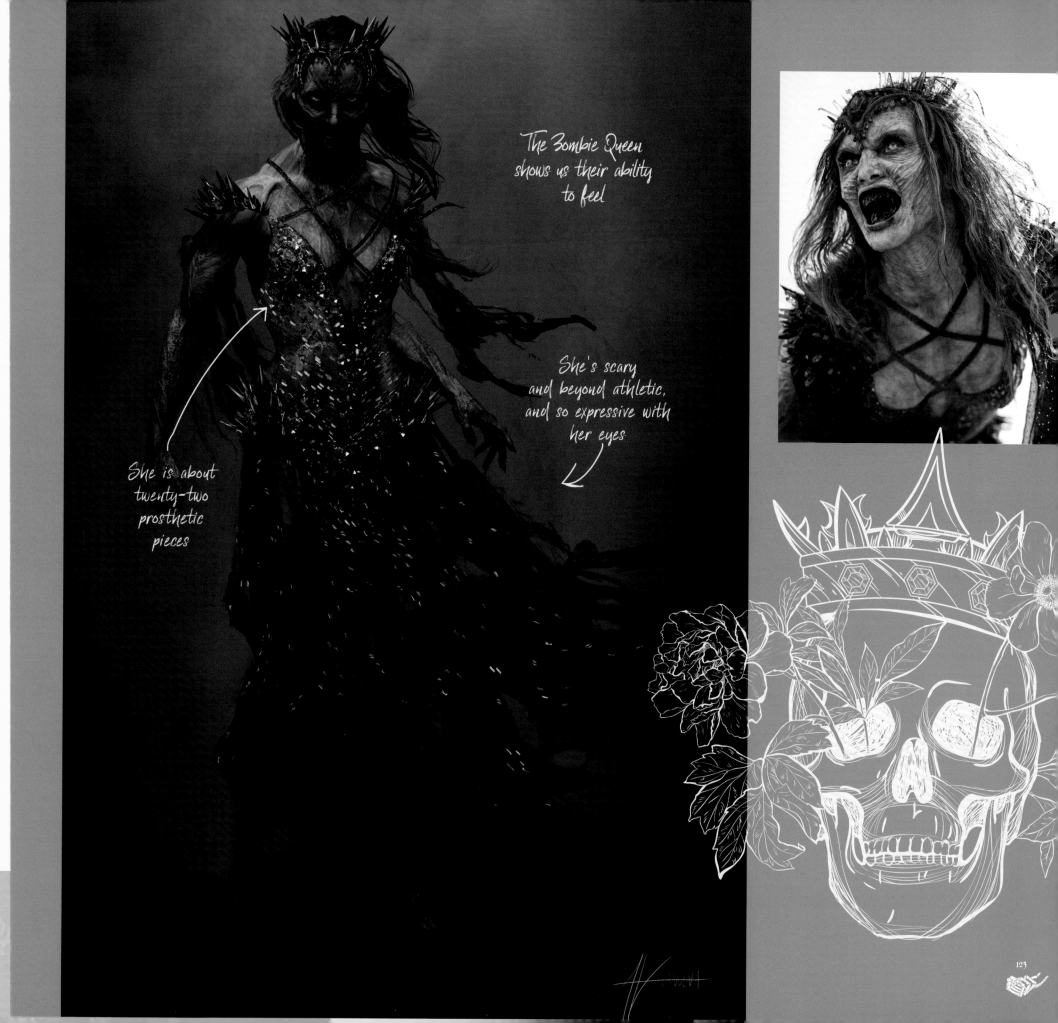

The Zombie Queen shows us their ability to feel

She's scary and beyond athletic, and so expressive with her eyes

She is about twenty-two prosthetic pieces

123

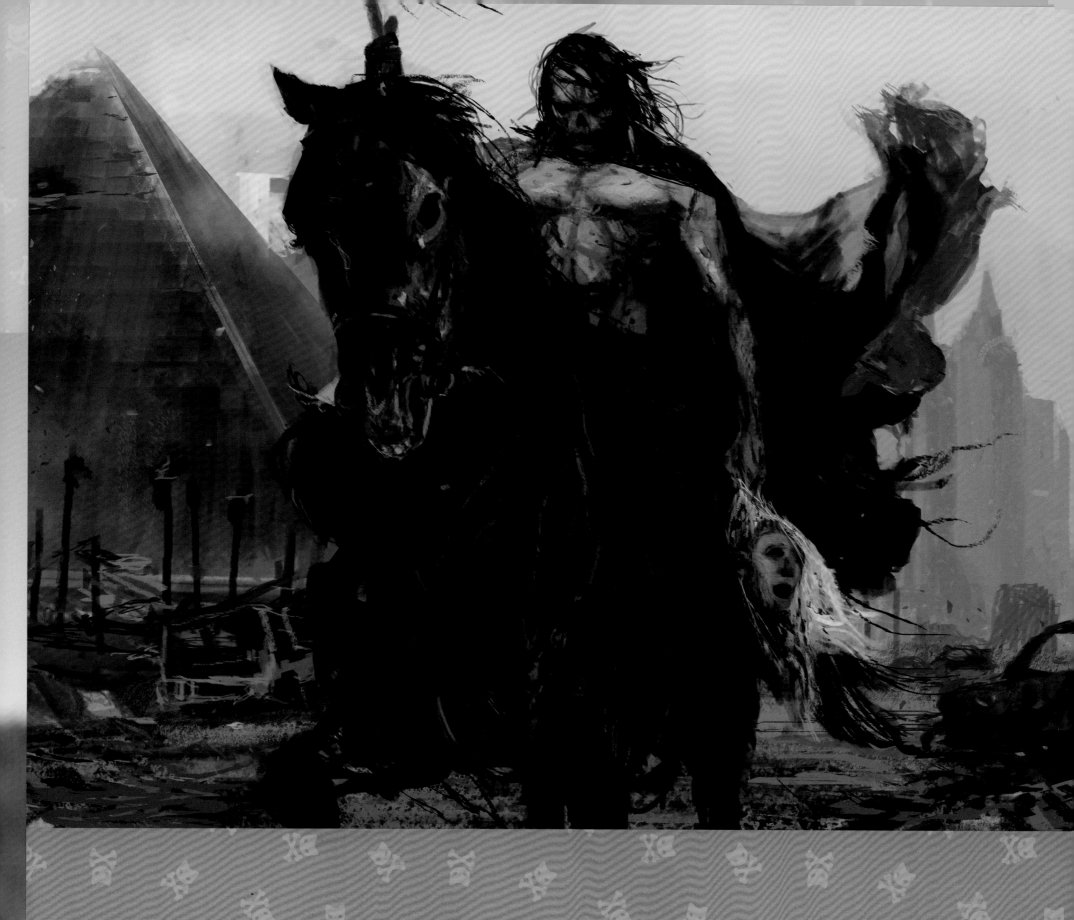

Taormina observes that, despite the long development time, only minor changes and modifications were made to the build, thanks to the strength of the early concept artwork. "Her eyes, for instance, changed to more of an Alpha yellow from the ice blue that the concept portrayed. We also discussed where she had come from and how she got turned into an Alpha tiger, and concluded [that] Zeus bit her. So, we needed to add a visible bite mark," he says.

While the Valentine that appears onscreen is a completely CG creature, makeup effects built custom green-screen elements for the cast to interact with in the real world. Those made for more authentic movements and reactions. "We built an interactive, puppeteer-able tiger head that was to scale, so we could use that for interaction, but it was completely skinned in CG," explains Raleigh. "We also had some attack paws, basically shoulder down to paws, that could be used for insert shots." Finally, Taormina says, "We shot each Valentine scene with Albert Valladares, a very talented stunt performer, acting as a sauntering tiger for cast eye-lines and interaction.

"Everyone involved has given Valentine the attention she deserves, the same attention Zack asked me to give to her from the beginning," Taormina concludes, "and she speaks for herself onscreen."

Snyder recruited special makeup effects artist and creature constructor Gabe Bartalos, head of Atlantic West Effects, to develop a practical zombie steed for Zeus, because he knew that he could do it—this is the eleventh zombie horse Bartalos has created during his long career. That experience brings with it a great deal of knowledge about how to ensure the live animal's comfort and safety. "The biggest challenge is that I'm an animal lover, and when you're working with animals, they can't talk," says Bartalos.

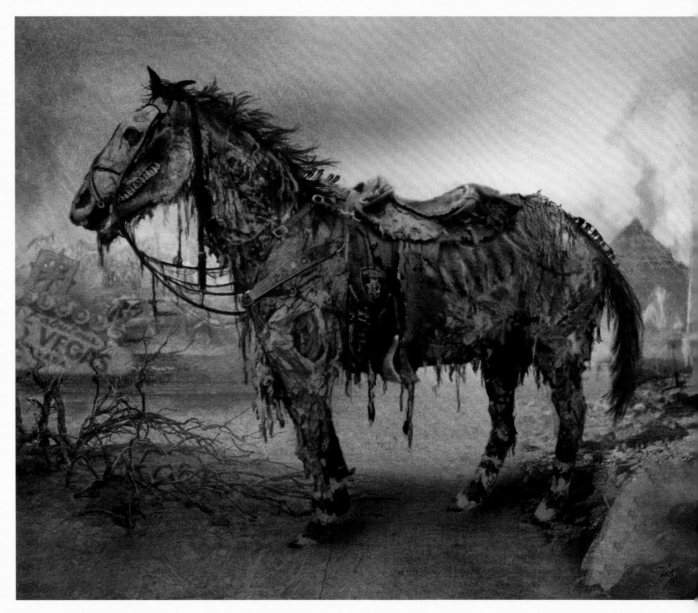

OPPOSITE/ *Zeus astride his noble steed. Concept art by Jared Purrington.*

ABOVE/ *Finished close-up of Valentine.*

RIGHT/ *Zombie horse concept by Gabe Bartalos.*

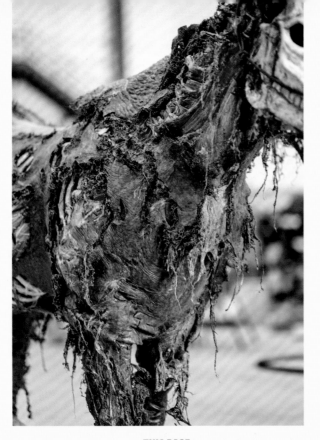

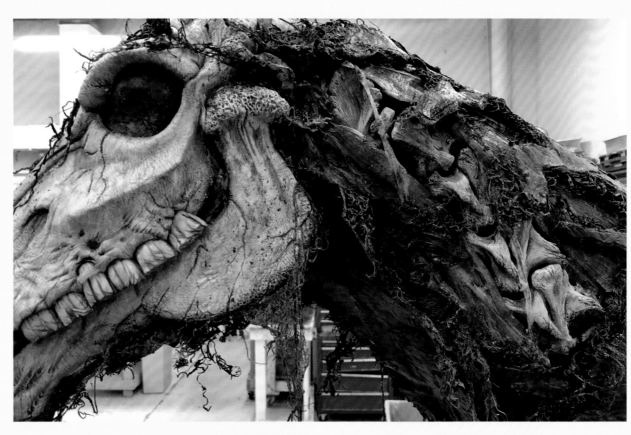

THIS PAGE/ Ace decked out in his zombie prosthetics.

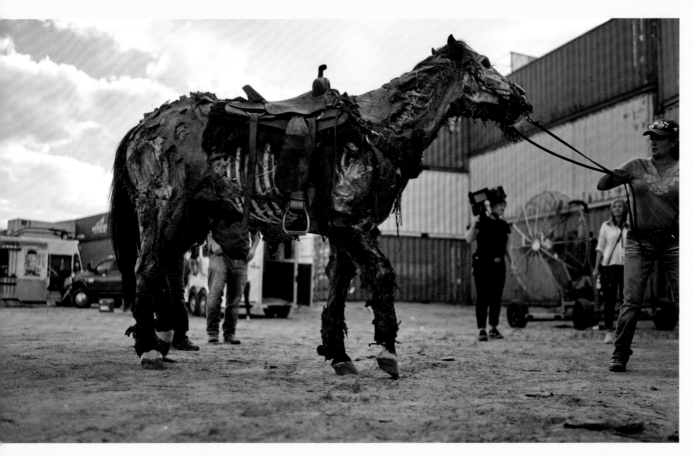

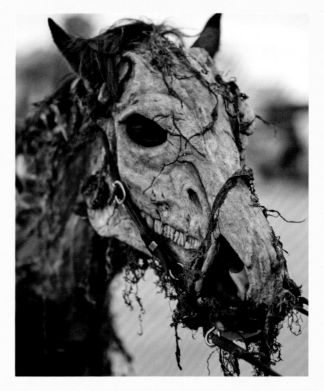

"They have their own way of gesturing, but it's not the nuances we need to know when we're working with actors." He adds that relying on the trainer's instincts is crucial. "Mary Towslee, the trainer, knows Ace the horse inside out, so we follow her lead. If she's happy, we know Ace is happy. The more comfortable Ace is, [the] better [it is] for us, because we get more shooting time."

The first thing Ace needed was a custom-fitted body stocking to glue the makeup appliances to. "We start at the beginning with the raw canvas," says Bartalos. "It's called super spandex. It's a four-way stretch. It's very tough, but we reinforce it. We figure out zippers and buckles that we can hide underneath. We did test fittings with Ace. We actually put it on and ran him around. We looked at our stress points, we looked at where it was baggy, and we literally marked it like we were tailoring a suit."

After they were satisfied with the body stocking, they could get down to sculpting the bones, the muscles, and any exposed innards. "All of them are made out of foam rubber, and they're backed with more of the super spandex. We can now glue and sew these into place. We looked at anatomy books to make sure the bones, the muscles were placed right. It's really cool seeing it all come together," Bartalos says.

The final looks applied to Ace reinforce his backstory of a police horse that had met its fate, only to gallop once more under the desert sun. "When we did the dressing, we looked at pictures of when animals—specifically deer and horses—decay," explains Bartalos. "It's very interesting: The skin begins to deteriorate, and what's left is all the veins and arteries. It becomes like this mesh of moss. So, we used a lot of organic materials suspended in latex and fused into the skin. If a vet is looking at it, he's gonna go, 'That's it. That's exactly what that would look like, except it's reanimated.'"

RIGHT/ Trainer Mary Towslee rides Ace into the Las Vegas wasteland.

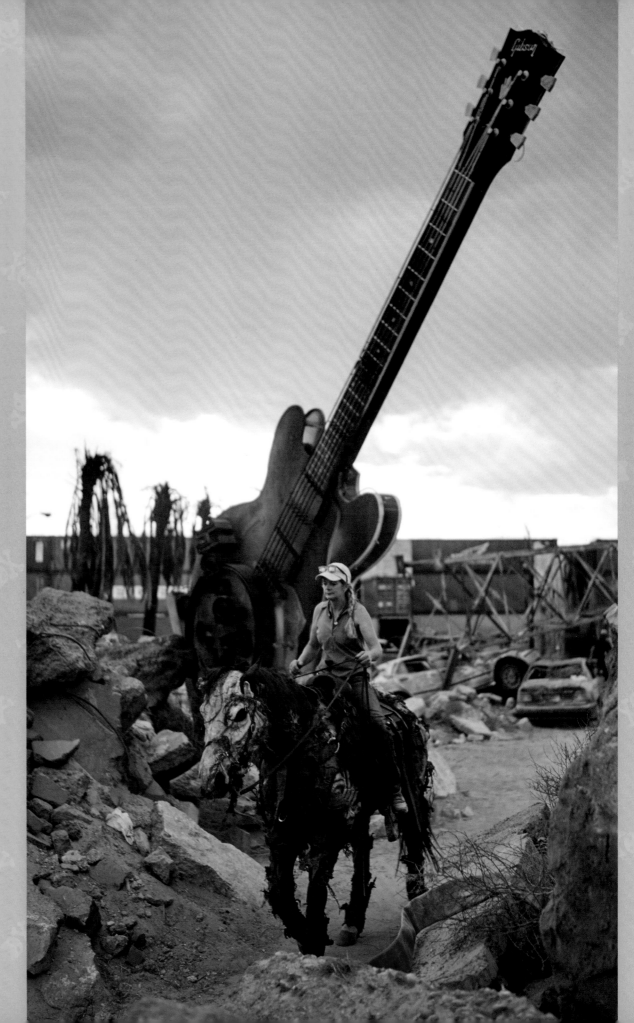

THE
BUY IN

Several horrific incidents set the events of *Army of the Dead* in motion. They not only irrevocably changed the world and the country, but they continue to reverberate through the lives of a small family ripped apart by the zombie war.

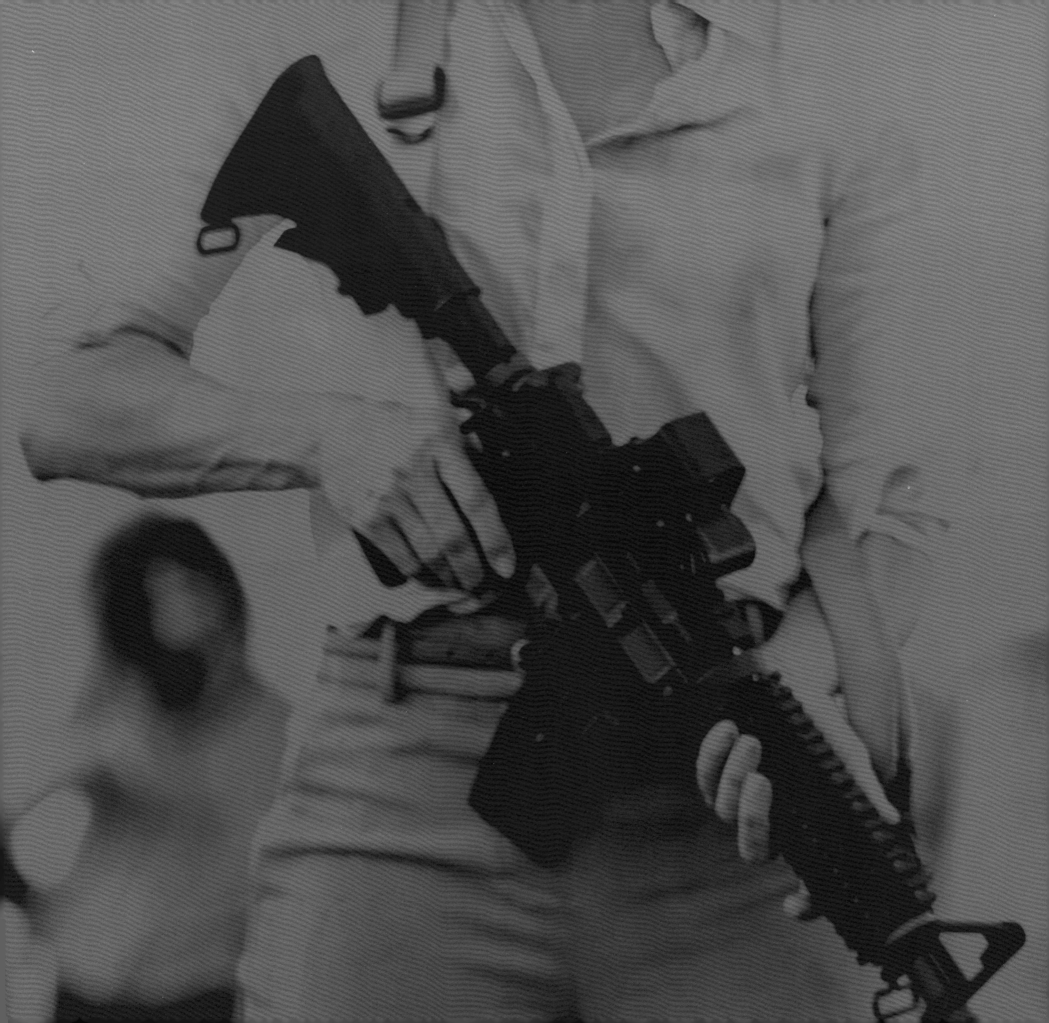

UNLEASH THE BEAST

YOU ARE NOW LEAVING AREA 51

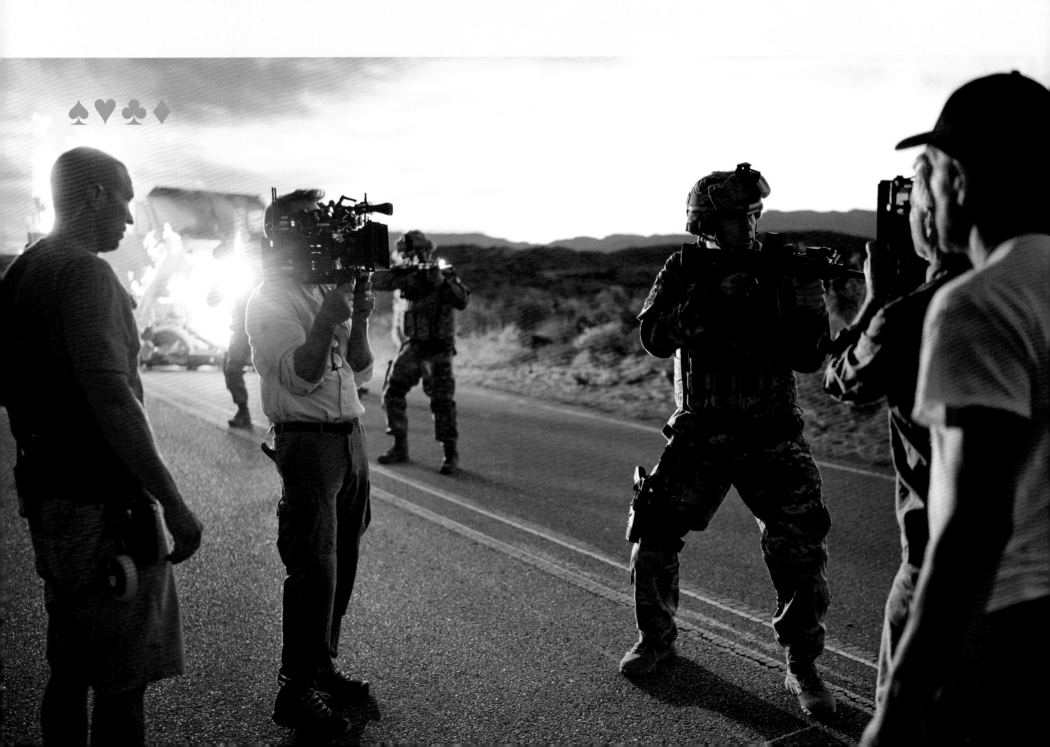

A super-secret military convoy meets a car driven by an inebriated and distracted pair of honeymooners on a two-lane desert highway. It's a recipe for an apocalypse. The resulting fiery collision cracks Zeus out of containment, and that's when the real carnage begins. With a couple of new recruits in tow, he sets his sights on the shining city just over the next hill for his kingdom: Las Vegas.

The crash scene was one of the more complex sequences to capture. "Timing the impact of the Cadillac with the military vehicle and the Humvee that had to avoid getting hit and spin off the road was challenging," second unit director Damon Caro explains. "It's not like we did it on a flat, long highway. We did it on the downward side of a hill. [With] the short distance we had, and our limited choices for our location that we could get from the city, it was difficult to pull that off in camera."

Ever the photographer, Zack Snyder wanted the entire scene to occur at sundown, aka 'magic hour,' upping the difficulty considerably. "We were doing that at dusk, and then the storms started coming in in the evenings—the great New Mexico weather! So, at one point we shifted to dawns, and had like a 2:30am call," says Caro. Snyder admits, "It was very tricky. We had to make sure we were on our game to get it done in a forty-minute shooting window. We shot it over the course of I think it was five weeks. It has a very dusky, last-light-of-day look, and it was very hard to maintain. But it allowed us to have the end of the scene be just into night, so when we see Vegas for the first time, we get the bright lights of the city."

THIS SPREAD/ Capturing the chaos of a wrecked military convoy and the emergence of Zeus.

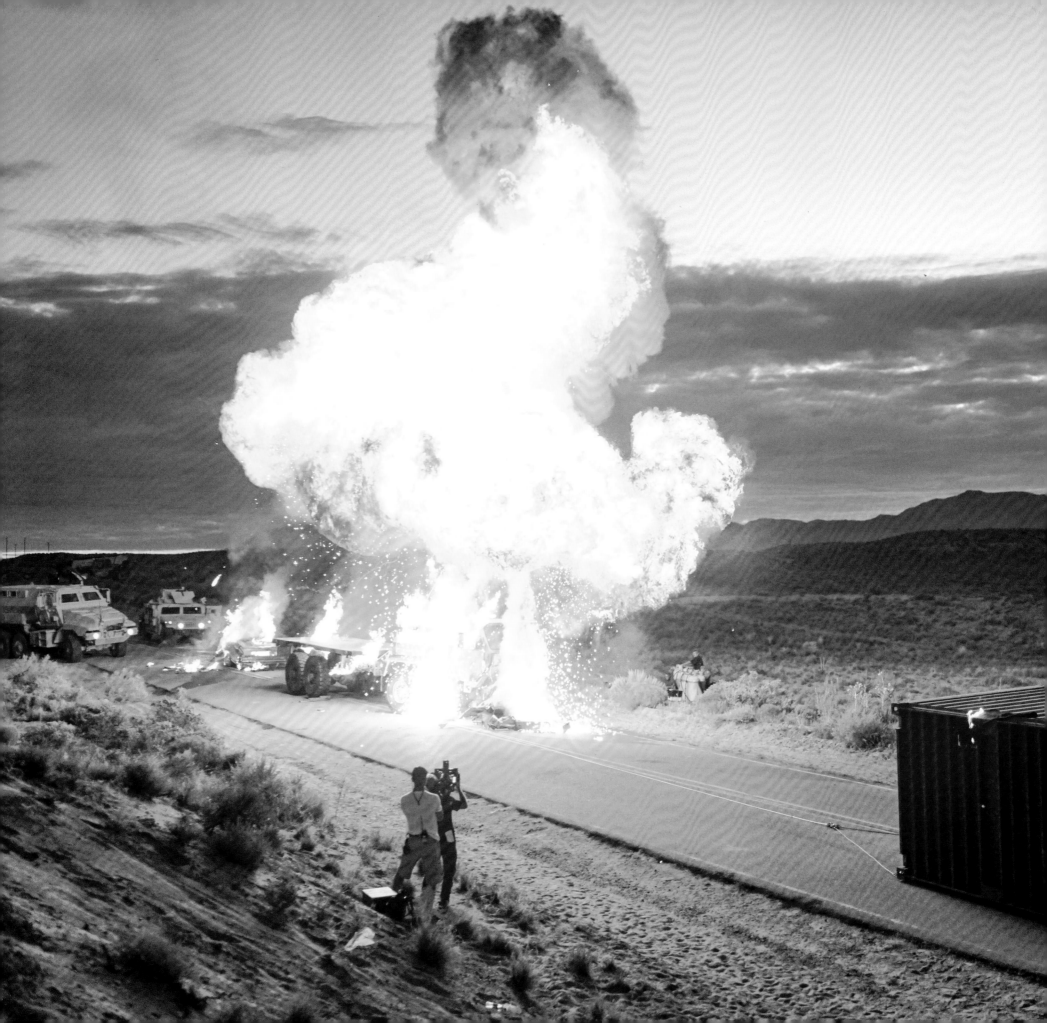

"The initial crash scene credits are due to [special effects supervisor] Michael Gaspar and his special-effects crew, along with the talented precision stunt driving team and the camera department, including the drone operation," says visual effects supervisor Marcus Taormina. "There wasn't much we needed to do aside from some rigging cleanup, ground plane manipulation, and explosion enhancement."

Safety concerns, however, led to them rendering in CG the shipping container holding Zeus as it launches off the transport. "After some careful discussions, Zack, Gaspar, and myself decided we would capture as much as we could in camera, and VFX would add the shipping container in post," explains Taormina. "For a volumetric and camera stand-in, we built a green box that we secured to the back of the transport vehicle in the same spot that the practical one is secured to. Once in post, we decided that one of the setups we were using where the container tumbles toward us needed to be elongated. So, armed with photographic and geometric data that we captured on set, we were able to elongate the slide almost two times as long by utilizing a practical-to-digital-back-to-practical stitch of the environment and the shipping container."

The scene also includes the first reveal of Zeus as he makes his escape and tangles with the guards. "Zack wanted to show a little of his history," says special makeup effects designer and creator Justin Raleigh, "that he was military and had been experimented on. He actually has short hair. He's not scarred up, really, at this point, until he gets into the action."

Although the emphasis during shooting was on practical makeup effects, VFX enhancements were used strategically throughout to up the gore factor or to emphasize certain story points. "VFX was engaged when Corporal Bissel gets his lower mandible ripped off by Zeus in the beginning of the movie, while in other scenes, the subtlety includes rapidly growing sub-surface veins to signal infection," says Taormina.

THIS SPREAD/ Anatomy of a collision.

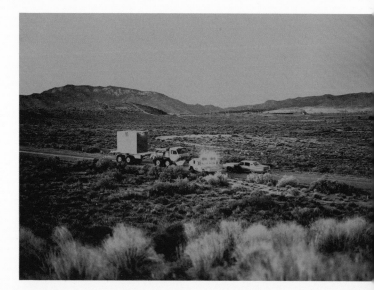

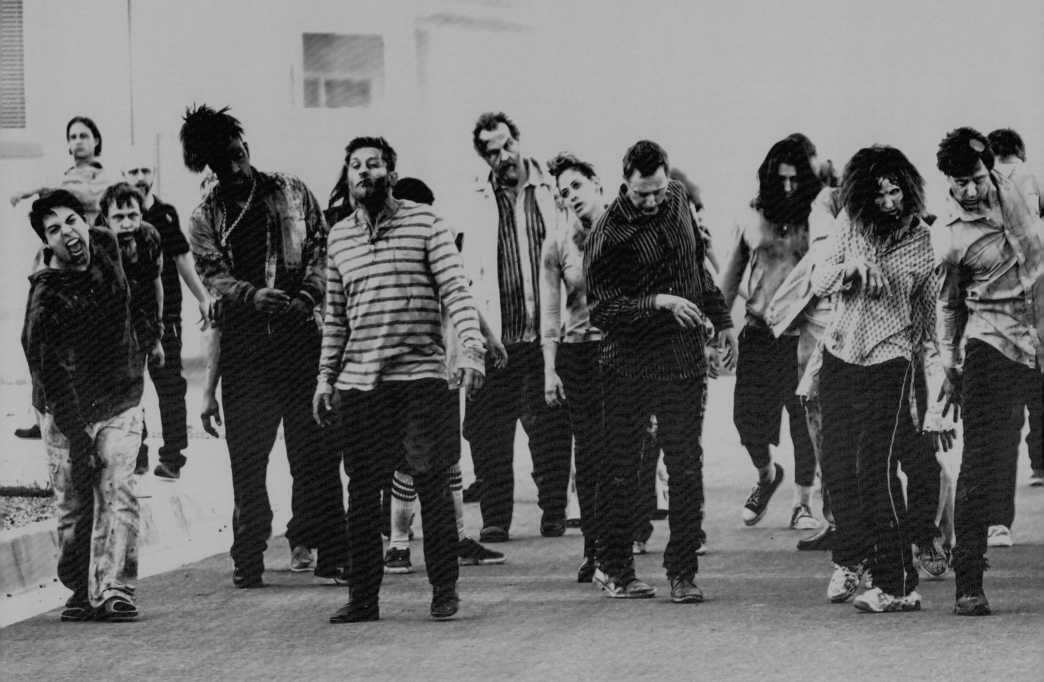

A PARTY GONE WRONG

THE ZOMBIE INVASION

Telling the story of a months-long zombie outbreak in just a few minutes—without any words—is a lane Snyder is comfortable driving in, since he got his start in music videos. He takes the audience from the first attacks, to the exploits of the Las Vengeance crew aboard their taco truck, to the military's response, to the building of the wall of containers around the city. There's heroism and horror, combat and chaos, terror and tragedy, all set against the spectacular demise of a glittering playground. Snyder is quick to admit that such visual shorthand was only possible because of the public's familiarity with the genre. "You can imagine that if we had never made a zombie movie before, we would only have gotten to the first day of the fall of Vegas. That would be the movie, because otherwise you'd stretch suspension of disbelief. 'What do you mean, Vegas falls to zombies? How did that happen?' Now you can do it in eight minutes and everyone knows exactly what happened," he says.

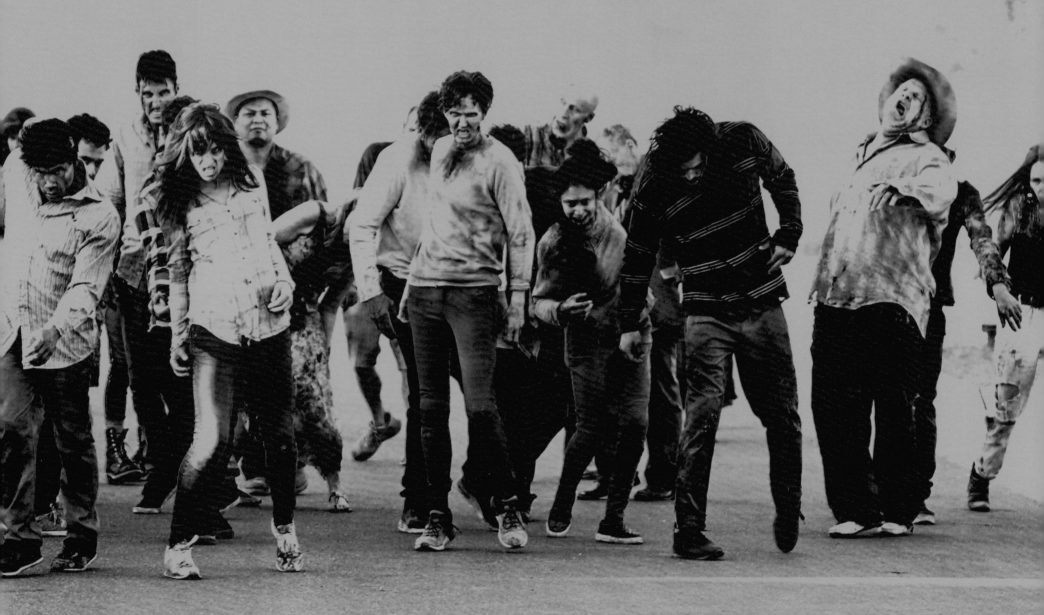

This is where the premise of 'zombies in Las Vegas' comes into its own. "There's entertainers, there's zombie Elvises, there's zombie showgirls," says producer Deborah Snyder, "so we get to see the rich fabric of all that cast of characters as zombies. We have a lot of fun with that." That fun extended to creating the countless gory makeup effects used to make the scenes memorable. "[The] initial zombie invasion was loaded with gags and bits of humor," says Raleigh. "The high-roller suite was a fun sequence, with people getting shredded. Bite gags, people's necks getting torn out, blood gags, lots of wounds, just general melee."

Undead assaults indoors were filmed in the currently vacant Atlantic Club and the Showboat in Atlantic City, New Jersey, as the real Las Vegas is open around the clock and generally too busy to shoot around. Used more extensively during the 'heist' portion of the film, these casinos also offered some luxurious locations for the initial invasion. "My favorite set is the high-roller suite [at the Atlantic Club]," says Deborah Snyder, "which we learned was Frank Sinatra's personal suite

THIS PAGE/ A paratrooper drops into a zombie rave on the Strip.

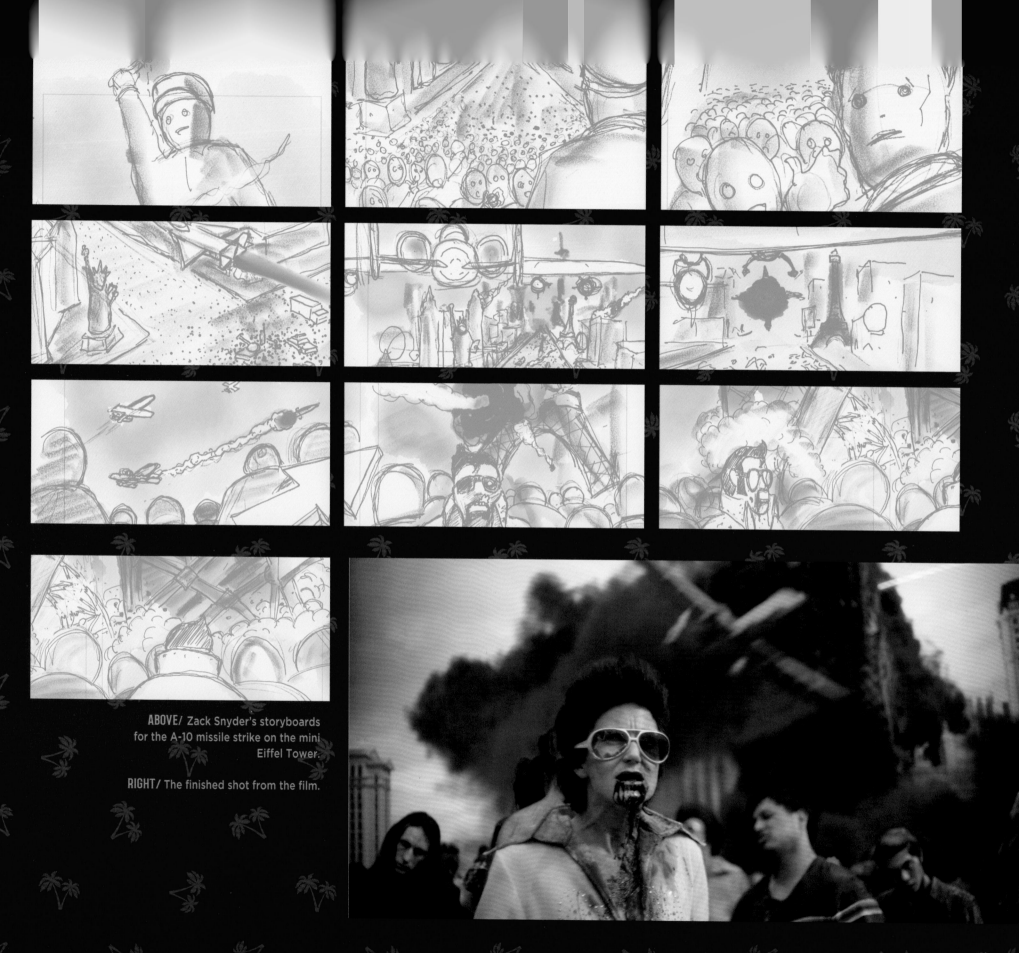

ABOVE/ Zack Snyder's storyboards for the A-10 missile strike on the mini Eiffel Tower.

RIGHT/ The finished shot from the film.

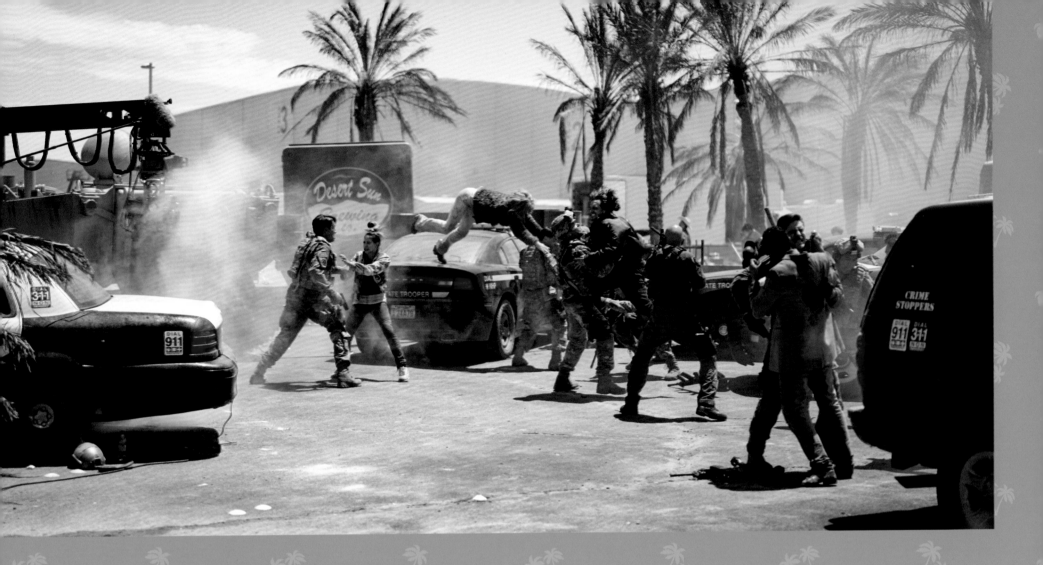

that he used to entertain people in. It has gilded mirrors and gold wallpaper, and when we walked into it, it just felt so historic and so real."

The exterior carnage was shot in and around the neighborhoods of Albuquerque, New Mexico, as well as on a specially constructed backlot. There they recreated much of the iconic intersection of Las Vegas Boulevard and Tropicana Avenue, with the intention to shoot it from a number of angles for use in a variety of scenes. The art department coordinated incredibly closely with the visual effects department and Snyder to map out every square foot of the area, placing fictional locations such as the Bly and the Olympus within the real-world cityscape. It ensured seamless transitions from physical sets the actors could interact with to the larger computer-generated imagery in the background, such as the MGM Grand, the Statue

of Liberty at New York-New York, and devastating napalm strikes during the city's last stand.

"We went to Vegas, we studied it, we measured it, and we tried to recreate it as close as possible so that we could take you in and you feel like you're there," says production designer Julie Berghoff. "We foreshortened it around two lanes on each side, but not enough, hopefully, that you notice. We did tons of research: The cars, taxis, people movers. We got a pink limo in the background. When we did the last stand, we brought in garbage trucks, buses, the police vehicles, anything to create a barrier from the zombies. We did lots of graphics on them with showgirls, etc. It was really [about] studying the nuances of Vegas and bringing them into that intersection. We shot on it for about two weeks and kept coming back to it quite a bit."

At a certain point, creating the massive crowds of Shamblers—and later in the film, Alphas—that were desired exceeded the number of extras that could be hired, made up, and wrangled for the budget. That's when VFX stepped in to amplify the number of zombies present. Frequently, filmmakers use motion capture (mocap) of actual performers as a baseline to allow animators to go in later and multiply the individuals in a shot. But mocap can be expensive and time consuming, requiring special cameras, special suits, a limited stage area, green screens, lighting, and careful calibration of all the necessary equipment. Luckily, Taormina had heard of Xsens, a camera-less, marker-less mocap system. It uses a suit fitted with a dozen or so inertial sensors (like on your iPhone) to record movement, rather than relying on visual data. Performances can be captured anywhere, including on actual sets, regardless of lighting conditions. You don't even need a computer; you can record the data directly onto a belt pack for later upload. As Xsens records movement, the only reason to film the performances is to provide a reference for the animators.

"We had five hero stunt performers. We secured half of an interior sound stage, by our lunch tables," recalls Taormina. "Lasting for a day and a half, we captured the full extent of our Alpha and Shambler zombie libraries with two mocap technical directors, two witness-camera operators, an animation supervisor, and an assistant director."

Mocap artist Eric Jacobus finds the new system to be a godsend. "Coming from an action background, using Xsens suits just makes a lot of sense, because you can put pads over it. Because there are no cameras, you could wear a whole-body shell over this thing and it wouldn't matter," he says.

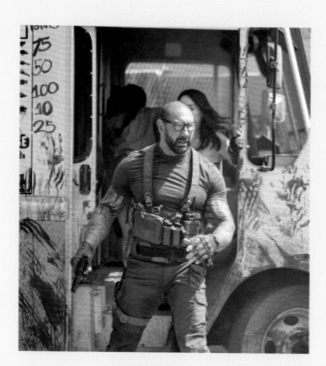

THIS SPREAD/ The US Army and Scott's crew mix it up with the undead during the outbreak.

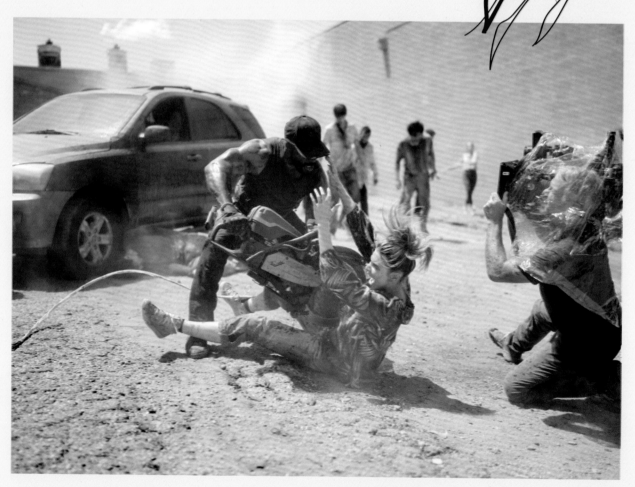

THIS PAGE/ Concept and execution of
the wall of containers. (Bottom Left)
Concept artwork by Zack Synder.

One of the most memorable moments for the crew was when Zeus makes his grand entrance during the pandemonium on the Vegas Strip and gazes up at the Olympus Hotel. "It was at night, and he walks through the fire," explains Deborah Snyder. "We had been talking about this film and developing it for basically ten years, and to finally see the Alpha zombie for the first time, that was really exciting and exhilarating for us as filmmakers."

The invasion montage is also where we're introduced to Scott, Cruz, Vanderohe, and the rest of the team—including a few that don't quite make it to the end of the montage.

We see them in vignettes, grubby and geared up, surrounded by fallen zombies, posing as if for an Annie Leibovitz photograph. To complete the heartbreaking tableaus, each team member carries a photo of themselves in their happy former lives, giving us a silent sense of the heavy toll that the

months of grueling adversity and bloodshed have taken on them.

The sequence ends with the final section of the container wall being slid into place to hold back the zombie horde. The original plan was for the wall to be made of simulated concrete, but Berghoff had another idea to save time and money. "We had to build the container walls anyway for support to make a wall that's thirty feet tall, especially with the wind velocity in New Mexico," she explains. "So, I pitched that we just do it out of containers, because it just made sense: How [else] can you create a wall in two seconds that has some girth and durability that they can't climb over or dig under? So, we ended up using containers. I created a palette with specific colors, we put these containers down, and we structurally supported them by locking them together and then putting weight inside of them, because the winds were incredible there."

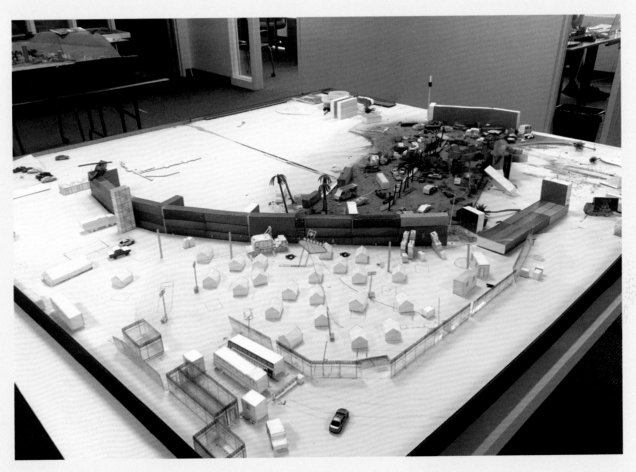

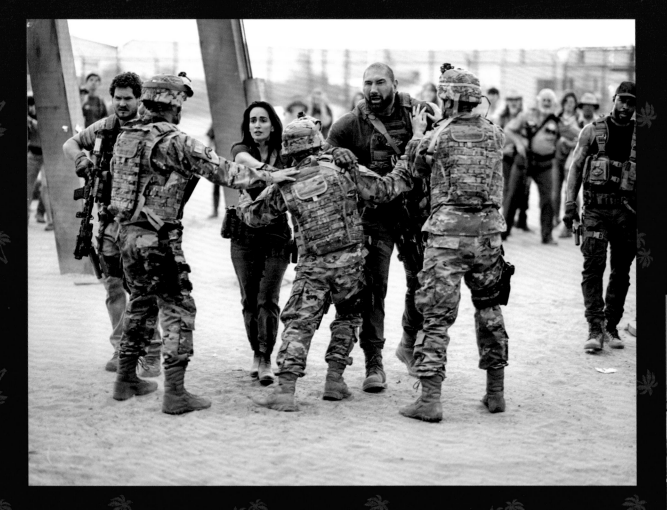

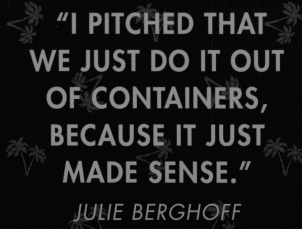

"I PITCHED THAT WE JUST DO IT OUT OF CONTAINERS, BECAUSE IT JUST MADE SENSE."

JULIE BERGHOFF

ABOVE AND RIGHT/ A Soccer Mom (Danielle Burgio) takes up arms against the zombie invasion.

ABOVE AND TOP/ Scott and Cruz try to leave no one behind as the wall comes down.

A DEFINING MOMENT

"I HAD TO STAB MY WIFE IN THE BRAIN WITH A KITCHEN KNIFE."

♠ ♥ ♣ ♦

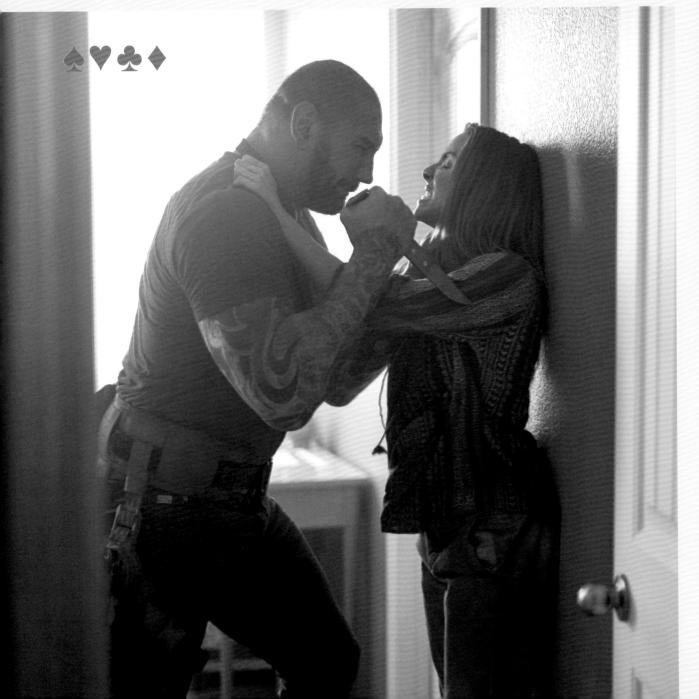

One of the more gut-wrenching scenes from the zombie outbreak, shown later in a flashback, is when Scott is forced to commit a terrible act. He returns to his family home to find that his wife, Laura, has become a Shambler, and is attacking his teenage daughter. He puts his wife down with a knife to the brain to save Kate, but in doing so drives a wedge between the two of them for years to come. That incident and its aftermath, beyond anything else in Scott's backstory, became the defining character moment for Dave Bautista when discussing the role with Snyder. "We talked more about the relationship and struggles he was dealing with, having killed his wife and being estranged from his daughter," he says.

The sequence at the Ward home was filmed on a practical set (one that can be shot for both interiors and exteriors), a real house in the Albuquerque

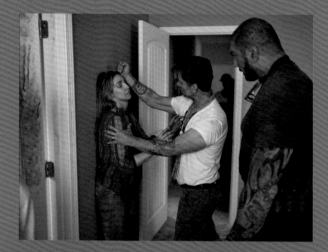

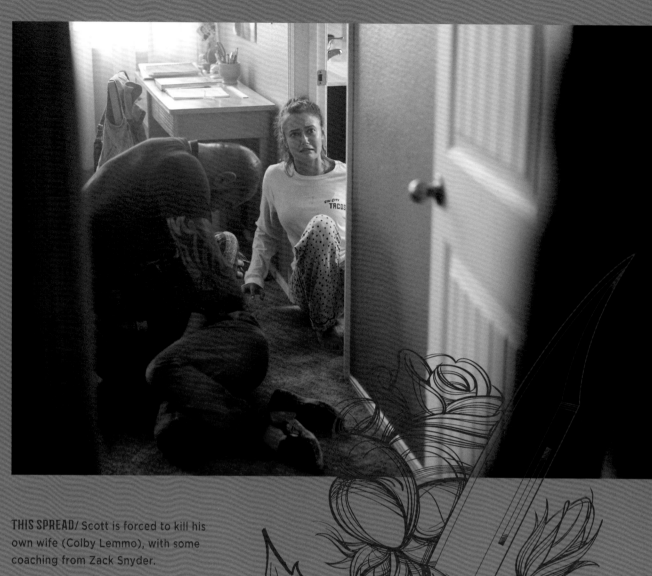

suburbs. "We were looking for the quintessential suburban abode look, a pretty generic home," explains Berghoff. "Scott had a food truck that was successful and was able to provide for his family. It was a newer home, and they were in a pretty good place. I wanted it to feel like it could be any person's home. There's nothing distinctly different that you would find if you went to go visit a friend's house."

That familiarity helps drive home the horror for the audience, as it did for the cast. "It was really intense and emotional for Dave and the actors," says Snyder. "We got to talking about the reality if you had to confront these kinds of transitions in your loved ones. What would you do in the same situation? The movie asks you to put yourself in their place, and I think that's an interesting sort of equation that you have to work [out] when you talk about these kinds of moral decisions."

THIS SPREAD/ Scott is forced to kill his own wife (Colby Lemmo), with some coaching from Zack Snyder.

THE OPENING

With the wall built, the world outside went on with its life. Over the years, it all but forgot about Las Vegas and the former heroes of the Sin City streets. That is, until a certain casino owner approaches Scott Ward with a proposition that could let him shut the door on the past and hope for a better future—possibly even with his daughter.

A GREASY BURGER JOINT
LUCKY BOY DINER

Scott lost everything in the zombie invasion: his home, his livelihood, and his family. The last thing he's expecting is a visit from one of the world's richest men. Bly Tanaka finds him in dismal circumstances, leading a solitary life in a dead-end job, working for a punk kid, flipping burgers at a greasy spoon outside Victorville, California. 'Lucky Boy' is definitely not how he feels, and so the thought of braving the undead once more for a big chunk of cash doesn't sound quite so crazy.

The Lucky Boy was another practical set in New Mexico, a working diner dressed up with custom signage produced by the art department.

THIS PAGE/ Scott's workaday life gets upended when Bly Tanaka visits the diner.

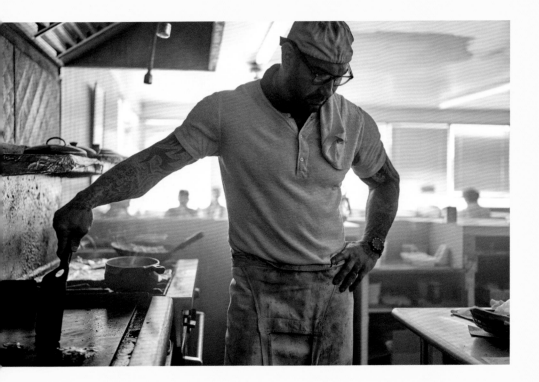

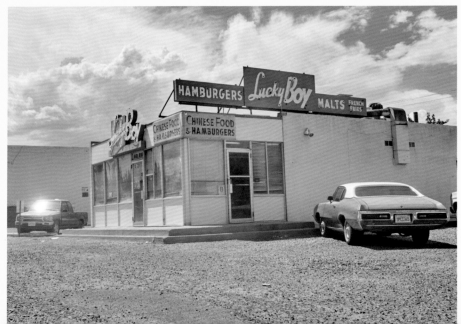

148

NOT MUCH TO LOOK AT
INSIDE SCOTT'S APARTMENT

Further evidence of Scott's sad state of affairs is his apartment, where he retreats to mull over Tanaka's daring proposal. "He's living in basically a studio. It's one of those motel rooms where you have long-term tenants. I decorated it to reflect his character," says production designer Julie Berghoff. Adding that the décor is, "Stark, minimal, utilitarian." About the only decoration is Scott's Medal of Freedom, a gesture of thanks from a once-grateful nation. No special build-out was required to make this practical set ready for filming inside or out.

It is also here where we see news reports about the nuclear bomb due to be dropped on Las Vegas to coincide with the Fourth of July holiday. As Scott checks over his arsenal from the old days, talking heads debate the wisdom of using a nuke on a major American city to end the zombie threat.

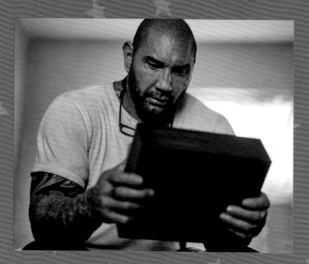

THIS PAGE/ Scott's apartment contains only memories—and LOTS of firepower.

THE SHOW-AND-TELL
TANAKA'S WAREHOUSE

The insane offer accepted and the necessary professionals located, Scott gathers his team for one final meeting with Tanaka to go over the plan. Using a model of the Bly Las Vegas, Tanaka points out that the vault is below Gomorrah, the south tower. Traps even he doesn't know about guard the safe, neither does he have the combination; both for security reasons. On top of the north tower, Sodom, is a rescue helicopter left behind during the outbreak. That chopper will be the only way out when they are burdened with hundreds of pounds of cash.

"Tanaka's warehouse was this closed-down railroad yard in Albuquerque. A stunning building, originally used to repair train cars," explains Berghoff. "Along with lighting, we created some doors to help with the transition of cars pulling in. We brought in colored glass panes for our color palette. Other than that, it was this gorgeous space that we cleaned and took things out of, rather than brought things in."

The highly detailed hotel model for Tanaka's show-and-tell, on the other hand, required a bit more effort to design and put together. "This practical model probably took over six weeks to build, using laser-cutting techniques, fabricating, and painting," Berghoff says.

THIS PAGE/ Scott's newfound crew meet with Tanaka to go over the plan.

 ARMY OF THE DEAD

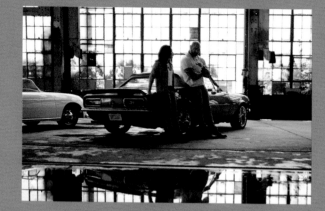

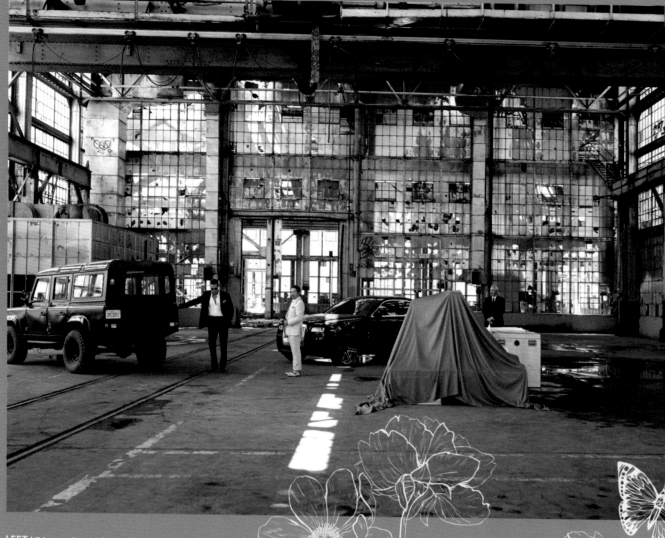

LEFT/ Discussions about the heist are ongoing as Tanaka reveals the model of his hotel.

ABOVE/ Tanaka and Martin await the team at the warehouse.

MCCARREN CAMP

DETENTION FACILITY

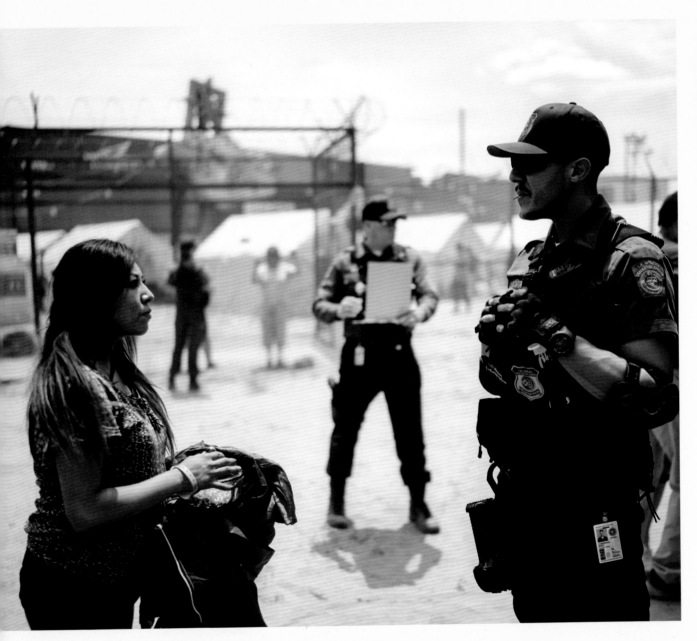

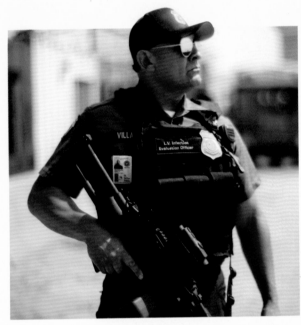

At the edge of Las Vegas, next to the airport and against the container wall, is a camp full of refugees from the city. The stated purpose of the facility is to quarantine those who may have been infected during the outbreak, but it's been years and the detainees show no signs of turning into the undead, so when does it end? It's become clear to those inside that this is a place for the government to indefinitely hold outcasts and those it deems 'undesirable,' using the zombie threat as a cover. Due to its location and the need of refugees to forage for cash in hopes of buying their way out of detention, this wretched place is Scott's best hope to sneak into the sealed-off city. Getting to see Kate is an added bonus.

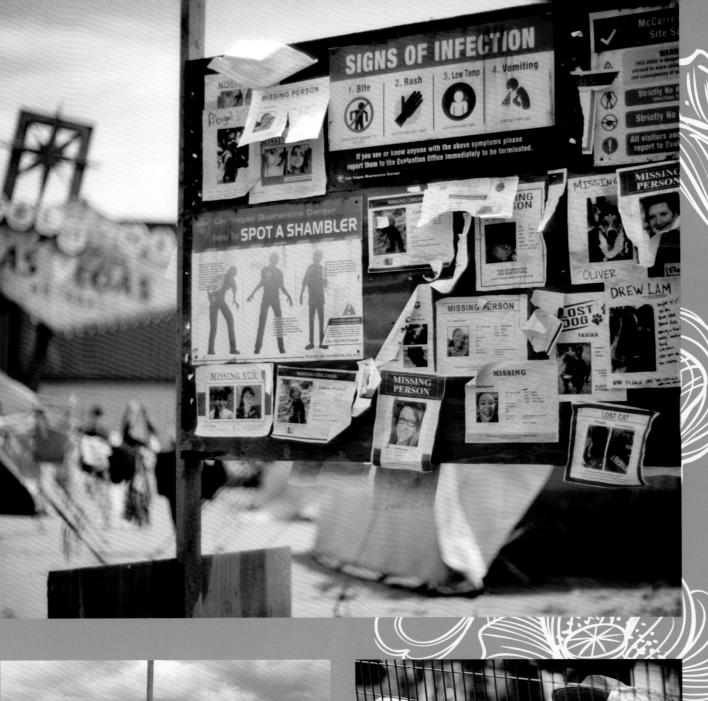

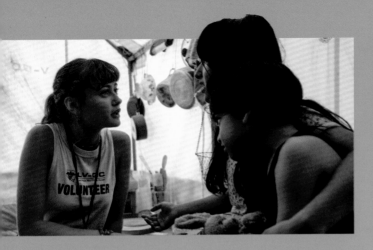

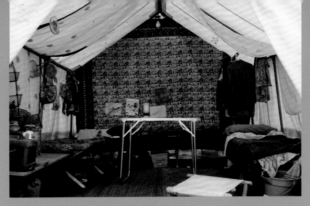

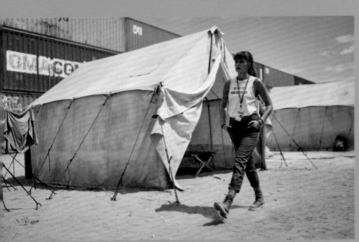

Sadly, there were far too many real-world analogs to mine for ideas when designing the camp. "I did a lot of research for it, looking at Syria, some of the UN's refugee camps around the world, and to see what they have to suffer and to endure... It's pretty astonishing how they become villages quickly," says Berghoff. "It allowed me to try to understand what people are going through, and I used that as a premise to really bring this to life and give it more of a backstory, instead of just a zombie movie that has a refugee camp.

"There were hundreds of army tents, and we tried to go with a couple of different kinds," Berghoff continues. "Because of the wind, we were having to go with very heavy steel-gauge-pipe tents and they had to be crazy staked down. [We built] roads, porta-potties, water buffaloes [drinking water tanks]. Where do they eat? What do they do all day?" Thinking about small stories

to tell sparked intimate details such as soccer balls, children's drawings, improvised toys, and a bulletin board filled with names and pictures of the missing (featuring actual crewmembers).

It was natural that the inmates themselves would react to life in the camp, telling their own stories, with what little voice they had, to whoever would listen. That manifested itself as graffiti on the container wall. "I did a lot of research on graffiti, and how people are speaking out against the [US-Mexico] wall in our country. So, there's little moments of our flag upside down with crosses; people expressing their thoughts on being singled out, racism, and whatever else was on their minds," says Berghoff.

The official side of things was also intended to tell stories. "For the transition areas with guards, we looked to Israel and how they have their transitions in and out, with cages and different checkpoints,"

explains Berghoff. "We built these quarantine cages for also the intimidation aspect, because pretty much if you're bitten and you become a zombie, you wouldn't need to be quarantined very long, because they would shoot you in the head. We made a lot of humorous signage like, 'If you are infected and you have these symptoms...' and graphics of zombies."

The color palette used sold the idea of a windblown, desolate outpost at the edge of a desert ruin. The final touch was the addition of a properly aged icon. "The Las Vegas sign we copied one hundred percent, and then gave it our little movie flair of distress, having been on fire, being part of a war," says Berghoff.

Snyder, as both director and director of photography, was naturally involved with the art department from the very beginning in planning how to bring such a massive film set to life. "I'd concept it, and then we built a model of it," explains Berghoff. "Zack would come upstairs, and the group of us would just move things around, like the camp, and how he's going to move through it and shoot it. We have this cool little view-camera that you can look through and look down into the model. There's nothing like it. 3D is not the same as actually seeing something, being able to pick up a little car, a little barrel. It was such a collaborative, amazing process."

PREVIOUS SPREAD/ The McCarren Camp Detention Facility.

THIS SPREAD/ A few details of the realities of life in the camp.

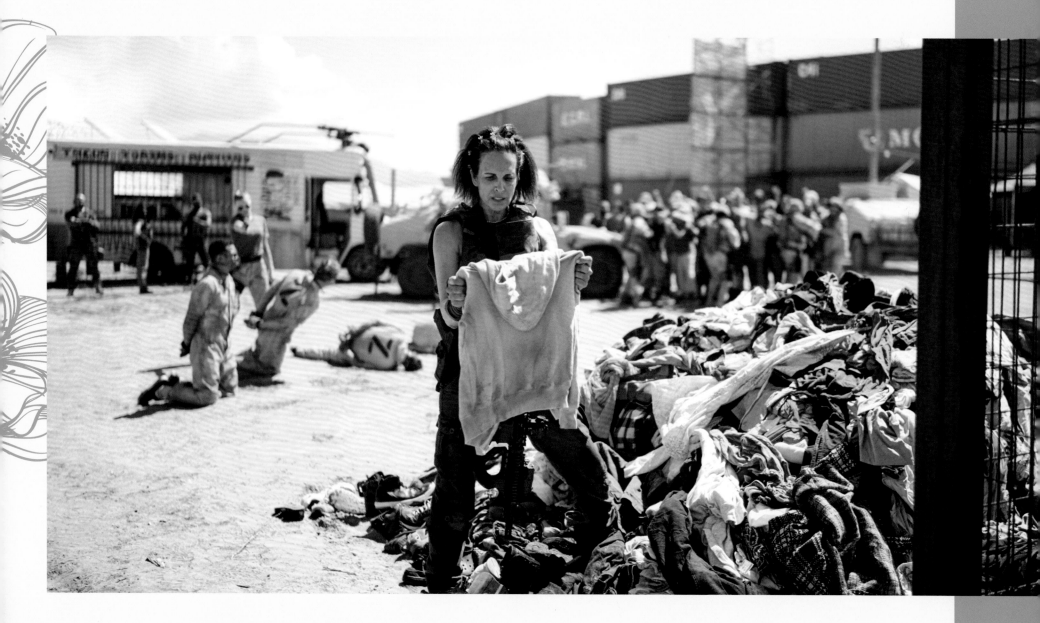

A COYOTE'S DEN

LILLY'S MERCANTILE EMPIRE

Lilly lives all by herself at the back of the refugee camp in a literal hole in the wall. She's cut into one of the containers that comprises it and created a cozy home for herself. It's a supreme testament to her skills as a wily scrounger: she's ingratiated herself with the guards so well that they not only let her live there, but they also turn a blind eye as she runs her less-than-legal operations out of it.

A SUPREME TESTAMENT TO HER SKILLS AS A SCROUNGER.

On first entering, it might seem that Lilly lives a frugal existence. She has scavenged a few things to make life in the camp more livable, but it appears to be not much more than that. "She lives in the front and is living pretty simply, with a camping stove, really simple food, and sleeping on pallets, but she's got electricity, a TV," says Berghoff. If she allows you to pass through the curtains, however, you'll see the full extent of her mercantile empire. Her forays into zombie territory have netted her everything you might find in a second-hand store. "She would take in things from casinos or what people have left behind: guns, alcohol, toys for kids, medicine," Berghoff elaborates, "mostly survival things, the little things that you can't get when you're in a refugee camp and you can't leave. Some of it's a little decadent, like art, chandeliers, dresses."

Of course, Scott and his crew aren't interested in all this merchandise. They came for the coyote to lead them out the secret backdoor of her home and into the city of the dead.

THIS PAGE/ (Left) Zack Snyder, first assistant director Misha Bukowski, and script supervisor Kimi Webber enjoy Lilly's hideaway. (Center) The Coyote outside her den. (Right) Lilly being introspective.

OPPOSITE/ Lilly's general store.

Those who had fought in Las Vegas in years past find a city unrecognizable as the one they left behind. There are new hazards to encounter, sacrifices to be made, and betrayals to face. And that's all before they even try to beat the security measures at the Bly or open the impossible safe.

ODDS

ZOMBIE VEGAS

MOUNDS AND MOUNDS OF DESICCATED ZOMBIES

The years and the desert have taken their toll on the city and its Shambler denizens. When the team passes through the wall, the first thing they encounter are mounds and mounds of desiccated zombies. "You come out to the Shamblers, who over the years have tried to come up to the wall, piled up, and then they've basically dried out from the desert heat and just literally dropped here," explains production designer Julie Berghoff. "Our backstory is that they're not necessarily dead, because they haven't been shot in the head. If it rains on them, they would come back to life. [Lilly] basically swept them to the side as she started exploring Las Vegas and created a path."

In keeping with the goal of making as much of the background as practical and as tactile as possible, representing a sizable portion of the city's population as zombie husks became a herculean task for the art department. "[Special makeup effects designer and creator] Justin [Raleigh] and I worked together and he created eight very, very expensive, super high-end, molded latex casting, armatured, bendable zombies," says Berghoff. "But then we had to create five hundred of them. We had to come up with an inexpensive way of doing this. So, we took the highest-end Halloween skeleton that you can get and we created a skin on them [using] three different colors of nylons—because we wanted diverse zombies: black, white, Hispanic.

"We 77'd [spray adhesived] the nylons and stretched them over the skeletons, and then burned it with an acetylene torch to create the texture of skin that was emulsified. Then another layer of 77 and put sand on it. Then used different colors of scenic paints to create different skin tones, all of them translucent. Then added purchased used clothing. We had ten set dressers working, and we also had to age all the clothes ourselves. Close up, they're kind of weird looking, but when they're all together as a group, I think they look pretty awesome."

THIS SPREAD/ Zack Snyder explores the Shambler graveyard with Scott's crew.

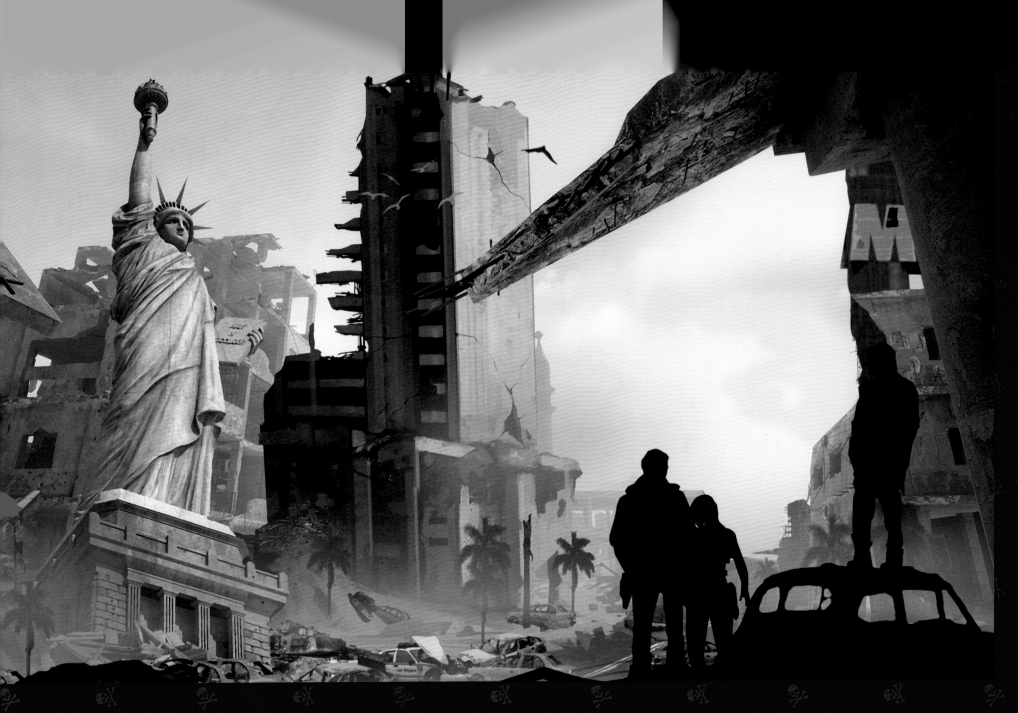

"Everything about making believable textures is about layers," Berghoff adds. "You can't just do one layer, including in Photoshop, or any kind of visual effect, or anything anyone does with wardrobe, when you're working with all these different layers of dirt, and grime, and blood."

The return to Vegas also meant a return to the intersection of Tropicana Avenue and Las Vegas Boulevard—only aged and significantly the worse for wear. Redressing the streets to show the aftermath of the war used a surprising number of real-world

materials and objects, as opposed to Hollywood fakery. "I like to use real materials, because it looks the best," says Berghoff. "There's all this scrap metal that my guys bend and flex and pound and run over with a forklift to give it all this different structure, and I use mostly real rubble. Fake rubble here would blow away, because it's so windy, plus it's really expensive and a pain in the butt to make! So, we contacted some city companies who scrape up the street and had thirty truckloads of rubble dumped. It's the real deal, which makes it more exciting, but difficult to move around."

ABOVE/ A concept for fallen Vegas by artist Clay Staub.

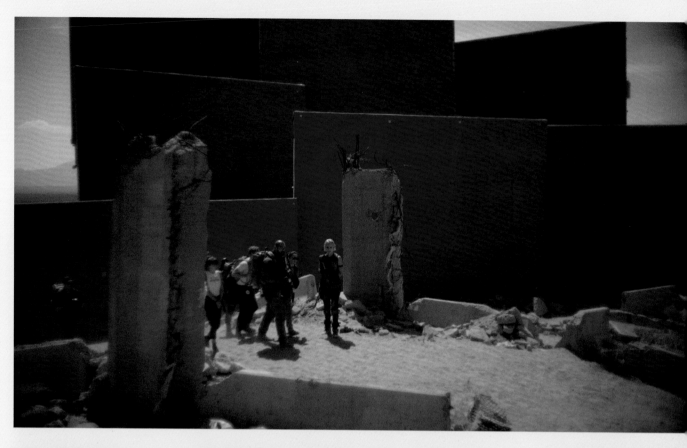

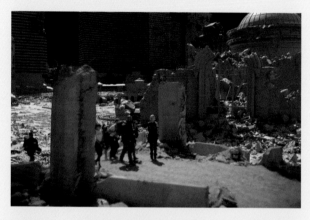

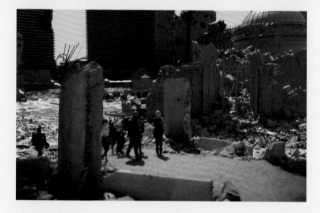

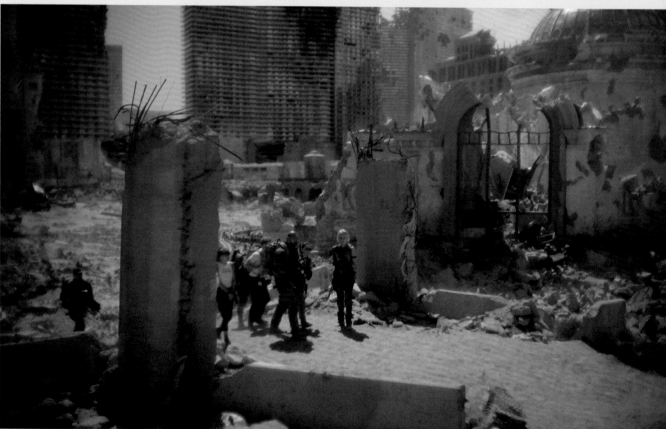

THIS PAGE/ Building the ruins of Las Vegas digitally around our heroes.

THE TRUE ODDS ♦ ♣ ♥ ♠

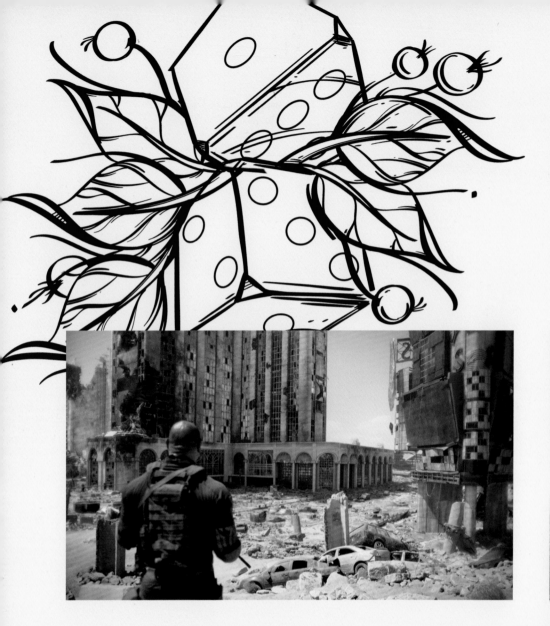

While their current occupants might be convincing artifices, all of the cars were real. "I had to replace all the vehicles with burned-out vehicles, and crush them, and show the napalm," Berghoff continues. "We created this whole overpass that just came crashing down on this bus and this party van. Most of these cars can't drive, so we had forklifts coming in, and we had to bring in sand and make it look burned. It's actually super time consuming. It looks like craziness here, but there's a lot of thought process behind the cars we chose and the position they're in."

Just add a crashed guitar from the Hard Rock Hotel and the wreckage of a faux Eiffel Tower, and you have a frighteningly realistic, post-apocalyptic Vegas to explore.

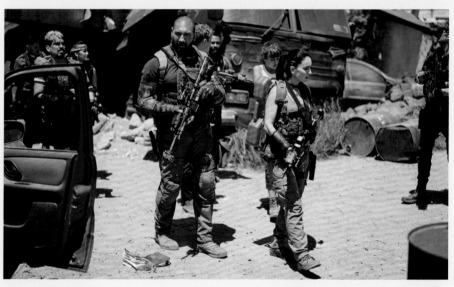

"THERE'S A LOT OF THOUGHT PROCESS BEHIND THE CARS WE CHOSE AND THE POSITION THEY'RE IN."

JULIE BERGHOFF

THIS PAGE/ Creating a convincing hellscape requires both art and grunt work.

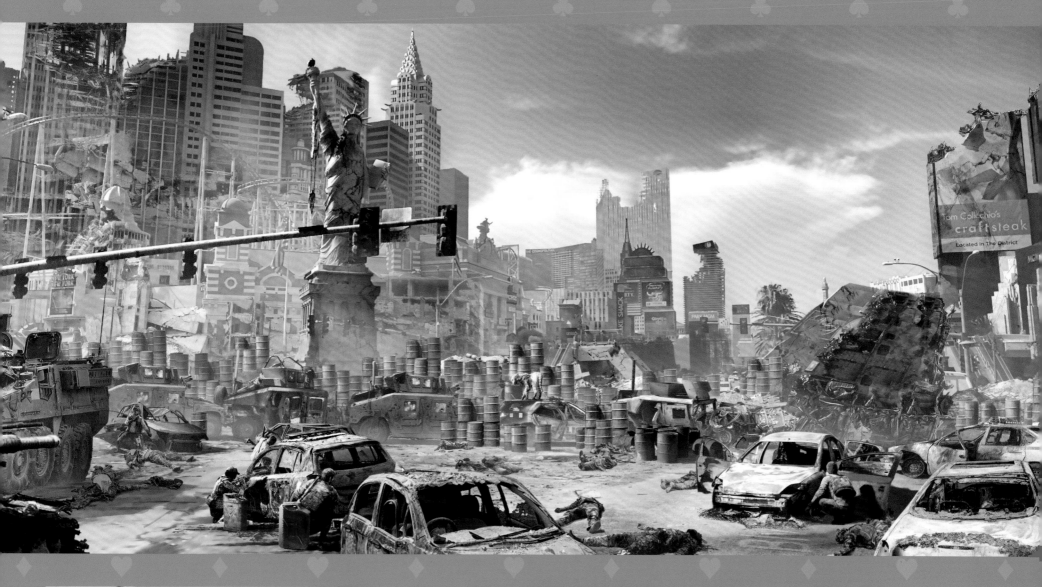

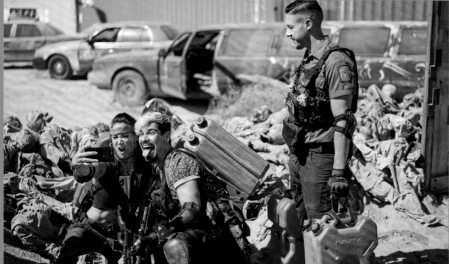

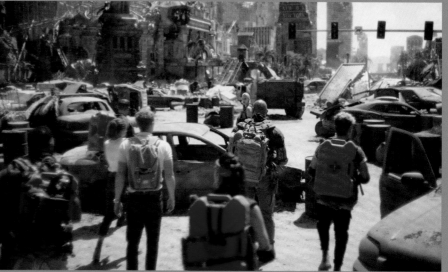

TOP/ A detailed concept rendering of post-apocalyptic Las Vegas by artist Jonathan Bach.

ABOVE/ A seamless combination of practical and digital Vegas awaits the crew.

THE UNDERGROUND MALL

IT MIGHT AS WELL BE THE MIDDLE OF THE NIGHT

Taking every precaution, Lilly leads the team off the streets, away from the prying eyes of the Alphas, and into an underground mall to continue their progress toward the Bly. Without electricity, it's a chilling journey down darkened utility corridors and past gloomy, shuttered shops offering long-expired bargains on luxury brands. Everything's going fine until they encounter dozens of Shamblers, who appear to be frozen in place.

The shopping mall was a transition to get the team from the Las Vegas exteriors to the casino interiors, but it also marked a transition from filming in Albuquerque to filming in Atlantic City. The change in location brought with it a stark change in scenery, but telling stories was still the driving force behind dressing the scenes. "In New Mexico it was brown and tan and dried zombies, and then when we got to Atlantic City it was all bloody," says Berghoff. "We told stories along the way of people's struggle to survive. You saw transitions of people trying to escape and getting killed, blood smears on the walls, and dragging themselves to get help. Zack wanted to show people who had holed up in a space, blocked off the doors from the zombies, like we had all these Elvises that gave up and hung themselves after running out of food."

RIGHT/ Zack Snyder sheds some light on our heroes' journey.

♠ ♥ ♣ ♦ ARMY OF THE DEAD

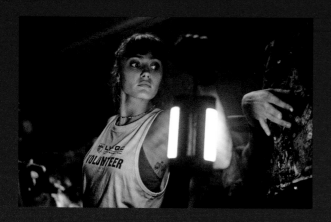

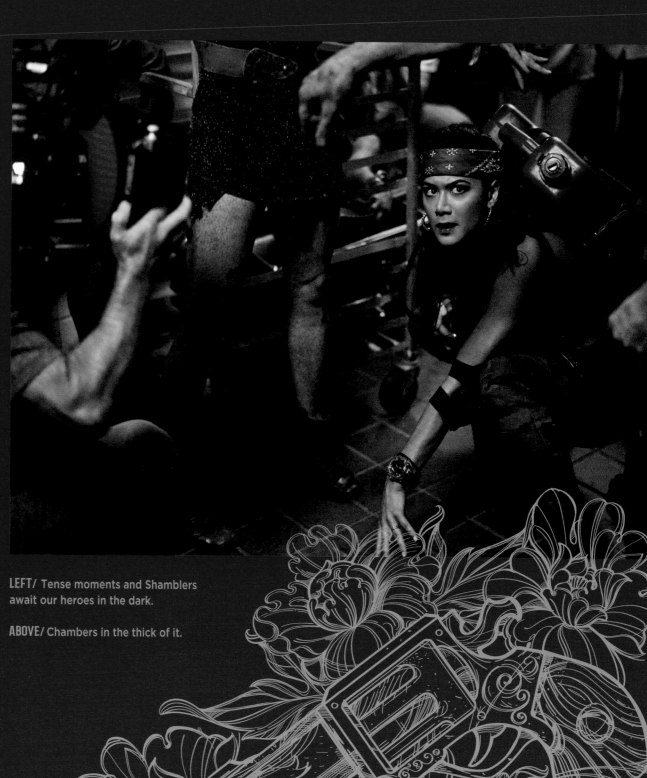

LEFT/ Tense moments and Shamblers await our heroes in the dark.

ABOVE/ Chambers in the thick of it.

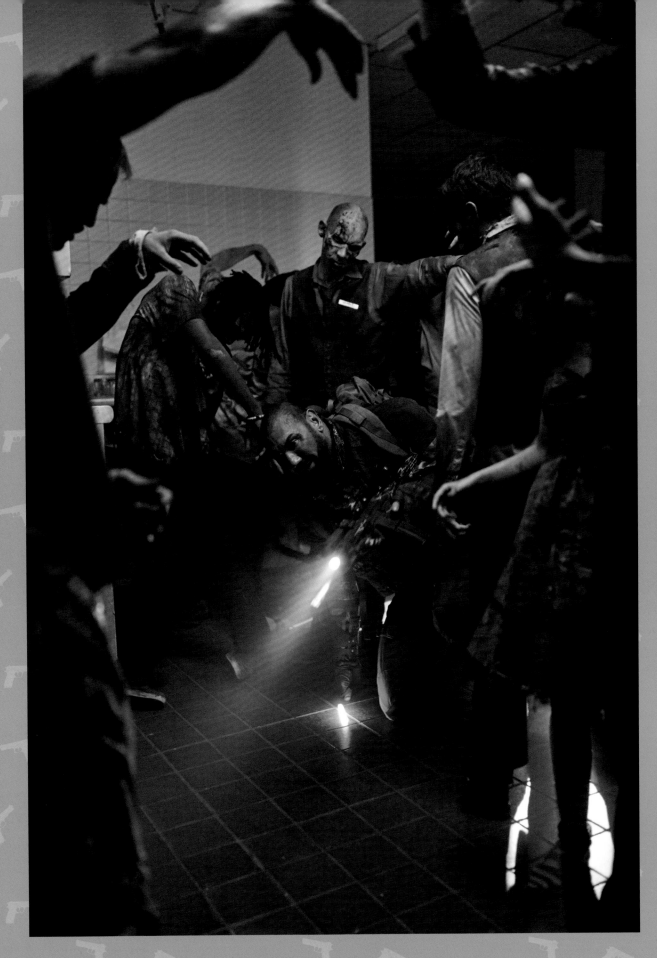

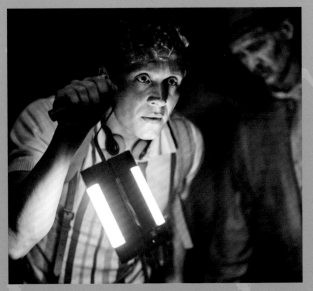

THIS PAGE/ It's about to go down.

OPPOSITE/ Things get real for social media star Guzman.

"There weren't any closed shopping malls we could use in New Mexico or Atlantic City," Berghoff explains, "so I basically took one of the casinos we were working in and created vignettes to sell the shopping mall by creating storefronts. We came in through a loading dock. It's like going behind the curtain at a theater: it's stark, it's super uneventful, and you go from that utilitarianism to a mall with Gucci, and glass, and fancy clothes."

The corridor the team must navigate is filled with Shamblers standing absolutely still. These aren't dried out like the ones outside—they're in a state of hibernation. Lack of food has made them shut down to conserve energy, and our heroes need to weave their way through the throng without disturbing the sleeping zombies. Adding to the terror is doing so in near total darkness. "I lit that scene mostly with flashlights, literally just pounded into the ceiling," says Zack Snyder. "My idea was to try to shoot in the dark, because that's what it would really look like. I tried to make it not look like fake movie 'night.'"

Due to some nefarious double-dealing, all hell breaks loose as they try to navigate the corridor. But it's also an opportunity for team members to shine. As Snyder explains, "Zombies get woken up, and they don't like that. Sam Win [aka Chambers], a longtime collaborator of mine, gets to fight her way through this horde of Shamblers in a pretty amazing sequence in the middle of one of those casino malls. That's pretty intense."

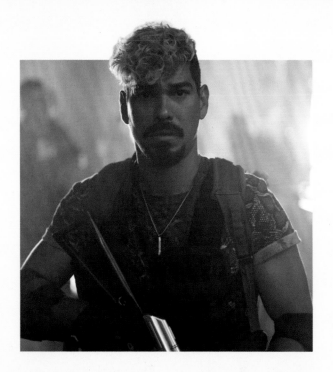

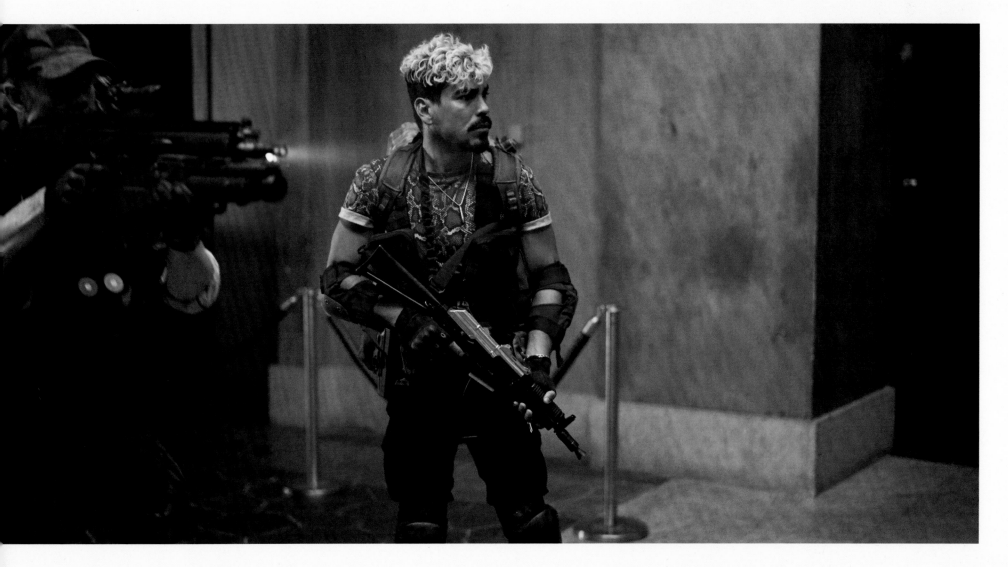

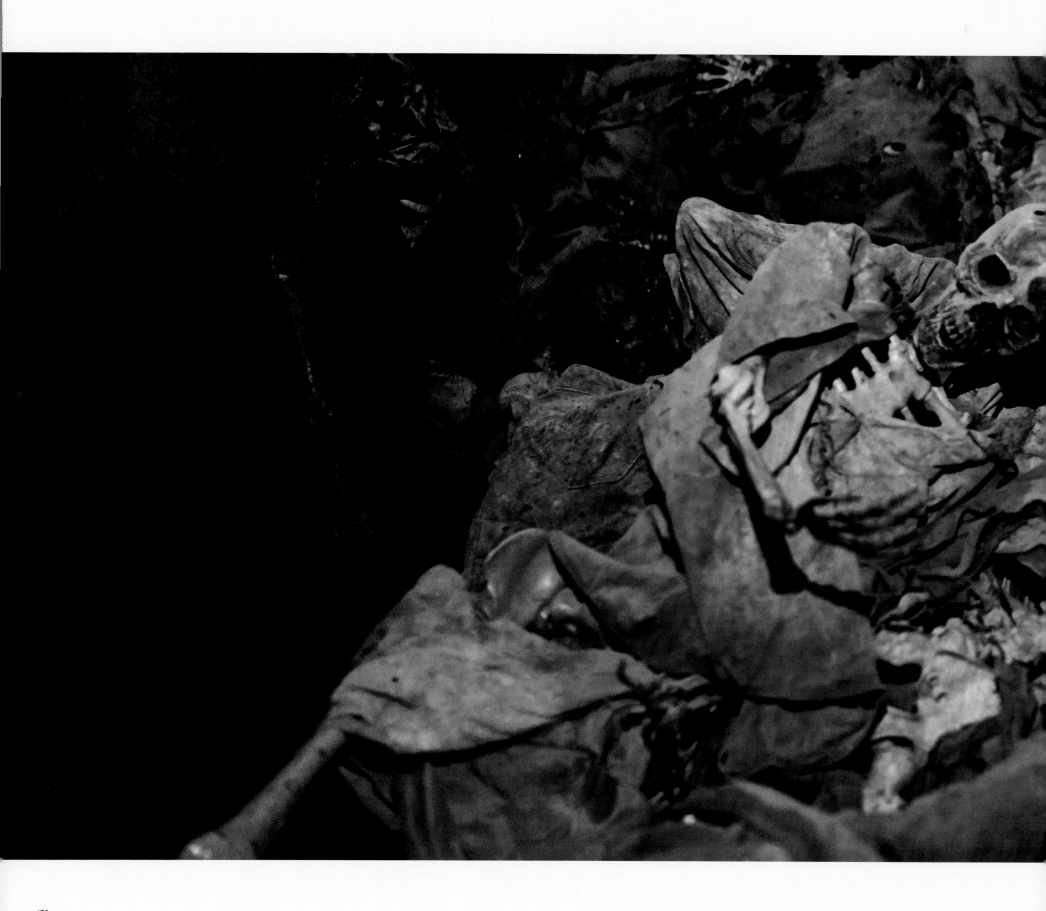

"WE TOLD STORIES ALONG THE WAY OF PEOPLE'S STRUGGLE TO SURVIVE. YOU SAW TRANSITIONS OF PEOPLE TRYING TO ESCAPE AND GETTING KILLED, BLOOD SMEARS ON THE WALLS, AND DRAGGING THEMSELVES TO GET HELP."
JULIE BERGHOFF

A SIGHT TO BEHOLD

THE GÖTTERDÄMMERUNG

♠ ♥ ♣ ♦

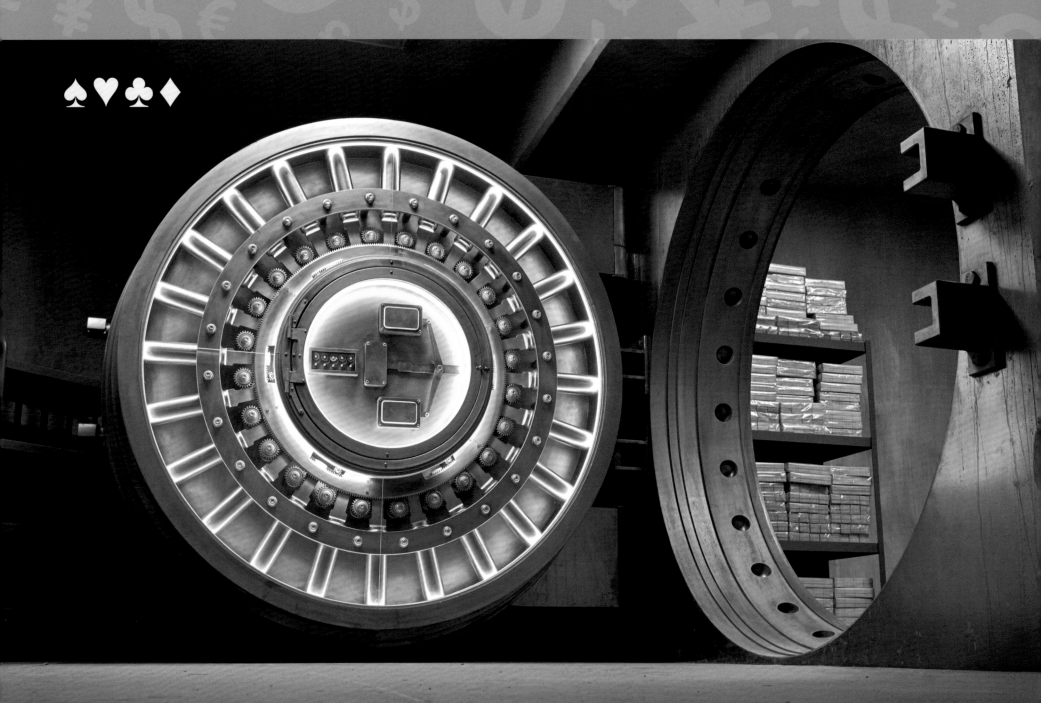

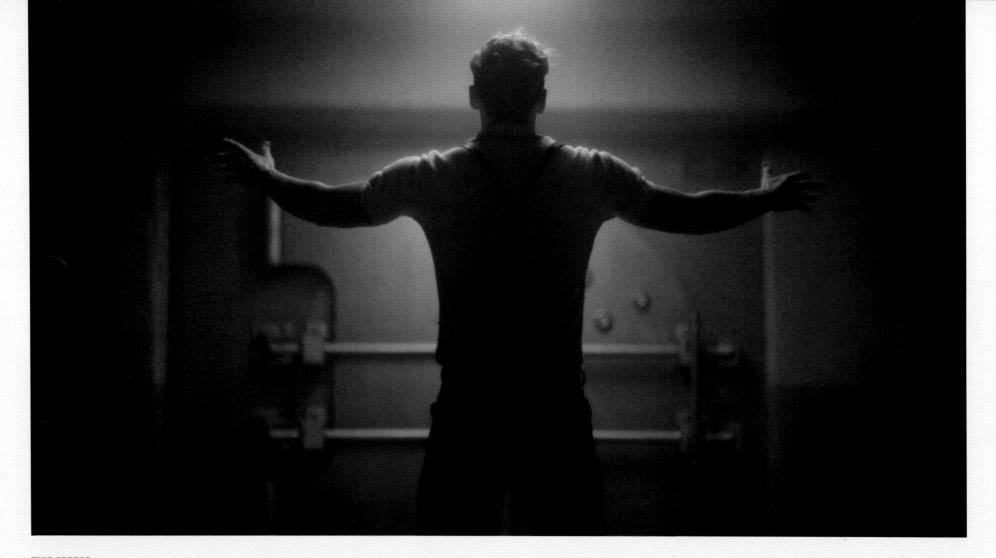

THIS SPREAD/ Dieter meets his destiny, the Götterdämmerung vault.

The Prize. The Brass Ring. The Ultimate Challenge. The team's objective stands just a few feet away. It is tantalizingly within their grasp. They only have to get through some deadly traps and crack an impregnable safe door. They'll also have to deal with some enraged Alphas, as well. The model name of the safe, Götterdämmerung, literally means 'twilight of the gods.' That could prove to be an ill omen.

The approach to the vault has all the requisite safeguards you would imagine, titanium gates, electronic alarms, and so on, and Martin has keycards for those. But the Bly has failsafe measures in place that up the security to insane levels. "This came out of the notion that we wanted a fun sequence that was sort of *Ocean's Eleven*-y, when you see these sequences in a movie where there are all these types of alarms," explains Snyder. "But in the zombie world, there's no

one to answer the alarms. You're not going to call the cops. So, in ours we had this notion that Bly Tanaka had installed these lethal deterrents in the eventuality that someone might get the alarm power shut off. The analog solution, if you will."

The solution to those analog measures turned out to be rather simple, as well as visually entertaining. "They captured a Shambler and sent him into this space so he'll set off all the traps," says Berghoff. "We talked about it for a long time. We wanted it to be a little bit over the top, Indiana Jones-ish, but our version of it. Everything is triggered from the floor. It starts with rifle gauges coming from the wall. Then there are these poisonous darts that were hilarious, with a feather that was like [it was] from a costume of a showgirl. Third are concrete walls coming from both sides and smushing him. The fourth one comes down

from the top and crushes him. You just watch him lose limbs along the way. We built the walls actually being able to be pushed in and smush him like a bug for the last scene."

Except for that climactic "smush," the booby traps were mostly practical effects with minor VFX enhancements. "In the final beat of this sequence, we decided to run a multi-pass setup that consisted of the [zombie]-action pass, a door-sliding pass, and a practical blood explosion to simulate the body smush," says visual effects supervisor Marcus Taormina. "When we assembled all of these elements, it was apparent we needed to amplify the gore with additional CG blood simulations, and we also had to warp some of the [zombie] chef's body to simulate the compression of his body in between the sliding doors."

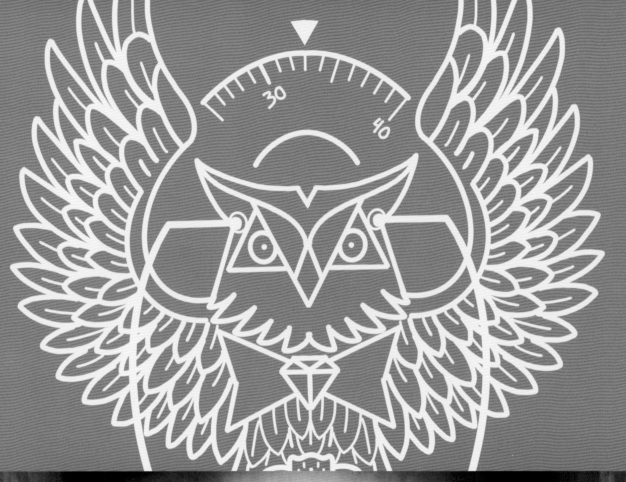

Even seen close up, it would be difficult to believe the Götterdämmerung is not a real bank vault, rather than a set on a soundstage in New Mexico. "For the safe, we created a twelve-foot-circumference door," says Berghoff, explaining the process for achieving that realism. "A safe door is very, very intricate, and we wanted it to actually move and function, be able to spin the wheel, and show that it opened. It took a lot of engineering to come up with that. Even though they've come really far with metal paints and chrome, it's really difficult to create the texture properly on something that scale without using some real metal. So, we just used a super, super, super-thin gauge metal on some of it, and some of it was laminates, because otherwise the door would've weighed hundreds of pounds and would not have been able to be supported properly."

Producing the mountain of cash inside the vault fell to property master Brett Andrews. "We were actually

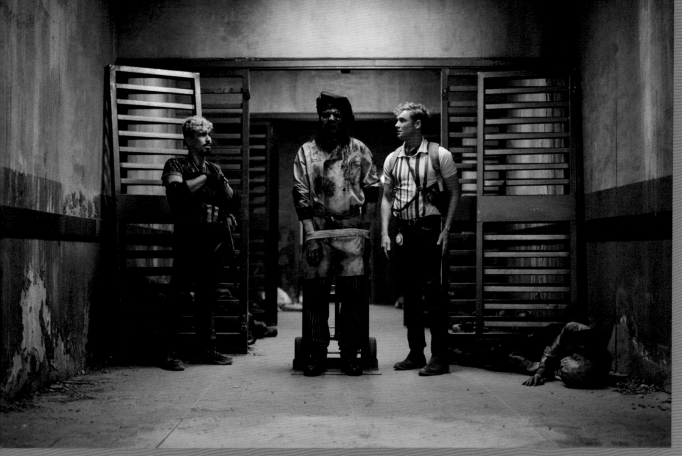

THIS PAGE/ Guzman and Dieter seek help from a Shambler chef.

OPPOSITE/ Dieter asks for patience as he works to free all that cold, hard cash.

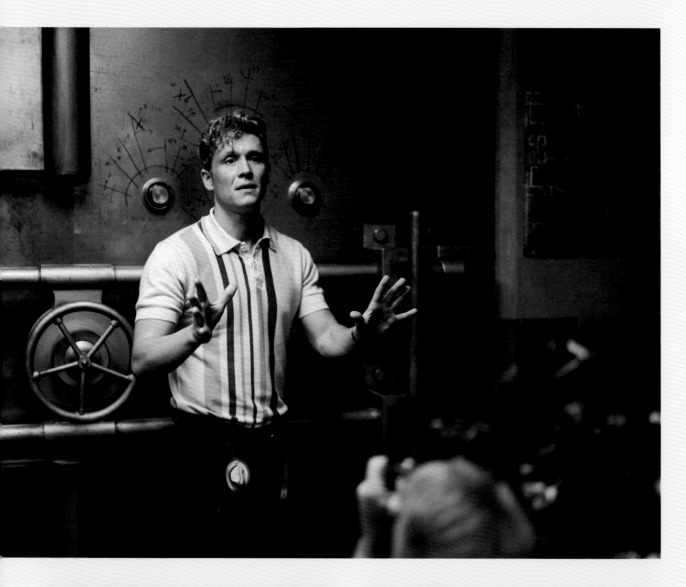

trying to be realistic about that $200,000,000. When they walk into that safe and you see one tray, on there is one metric ton of money, and we had four of those up there," he explains. "We had three that we faked [the weight of], so we could move the camera around, but one of them was real, and it was not easy to adjust camera around one metric ton. Every time they said, 'I want the camera here,' it was like, 'Do you really want it there?' The characters are actually picking up $250,000 in hundreds in each one of those bags. I wanted to show the weight, the lunacy that people could walk away, even strong people, with that amount of money.

"All $200,000,000 were fake," Andrews continues. "There were two shots where we slotted in real bills, but what was manufactured custom for the show was so screen accurate—we used a band to cover the inaccuracy that was made on purpose—that it was slightly phenomenal. That's why we protected the money so meticulously, because it was a new breed that we designed just for Zack."

Besides money, sharp-eyed viewers should be on the lookout for Easter eggs inside the vault. "We created the safe, along with things that Tanaka had collected along the way, his artwork and things he kept in there, almost as a personal safe. So, when you open it there are all these little surprises about his character and his hobbies," says Berghoff.

The vault is also where Scott and his crew tangle hand-to-hand with Alphas for the first time. It's a chaotic scene of unbearable tragedy, but also incredible heroics, as team members rise to the occasion.

Bautista gives a standout performance in the melee, calling on his background and extensive training. "Kali is a Filipino martial art that's both an empty-hand and a weapon-based art," says second unit director Damon Caro. "We did a combo of this with Dave in a couple of scenes. Dave did a really great piece with a single blade in the point-down, ice-pick position in the vault. He goes ballistic and goes on a rampage against a bunch of Alphas. Dave is crazy-talented in several martial arts, so he did a great job."

GOING

ALL IN

The survivors have very little time to get to the roof and fly away to safety. Zeus has just unleashed the full fury of his horde of Alphas, and the nuclear warhead is due within minutes. The stakes have never been higher in that casino as when they make their dash for the elevators.

THE OLYMPUS HOTEL

AND THE ARMY OF THE DEAD

The center of Zeus's domain, the Olympus Hotel is his inner sanctum, where the Alphas congregate like a gigantic beehive. It is also where he has human captives brought. Initially locked away in hotel rooms, these hapless victims wait, terrified, until they are brought to the indoor pool to be judged if they're worthy of being turned into Alphas. Those that aren't become food for the gods.

The exteriors of the Olympus Hotel (including the Zeus statue) were wholly computer generated. All of the interiors, however, were shot on location at the Atlantic Club in Atlantic City, New Jersey. The biggest single set piece in terms of the sheer volume of blood-and-guts decoration, along with makeup effects, was the gathering of the Alphas at the hotel swimming pool. It began with exchanging one type of filth for another. "In the pool, we had to actually clean away all of the dirt and debris and bring in our own," says

production designer Julie Berghoff. "Years of killing in a pool—what does that look like? Almost like a tiger or lion's lair. That's really where our inspiration was from."

Making this gory spectacle look realistic involved more than simply throwing around bones and spraying fake blood. Considerable thought went into the materials, the palette, the texture, and the composition. "We had five different buckets: the dark red blood, which was the dried blood; the bright red blood, which was the 'just-killed' blood; and then we had these three buckets of intestines, brains, with different textures," says Berghoff. It was environmentally friendly, too. "We used all natural ingredients, almost all water soluble, like wallpaper paste and mulch from Home Depot, because Atlantic City is very strict about what goes into the water systems. Things that were not toxic, which is a new

twist for me. I love that toxic stuff, like coconut hair," she says.

"It took a week to scenic it and add all the layers, rib cages," Berghoff continues. "Fractured FX gave us some body parts, and we literally had eight hero zombies. Zack kept saying, 'More! More!' And we were all, 'Oh my god, we already used the best eight on the top.' We had to create a lot. So, we would grab skeletons from the skeleton store and add layers. I'm super detail oriented in terms of texture, because I came from model building, and that's my passion."

Once the grisly palace was furnished to satisfaction, all that remained was to populate it with multitudes of Alphas. "The army at its core is maybe five hundred Alphas. Over the years, Zeus has been slowly turning people into Alphas who have wandered into Vegas or have tried to, mostly from the refugee camp," says Zack Snyder.

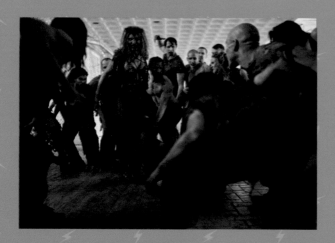

OPPOSITE/ Concept art of the Olympus Hotel by Film Frame.

THIS PAGE AND NEXT SPREAD/ Zeus gathers his army of Alphas around the indoor pool at the Olympus.

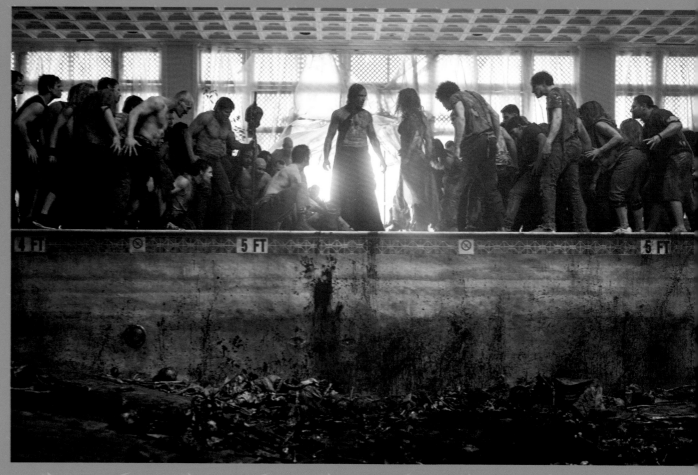

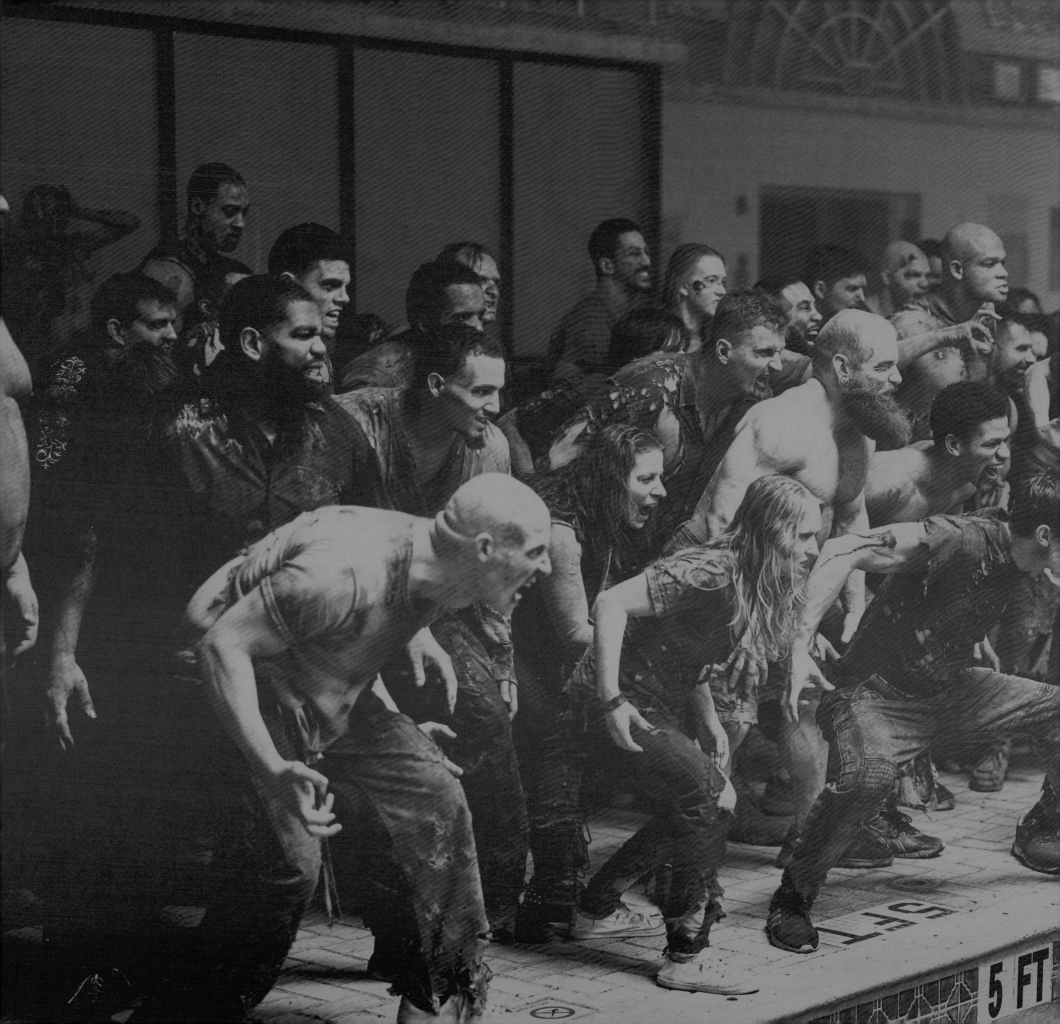

"The Alpha hive was probably one of our most challenging sequences, just because of the sheer numbers," says special makeup effects designer and creator Justin Raleigh, explaining how monumental a task that was. "A hundred and fifty people, in some cases more, that would have to go through costumes, makeup, prosthetics. We tried masks and a variety of different things, but we found [that with] the way it was being shot, masks just never really worked, it never held up. It had to be makeup on people.

"We built this on a tier system," Raleigh continues. "We would have thirty to thirty-five people in full prosthetics, full-body makeup—high-end Alphas, that also included the Queen, or the Queen and Zeus. Then we would have up to a hundred people that would have to go through a pretty detailed body paint, because the way it was all staged, the shots didn't allow for a really deep background, so you couldn't really bury people in there. We did have a handful of people in screen-printed suits that the costume and wardrobe

department and my department worked together on. The suits were translucent, almost pantyhose material, that would cover their legs and bodies, that had a paint pattern built into it, but they all still needed face makeup. We ended up with a team of thirty to thirty-five makeup artists on some of our heaviest days. Some of those were long eighteen-hour days, where we would have four to six hours of makeup in the morning, then we would shoot an eight- to ten-hour day, and then have to clean them all up at the end of the day."

Nearly as many practical Alphas were required when Zeus, mounted on his undead steed, led the full army of the dead out of the Olympus toward the Bly. That magnificent charge sequence was shot on the backlot in New Mexico. "I used dirt, putting cars under the dirt, to make the mound for the horse, and to pretend like it's a parking garage coming down," explains Berghoff. "So, all ninety Alphas are going to come running over this hill, into a fountain area, and then we'll cut to Atlantic City."

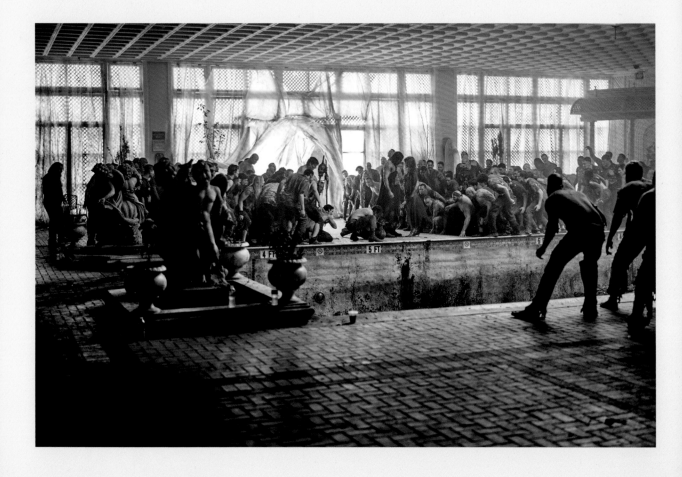

A GARGANTUAN BEAST

THE BLY LAS VEGAS CASINO

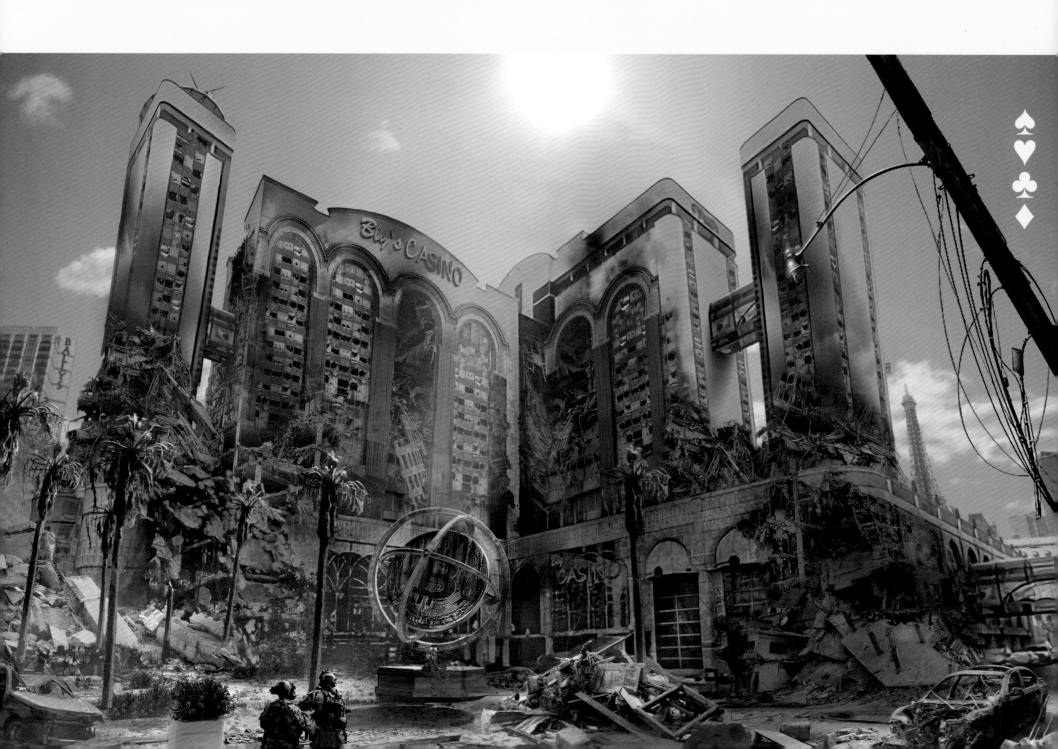

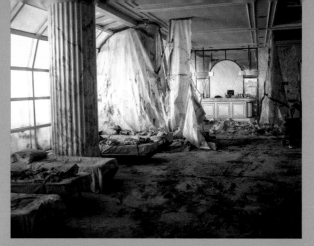

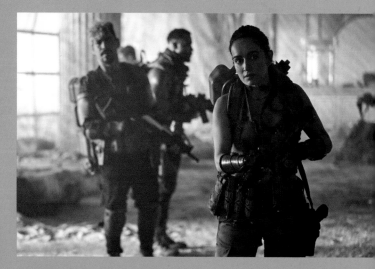

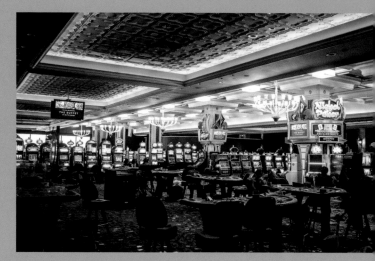

The setting for the final confrontation. The situation is dire for the crew as raging Alphas swarm the Bly and make escape all but impossible. "It's an intense situation, especially when the full strength of the zombie army hits the Bly casino," says Snyder. "Even though they're trying to make their way out and abandon ship, it's still a formidable force, no matter how much firepower you have and how equipped you are for it. Especially since the majority of the skillset that our team has is dealing with Shamblers, not with Alphas."

The Bly proved to be an unusual location to pull together for the shoot, because the exteriors were the only ones filmed in Atlantic City (at the Atlantic Club). Also, its interiors were stitched together from footage shot in two casinos. Filming began at the entrance to the Atlantic Club, then shifted over to the Showboat for the main casino floor. "We used [the Atlantic Club] as a hotel quarantined off, like a makeshift hospital, using casino beds and lamps to hold IVs, plastic all over, with blood smears that showed movement and struggling," Berghoff explains. "We created these tunnels that quarantined the hotel off for us to move through it and shoot through it, and then we brought that into the other casino [the Showboat], and that was our transition."

OPPOSITE/ A concept for the Bly's Las Vegas by artist Jonathan Bach.

ABOVE/ Details of the casino inside the Bly.

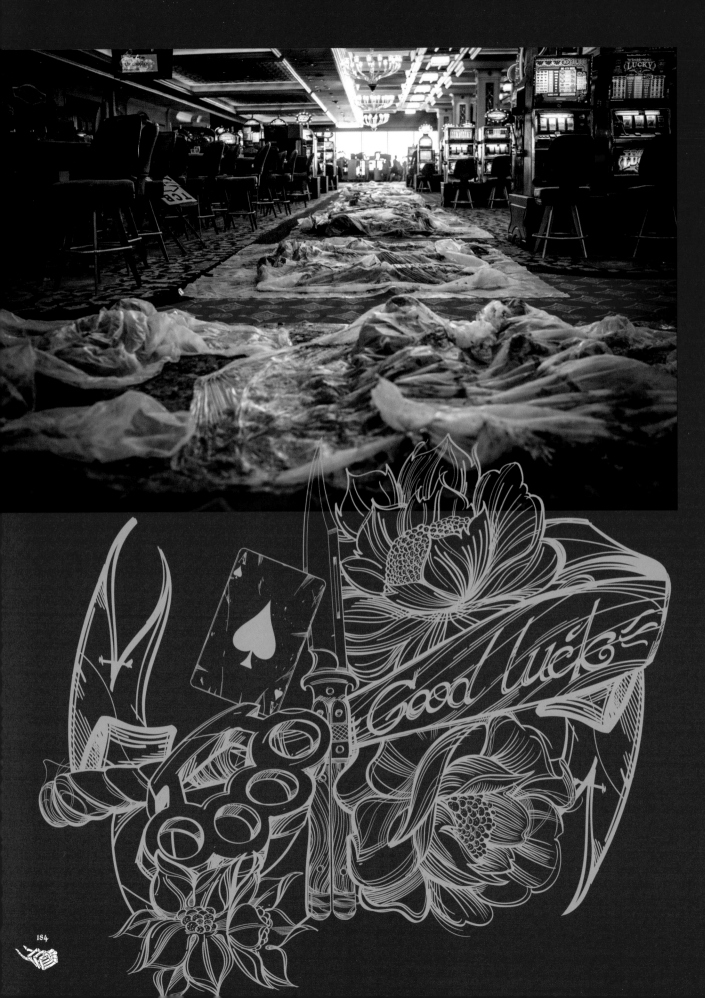

Decorating a vast casino turned out to be more involved than one might think. First of all, slot machines and other gambling devices are rigidly controlled by the state, so the Showboat was empty when they arrived. "We had to create the entire casino floor, which is over five hundred machines and tables that had to light up and not make sound," says Berghoff.

"My set decorator, Sophie Neudorfer, had to get all the machines, which is a very complicated situation. You had to go through the gaming commission and find a broker that could ship them in Atlantic City, and the commission had to know about them and they couldn't work. The newer machines turned out to be super expensive, but it worked out, because we liked the more vintage machines anyway. We made them look like some of the newer ones by building molded screens and things like that. The layout was based on the shape of the floor, working with Zack, and the fight choreography through the casino."

THE PEOPLE WHO WERE DEAD COULDN'T JUST BE DEAD, THEY'D BE ZOMBIES.

Aging the casino and placing the bodies of the unfortunates caught in the initial outbreak required careful consideration. "I like to have a backstory with everything," Berghoff says. "Every little element in here, from the cards on the ground, to the custom casino coins, to the layer of dust, and the ceiling coming down, and water stains, and everything. The people who were dead couldn't just be dead, they'd be zombies. So, did they shoot themselves? Did they get their heads ripped off? The six bodies that were playing cards shot each other and blew out their brains. We had some dressed in wedding dresses, and we had Elvises. We had the whole colorful story of Vegas. Every single detail is something that we had to think about to take you six years into the past in an apocalyptic zombie war. I think this is pretty close."

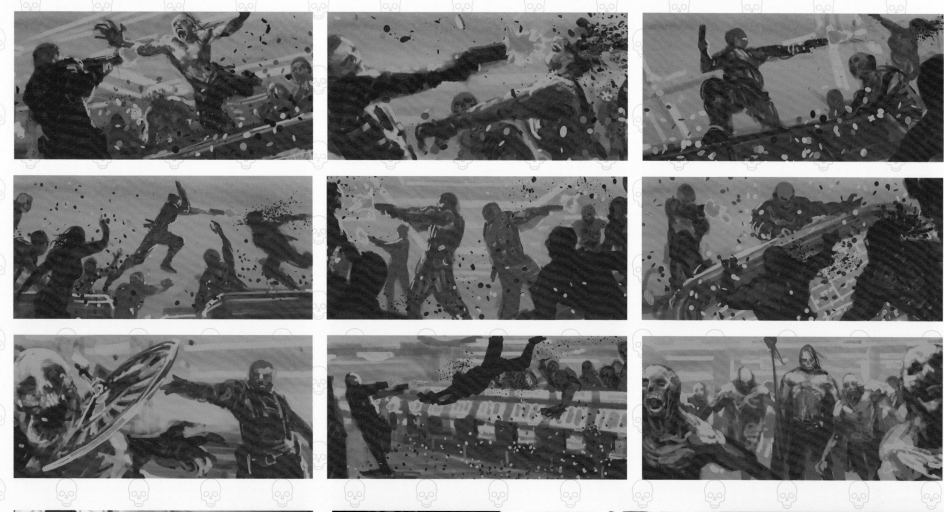

OPPOSITE/ The casino became an impromptu morgue during the zombie invasion.

TOP/ Storyboards for the casino fight by Jared Purrington.

ABOVE AND RIGHT/ Alphas attack!

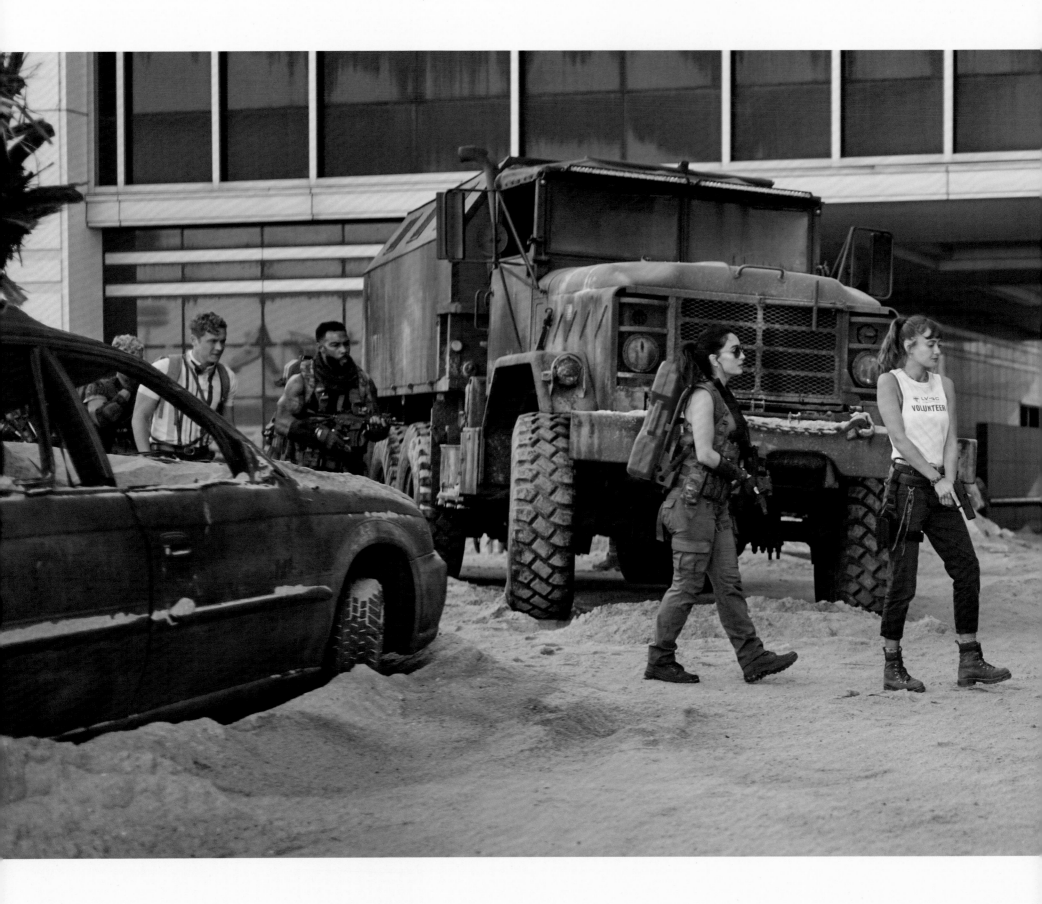

Bly's

LAS VEGAS

THE MAIN DOOR IS LOCATED IN THE CONNECTING BUILDING BETWEEN THE TOWERS. THE GLASS DOOR IS VISIBLY BARRICADED WITH BOARDS FROM THE INSIDE.

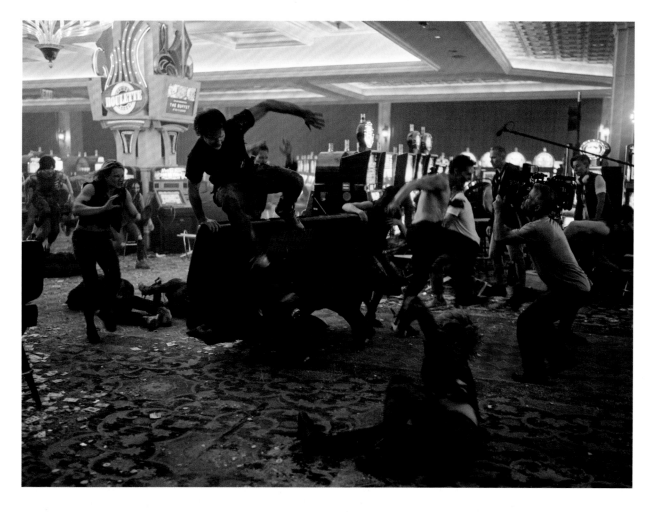

The casino fight took five days to film, mainly broken up into small action sequences to highlight each team member's fate. By shooting from multiple angles, it was possible to make the number of Alphas seem much greater than it was. This concession was appreciated by the makeup department. "It was still large numbers, but not as much as the pool sequence, especially the way it was shot," says Raleigh. "It was so stunt heavy, we really focused on getting fifteen to thirty key stunt players, done in sections at a time, and then we would have a bunch of background that would be used as filler behind them."

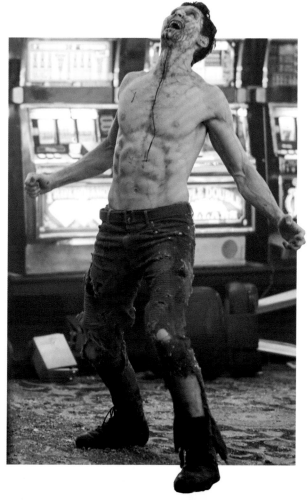

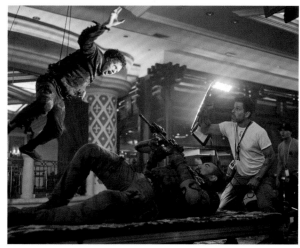

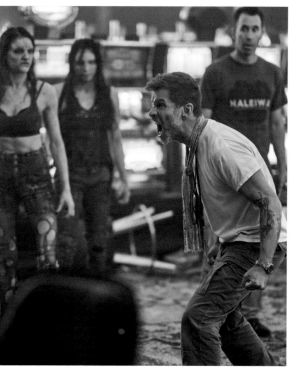

THIS SPREAD/ Crew members (including Zack Snyder) in the middle of things during the Alphas' assault on the Bly.

♠ ♥ ♣ ♦ ARMY OF THE DEAD

Over the course of the entire film shoot, the number of makeup effects used was astonishing. "It was probably pushing 3,500 appliances or more. We had hundreds and hundreds of dental appliances for people, hundreds of contact lenses, gallons and gallons of blood," says Raleigh. It's important to note, however, that Raleigh is mainly speaking about stage blood used for makeup and set decoration; ninety percent of the blood and gore seen throughout the movie is CG. "Early on in our discussions, one thing Zack was adamant about was utilizing VFX for all of the blood and gore to speed up the shooting process, allowing him to film more each day without costly and long reset times for gore scenes," explains visual effects supervisor Marcus Taormina. "Knowing this was his directive, I made sure that we had an opportunity to shoot a rather robust element shoot that could be used in compositing and for look development for our CG gore. With the help of Michael Gaspar and his special effects team, we were able to shoot a multitude of blood and gore FX in New Mexico, some of which is used in the final cut of the film."

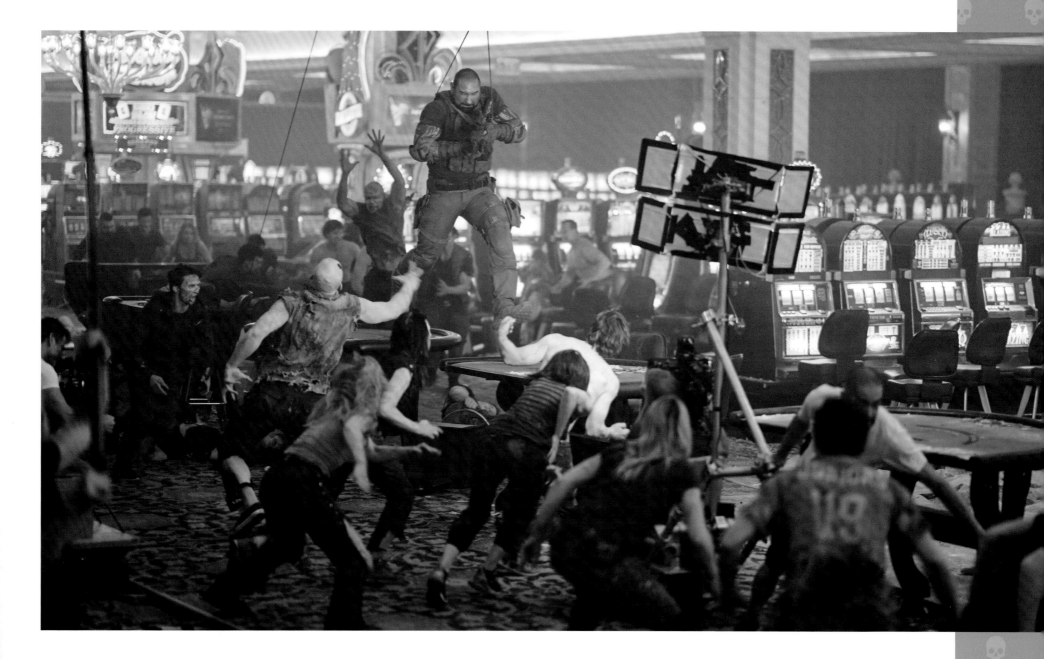

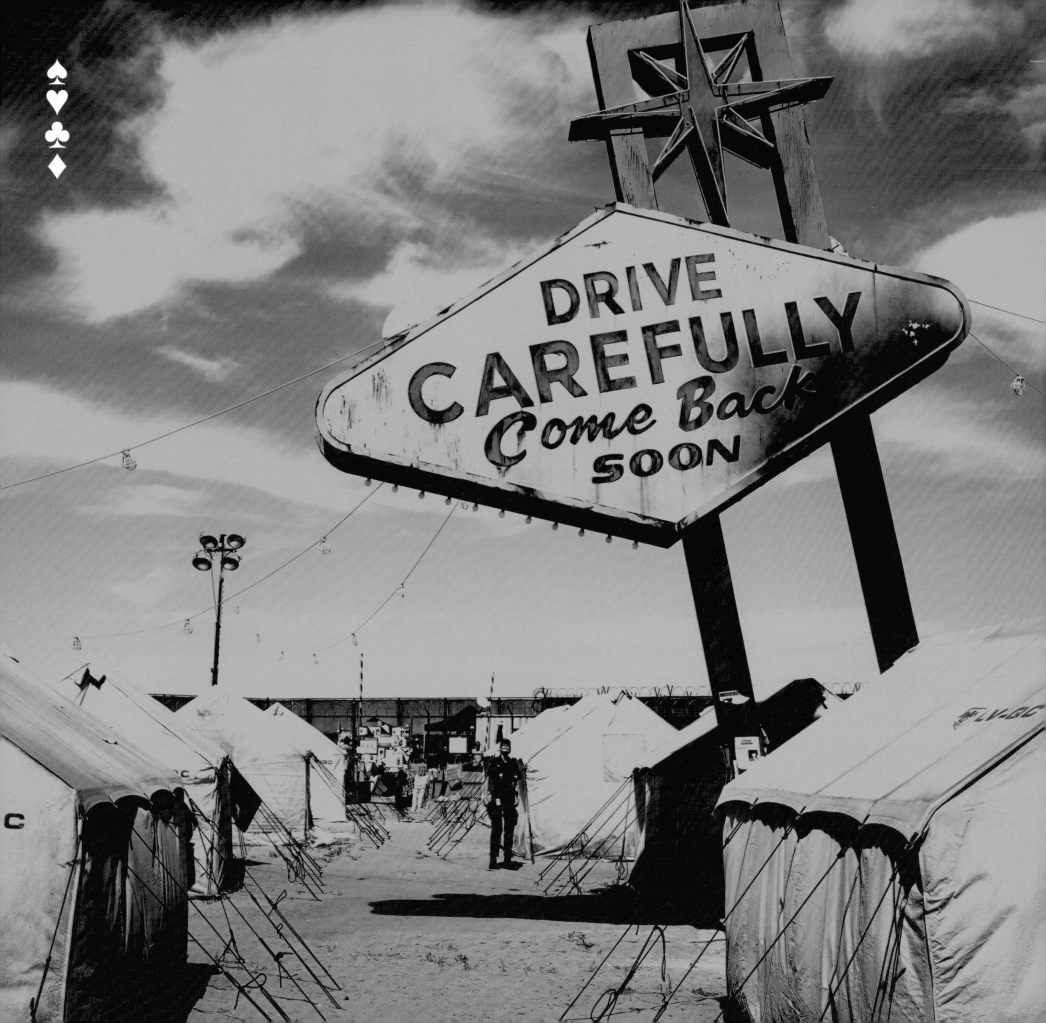

JACKPOT
CONCLUSION

The goal in a zombie movie is to survive.
The goal in a heist movie is to get away with the money. In *Army of the Dead*, one could argue that the true goal is neither of those things. The real prize, in the end, is reconnecting with family, with friends, and with comrades-in-arms. Through those reconnections, we discover truths that were once beyond comprehension or that were long forgotten.

A great deal of the credit for achieving that amount of depth in a film about undead monsters goes to a filmmaker reconnecting with a genre that had brought him success in the past and seeing how it could be moved forward. "Zombie movies. We know this is a thing that works, and so we have to push it," says Zack Snyder. "We can come at it from another angle. This movie is going to subvert expectations about what a zombie movie is, and I think it will be original and unexpected in a lot of ways. It allows an opportunity to be at the front of what I would hope is this continuing reinvention of the zombie genre."

ACKNOWLEDGMENTS

AUTHOR'S ACKNOWLEDGMENTS

I would like express my gratitude to all those whose efforts made this book possible—not the least of whom were the obliging cast and crew, who were subjected to the sustained fire of countless interview questions. Special thanks go out to the folks at Jamestown Productions, who shot off most of those questions; editor Stephanie Hetherington and her team at Titan Books, for leading the charge; designer Natasha MacKenzie, for infusing the book with her artistic DNA; and illustrator Adam Forman, whose infectious illustrations you'll encounter herein.

Lastly, thanks to Zack, Debbie, and Wes for allowing me once again to peek behind the curtain.

Peter Aperlo

FILMMAKER'S SPECIAL THANKS

We would like to extend a special thanks to all of the amazing and talented writers, actors, artists, designers, photographers, technicians, and countless other accomplished crew members, vendors, and partners who joined us on this epic journey. It is their combined wealth of talent, creativity, and tireless dedication that makes it possible to bring a film like *Army of the Dead* to life—err—undead—well, you know what we mean.

We had an amazing time making this film and are incredibly grateful to have been able to share in the undertaking of this endeavor with each and every one of you.

In addition, we would like to express our most sincere gratitude to everyone at Netflix for their enthusiastic support!

Zack, Debbie, and Wesley